CONTENTS

Introduction

When you first start to draw, you will discover that the basic techniques recur no matter what your subject may be. While there are obviously huge differences between animals and people and between rural and urban scenes, the same principles of drawing will hold good as you try to render your subjects in as lifelike a manner as possible.

Wildlife
Animals have been the subject of art since the first prehistoric artists scratched pictures on stone or finger-painted on cave walls. Today, there is a new fascination with them, not just as creatures to be hunted, domesticated, classified – or even eradicated – but simply as wonderful, free, living beings in their own right. We also know much more about animals and their world, and understand more about the way in which they interact with each other and with their landscape.

Nowadays, there are also greater opportunities to watch animals living their lives, whether we are in hides at reserves or simply near the bird-feeding table in the garden. The great improvement in binoculars, telescopes and cameras allows us almost to enter into their most intimate lives without disturbing them unduly.

People
Drawing people is a challenge that encompasses a wide range of subjects, from lifelike portraits of friends and family to swift sketches of crowds populating urban scenes or depictions of people at work. This last subject in itself offers the artist a number of challenges, as showing people at their occupations requires them to be given some kind of setting. This may include animals, buildings or countryside – or perhaps all three.

Of all the subjects in this book, portraying facial expressions is perhaps the one that calls for the greatest skill and accuracy, for the slightest alteration of mouth or eyelid can change the viewer's perception of the sitter's mood. As with animals and birds, there is also the need for a feeling of animation in the subject.

Drawing
for
Beginners

Drawing
for
Beginners

a step-by-step guide to successful drawing

Peter Partington

Philip Patenall

Bruce Robertson

David Cook

Collins

This paperback edition published in 2004 by
Collins, an imprint of
HarperCollins*Publishers*
77-85 Fulham Palace Road
Hammersmith
London W6 8JB

The Collins website address is www.collins.co.uk

Collins is a registered trademark of HarperCollins*Publishers* Limited.

First published in hardback in 1998

06 08 09 07
3 5 6 4

Most of the text and illustrations in this book were previously published in
Learn to Draw Wildlife, Learn to Draw People, Learn to Draw Countryside and *Learn to Draw Buildings.*

© Wildlife: HarperCollins*Publishers* 1998
© People, Countryside, Buildings: Diagram Visual Information 1998

Produced by Kingfisher Design, London

Editor: Diana Vowles
Art Director: Pedro Prá-Lopez
Designer: Frances Prá-Lopez

Contributing artists:

Wildlife
John Busby, John Davis, Martin Hayward-Harris

People
Laura Andrew, Peter Campbell, Arthur Lockwood, John Meek,
Bruce Robertson, Graham Rosewarne, Christine Vincent

Countryside
Laura Andrew, Peter Campbell, David Cook, James Dallas,
Kyri Kyriacou, Lee Lawrence, Ali Marshall, Philip Patenall

Buildings
James Dallas, Roger Hutchins, Lee Lawrence, Ali Marshall,
Philip Patenall, Bruce Robertson, Graham Rosewarne

A catalogue record for this book is available from the British Library

ISBN-13 978 0 00 719814 6
ISBN-10 0 00 719814 0

Printed and bound by Printing Express, Hong Kong.

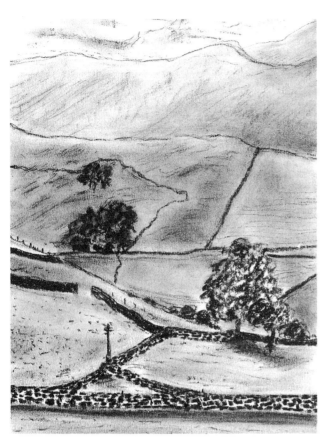

Buildings

Whether a building is a barn or an abbey, getting the perspective and proportions right is crucial to producing a drawing that will convince the viewer of the structure's reality. Once those basic elements have been mastered, adding texture and light and shade will give a building real form and solidity. Often the art lies just as much in knowing what to leave out, for sketching in just a few bricks and leaving the viewer's imagination to put in the rest will give a fresher, livelier drawing than one in which every detail is delineated.

In a drawing of buildings you potentially have a wide subject, as a street or market square scene may encompass all the elements in this book. As for rural scenes, most expanses of countryside will have a building nestled here and there, providing a focus of interest.

Countryside

Many countryside scenes will include animals, birds and people, but in this part of the book the setting itself is the subject under discussion. Realistic drawings of trees, water, skies and flowers will draw the viewer into the scene and evoke feelings of tranquillity or excitement according to season and setting. Weather and atmosphere are telling elements, as shadows falling according to the intensity and angle of the sun will inform the viewer as to the time of day and even the season.

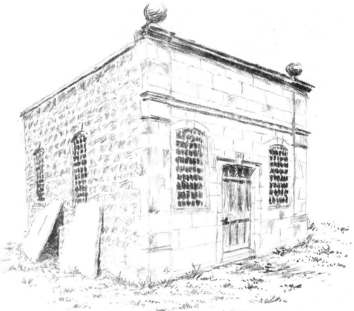

Because the light may change so quickly, photographs can be invaluable for providing an accurate reference to be used later in the studio. However, interpreting them sensitively rather than copying them slavishly is an art in itself.

Tools and Equipment

When you begin drawing, you will find that there is an exciting array of materials to choose from. They have been developed by artists to suit their own purposes. Each tool creates its own feeling and effect, and you will need to choose the one most appropriate for the particular drawing you wish to do.

Pencils

The pencil, that everyday object, is one of the most versatile drawing instruments available to us, capable of producing rough, quick sketches and finely worked detail. The graphite or 'lead' pencil ranges from the super-hard 9H to the luxurious and softest 9B, with the HB in the middle. The H range provides you with a light, hard, precise line ideal for detailed studies of shape and texture. The soft B range can provide rich, rough, textural effects and striking tonal

variations. The trail of graphite on the paper can be smudged to create depths and lights, and a sense of action and movement.

Some people prefer specialized pencils, such as the clutch and propelling pencils. These come in a lower range of hardness and softness, but offer a continuous and consistent line without the bother of constantly having to sharpen the lead.

Coloured pencils enable you to draw and introduce colour simultaneously, while watercolour pencils produce a line which can be softened with a wash of water.

You should experiment with as many different types of pencil as possible to discover what effects they produce and which suits your intentions and feelings best.

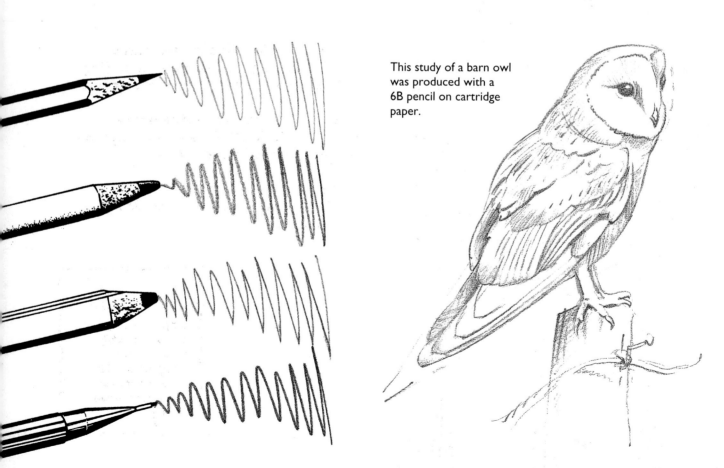

This study of a barn owl was produced with a 6B pencil on cartridge paper.

The criss-crossing lines of dip-pen and ink give form to this deer.

Pens

Pens can produce a fluid, uncompromising line. They are available in several varieties, each creating a different effect.

Fountain and **dip-pens** allow the artist to draw free-flowing or angular lines of varying thickness, depending on the pressure applied.

Ballpoint and **technical pens** produce a consistent, fine line. Quick to apply, ballpoints are useful for sketching moving subjects.

Felt-tip pens can create a similar effect, depending on their nibs. They are sold in a range of widths.

Artist's Tip

Dip-pens need washing after use, especially if you have used waterproof ink. This can encrust itself on the nib if it dries and will clog the pen.

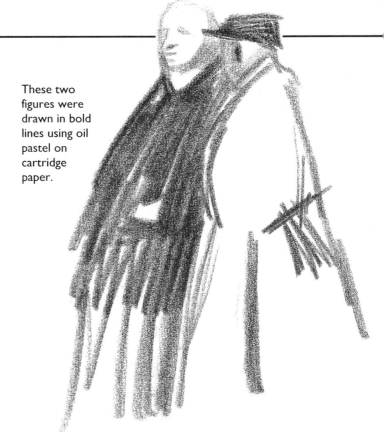

These two figures were drawn in bold lines using oil pastel on cartridge paper.

Pastels, crayons and chalks
The varied textures and tones that pastels and chalks produce offer an exciting alternative to the precision of pencils and pens. They work best on rough and textured papers.

The range of rich, powdery marks and lines produced by these materials can be smudged and blended. They are ideal for rendering dense or glossy textures because you can work light over dark, or allow the coloured paper base to show through.

Pastels and **chalks** can be used on their tips or on their sides to fill large areas quickly. Their rough unfocused line can suggest light, movement and mood – the eye fills in much of the detail the artist has merely suggested. They are particularly effective if you want to produce lively, spontaneous drawings.

Oil pastels and **wax crayons** come in a dazzling array of colours, both bright and subtle. They give us the opportunity to introduce colour at the same time as line and contour. Soft oil pastels can be built up to resemble oil paint.

Wax crayon drawings can sometimes become overworked – use overlapping, *cross-hatched* (criss-crossing) lines with care.

These 'greasy' media are all difficult to erase, so plan your picture carefully before you begin.

Compressed charcoal and **conté pastel** are also made in pencil form for ease of handling. Their effect is similar to non-compressed forms, but more manageable for smaller-scale work.

Compressed graphite sticks resemble large-scale pencil 'leads' in various softnesses, and produce effects like generous pencil strokes. They can apply graphite to paper in quantity and with speed.

Artist's Tip

While working with these delicate media, rest your hand on a piece of paper to protect completed areas from smudging, and cover them when you take a break.

The rough texture and shadows in the sketch of the Vila Viçosa, Portugal, are emphasized using conté crayon on rough paper.

11

Brushes and wet media

Brushes can be used to add colour or tone to a drawing or as a drawing implement in their own right. They can produce fine, flowing, thick or thin, rhythmic lines.

Brush tips come in various shapes. The most useful for drawing are the long-tipped, pointed brushes – the 'rigger' type being the longest. These produce long, fine lines. Short-tipped points are easier to control and can be used for fine detail.

Flat brushes, either short or long, are the best type for covering large areas, or for producing extreme variations of line, almost like a calligraphic pen.

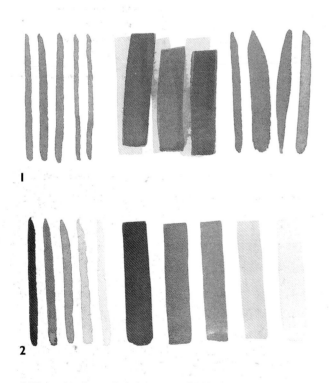

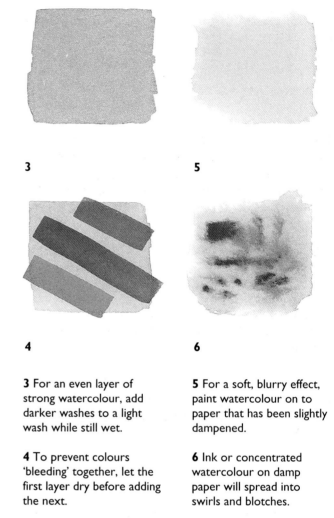

3 For an even layer of strong watercolour, add darker washes to a light wash while still wet.

4 To prevent colours 'bleeding' together, let the first layer dry before adding the next.

5 For a soft, blurry effect, paint watercolour on to paper that has been slightly dampened.

6 Ink or concentrated watercolour on damp paper will spread into swirls and blotches.

Sable is the best-quality hair in a watercolour brush and gives very attractive results. Cheaper squirrel and synthetic fibres are quite adequate, however, and produce work of good quality. The tensile springiness of synthetic fibres can create fine, dynamic lines ideal for expressing the liveliness of animals or of children playing.

Brush-pens, with a cartridge of coloured ink, are good for this, too, and ensure a consistent flow of colour.

1 These brush marks were made with *(from left to right)* a small, pointed brush; a flat brush; and a large, pointed brush.

2 Watercolour tone can be progressively reduced by adding more water, as shown by these strokes using different dilutions.

It is possible to draw in any medium, including oil paints, but it takes a lot of practice to get the best out of these. Water-based paints or inks are easier and more convenient to handle, and they dry more quickly.

Watercolour can be diluted with water to give transparent tones and gentle washes. Reducing the amount of water produces strong, vivid colours – a very effective technique when used to strengthen pencil outlines or an ink drawing.

Gouache is a form of watercolour that gives bold, opaque colour and can mask pencil sketching.

Acrylic paints can be diluted to create a watercolour effect – if undiluted, they will look like oils.

For wet media, you will need a palette for mixing and a couple of jam jars – one containing water for mixing colour, the other for washing your brushes.

Watercolour paper, when dampened, allows a watercolour wash to spread attractively *(above)*.

The grasses in the foreground *(below)* were painted using fine, delicate watercolour strokes on watercolour paper.

Artist's Tip

You can create fascinating results by painting water-based colour over water-resistant wax- or oil-based crayons.

Newsprint is very inexpensive, which makes it good for practising and rough sketching.

Tracing paper is semi-transparent, so that you can lay it over other images and trace them.

Stationery paper, usually available in standard sizes, has a smooth surface which works well with pen.

Cartridge paper has a slightly textured surface, and is one of the most versatile surfaces.

Cartridge paper makes a good partner for pen and ink (*above* and *right*) – these require a relatively non-absorbent surface so that the nib does not snag and the ink does not blotch.

Surfaces to draw on

You will find out through experience what surface suits your style best, and what suits the medium you are working with. Don't be afraid to experiment with different combinations of media and surfaces; it's exciting to explore the way in which each surface changes the appearance of each medium.

Watercolour paper is the most expensive paper. It may be hand- or mould-made, and comes in different thicknesses measured by the weight of a square metre (yard). It is tough and absorbent, consisting partly or wholly of cotton and linen fibres which can give it a quality almost like that of blotting paper. It will take vigorous drawing and watercolour washes, and is acid-free so it will not go brown if left exposed to daylight.

Cartridge paper, either cream or white, is the most versatile surface for day-to-day drawing. This can be bought in rolls or sheets.

Cheap papers are not to be despised. Brown wrapping paper, for instance, makes an excellent and tough surface on which to work, as does photocopy paper and plain newsprint.

Pastel and Ingres papers, in many colours with textured surfaces, are ideal for pastel, charcoal and conté.

Watercolour paper is absorbent, and can have a rough or smooth surface. It is ideal for wet media.

Bristol board has a smooth surface which makes it highly suitable for drawings in pen and ink.

Layout paper is a semi-opaque, lightweight paper which is suitable for both pen and pencil.

Blocks, books and **pads** are needed for outdoor sketching. Blocks consist of ready-cut and stretched watercolour paper on a card base. Books consist of watercolour or cartridge paper bound with a hard back. Pads are usually made of cartridge paper, spiral-bound or glued. They are available in *portrait* (upright) or *landscape* (horizontal) format.

Paper has one of three grades of surface: *hot-pressed* (which is smooth), *not* (meaning not hot-pressed, i.e. slightly rough) and *rough* (an interesting, textured surface).

Smooth surfaces are best for pen and wash and detailed pencil work. Rougher surfaces suit bold, dark pencil, charcoal and crayon. Pastels and chalks do not take to smooth surfaces because their particles cannot cling to them; they are best suited to tinted pastel paper.

Watercolour papers can often have attractive textures – 'laid' or 'wove' – according to the mould they are made in. This can add enormously to the interest and importance of your work.

These farm buildings, set in bleak hill country, were drawn in felt-tip pen on layout paper.

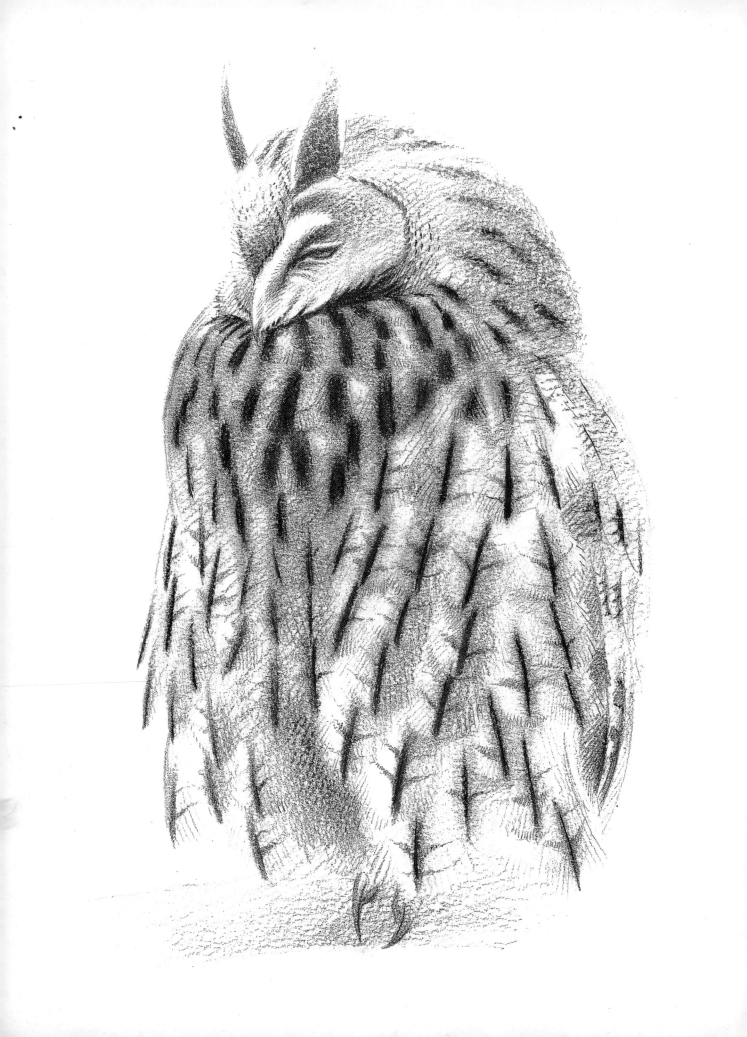

Wildlife

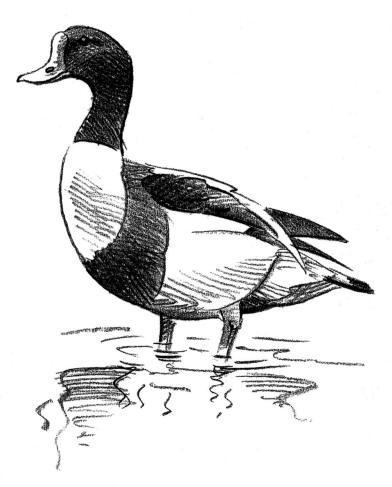

Peter Partington

Choosing the Right Medium

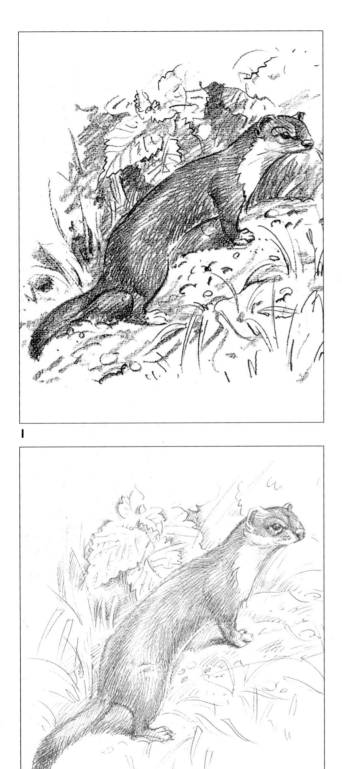

1

2

It is worth making yourself familiar with the wide range of drawing materials and surfaces available. You will find that the various media are suited to different purposes. Some methods and styles will suit you individually better than others; a combination of media may express the feeling you want to convey.

You may, for example, want to portray the details in an animal, in which case a fine point like a hard pencil will fulfil your aim. Alternatively, you may want to express a sense of flow and movement, or give a more general impression of the animal as a whole. Here, the flowing line from a wet brush will enable you to convey this feeling more easily. To create a sense of mood and atmosphere, the softness of charcoal is ideal.

If you look at the pictures on these pages, you will see that they are of a stoat in the same pose, yet they all look very different, according to the medium that has been used. Ballpoint pen on white card, for example, produces fine, crisp lines which are suitable for analysing fur, eyes, or feet, in detail. This can be compared with brushwork on wet watercolour paper, or with charcoal on textured paper. The softness of these two combinations gives a greater sense of light, movement and mood.

From the examples on these two pages, you can see how, by exploring different combinations of medium and surface and then choosing the most appropriate, you can achieve the effect you want much more quickly.

1 Soft pencil on cartridge paper
2 Ballpoint pen on white card
3 Dip-pen and ink wash on thick cartridge paper
4 Brush-pen on wet watercolour paper
5 Charcoal on textured paper
6 Watercolour on watercolour paper

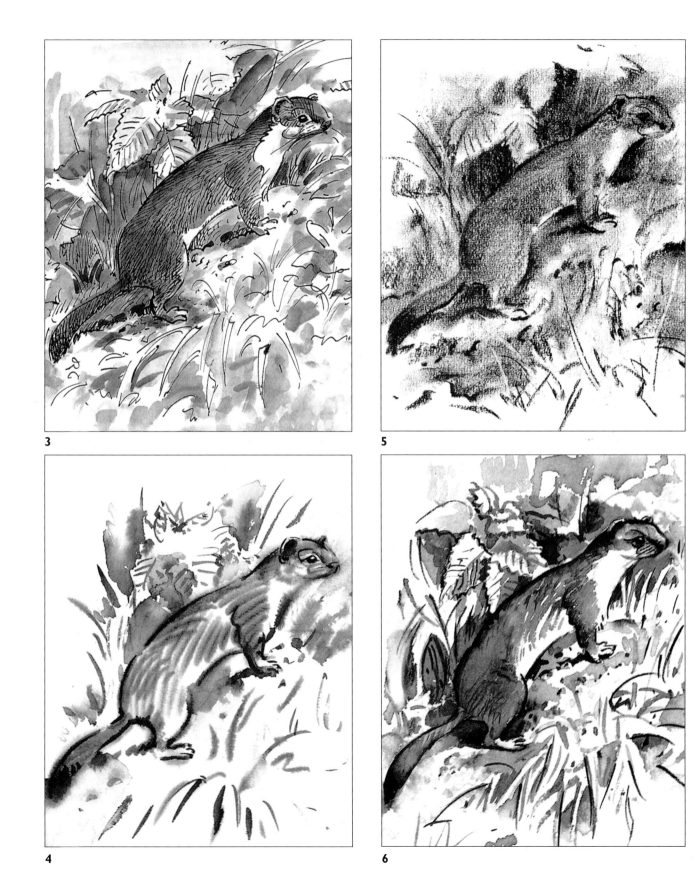

3

5

4

6

Looking at Character

Animals and birds have evolved to make the most of the niches they occupy in the environment. Each activity – swimming, flying, running, grazing or hunting – has defined the form and shape that their bodies have taken, and has given them their own particular 'character'. This section aims to help you to define that character, and to show you how to capture the essence of each animal or bird on paper.

Gulls and owls

On these pages are two contrasting species of bird, a black-backed gull and a barn owl. The owl has a big head and large, forward-facing eyes for hunting at dusk. It holds itself upright, with its rounded wings drooping behind.

The gull, by contrast, has a small head and longer bill, and long, narrow wings for gliding along breezy seashores. It holds its body horizontally.

Drawing a gull

The gull's folded wings form a long triangle. When it is alert, its long neck forms another one and the wedge-shaped head suggests yet one more. This simple format summarizes the gull's shape, which can then be elaborated by defining the feather masses. Details derived from your sketchbooks or photographs can be added, such as the small eye, the knobbly 'knee' joints and the hatchet-like beak.

1 This sketch shows how to begin a drawing of a gull. Start with just three triangles, hinting at the position of the legs.

2 Within the triangles, you can now begin suggesting the wing feathers, and defining the wing tips which reach well beyond the tail. Note how the base of the bill curves down and reaches back under the eye.

3 Work freely into your drawing, using a fluid line to add details such as the 'knees' and the webbed feet. This drawing was produced with dip-pen and ink. A wash of neutral tone was then added to introduce shadow and 'colour' on the back, but leaving white edges on the feathers.

Drawing an owl

For the barn owl, nothing could be easier than to start with a circle to represent the bird's head, and two lines from either side of it, meeting below, for the wings. The design is assisted by the helpful shape of the heart-shaped facial disc which can be added immediately to the circle. Again this simple shape can be worked into by carefully describing feather masses, and details such as the large eyes, the beak, legs and feet.

1 Begin your owl by lightly drawing in a circle for the head and lines for the wings. These can be erased or drawn over later. A horizontal line can be used to establish the position of the eyes, and the slant of the perch suggested to 'place' the bird in its setting.

2 To establish the beak's position, divide the heart-shaped facial disc vertically. You can now make a start on the feather masses, and begin delineating the legs and feet.

3 To complete the drawing, details such as the toes may be added, as well as tone to suggest shadow. Feather edges and feet may be strengthened, and the eyes darkened, leaving a white area within them to suggest the highlights.

The blackbird

The familiar blackbird makes itself useful to us by consuming quantities of insect pests and fallen fruit. Its shape is sleek and aerodynamic. The head fits snugly into the body and extends into the long tail, which is raised when the bird is alarmed.

Drawing a blackbird

The simplest approach to drawing the basic shape of the blackbird is the time-honoured device of an egg-shape for the body and a smaller 'egg' for the head, overlapping the body at the neck. The line of the tail can be found by dividing the body longitudinally. The legs emerge from just behind the belly. Although the bird will move its head and point its bill in many directions, it usually carries it a little upwards, which gives it its jaunty look. The eye is situated above the bill and near the mouth opening.

The blue tit

These attractive little birds are regular visitors to the garden feeder, so there are plenty of opportunities to draw them.

The heads of smaller birds are larger in proportion to their bodies than those of bigger birds. Care with this aspect will give your drawings a correct sense of scale. The same 'two-egg' principle used for the blackbird applies to drawing their basic forms, but you can let the head overlap the body more – making them even more compact than the medium-sized blackbird.

I Begin your drawing of a blackbird with two egg-shaped ovals, adding a line to establish the angle of the tail.

2 The head can now be joined to the body in two flowing lines, from crown to nape, and from chin to breast. Visualize the larger shape of the wings as wrapping around the body.

3 When you are happy with the basic outlines, erase unwanted lines and develop details, such as eyes and feather forms.

Drawing a blue tit

The blue tit has marked colour divisions in its plumage that not only characterize it but also help us to sketch it. Its head can be seen as mainly white, with a blue top-knot and a stripe running through the eye to the small bill. The cap is slightly crested and the neck feathers fluff out, giving its circular form a bull-necked appearance – thus the line from crown to primary feathers appears to be almost straight.

Its rear claw is slightly longer than the front ones and trails down. The foot from the front can be rendered with four pencil strokes.

Compare the ovals used to build up the blue tit in these charcoal drawings *(right)* with those in the blackbird opposite.

Seen from the front, the basic shapes of the blue tit's head and body become more circular, overlapping concentrically *(above)*.

Artist's Tip

Perching birds have three toes at the front of their foot and a larger one at the back, like a thumb. When drawing their feet, it helps to think of them as 'fists' grasping the twig.

Ducks and herons

Unfolding spirals, wave motions and whiplash lines all convey a visual sense of rhythm. If you can capture something of this rhythm, it will give your drawings a real sense of life. The mallard duck and the grey heron, both inhabiting the same wetlands, exemplify this rhythmic flow of line.

Drawing a mallard

These unfolding spirals are especially obvious in the body of the mallard. On this page, you can see how the expressive character of such a bird can be composed from curving lines. The essence of its outline can be simplified into two basic shapes – a question mark for the head, and a tear-drop shape for the body.

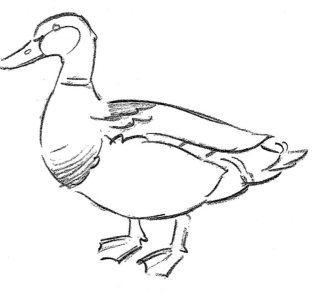

1 The mallard's body is a series of spiral sweeps, starting from the eye and going around the cheek, under the chin, over the crown, and down the back of the neck. This is echoed by a wider sweep over the breast, under the belly and around the flank, expressing the fullness of the bird's form. The back, too, curves subtly off towards the tail. The legs are set back slightly.

2 The bird's plumage divides into convenient coloured areas. Building these up will help you to understand feather masses.

3 Add in tone to complete the duck. Using contoured strokes will enable you to stress the roundness of the the body and give it a sense of three-dimensional form.

Drawing a heron

Since it is a fish-eating bird, the grey heron's beak is like a spear, unlike the spoon-bill of the dabbling duck. It has a long, elegant neck and long legs for wading, and remains motionless for minutes, which makes it a good model.

In its neck, the heron has a remarkable vertebra which gives it extra impetus when it snaps forward at lightning speed to catch a fish. This creates the broken S-shape of its neck – an extra element to introduce into its rhythmic form.

2 Begin to build up tone, using your strokes to suggest contours of folded wings. More detail may then be added to joints and toes.

1 Begin the heron's body by establishing the dynamic S-bend of the neck, fitting the small head on it, and lining up the bill with the eye. You can then add fluid, downward-curving lines for the body.

Artist's Tip

The rhythmic lines in a duck or heron correspond to the way in which we naturally move our hands as we draw. Exploit this natural tendency by keeping your wrist loose and flexible and your hand relaxed, and you will find that you are automatically producing the kind of flowing, curving line you require.

3 Complete the details of nostrils on the beak, the highlight in the eye and the black crest on the head. Softer tone may be used to create shadow under the chin and on the legs. Further refinement of feather detail will add to the solidity of the bird.

25

The red squirrel

Unlike the comparatively ponderous badger opposite, the red squirrel is almost fairy-like as it runs up tree trunks and skitters through the twigs and branches, balanced by its long tail.

Drawing a red squirrel

When the animal is at ease, its tail is curled up behind it like a question mark. The squirrel seems to be composed of a series of unwinding spirals, starting from its folded haunch and paw and travelling down and around over its back and into its tail. Once you have grasped this main shape, you can work into the drawing with more detail.

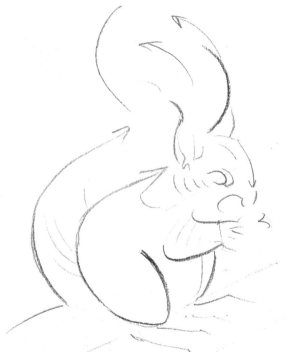

2 Now begin working in the detail (*above*). The squirrel's paws are small, but its feet are surprisingly big for gripping and balancing. Its eye is dark, and the tufts on the ears further accentuate its linear curves.

3 To suggest a sense of roundness and solidity, allow your pencil lines to follow the form of the body (*below*). Details of eyes, ears, nose and paws can be gleaned from drawings in your sketchbook.

1 To begin your drawing of a squirrel, sketch in the main outlines lightly. Notice the line spiralling out from the haunch and over the back. Note, too, how the tail closely follows the back, then curves away and out in counterpoint to the lower body.

The badger

A member of the same family as otters and stoats, the badger is characterized by rhythm and grace. It is a much heavier animal than others in the group but, like all its family, it has short legs and a long body. Its thick, coarse, hairy coat hides its limbs and disguises body movement. Its distinctive shape – the long muzzle, blunt nose, large forehead and long body – gives it a lumbering quality. It has large front claws for deep burrowing and a black and white striped face for night recognition.

Drawing a badger

Although details such as long hair may obscure the animal's body or features, it is important that you try to look for the larger underlying shapes. Exploratory pencil drawings are essential to developing an understanding of form.

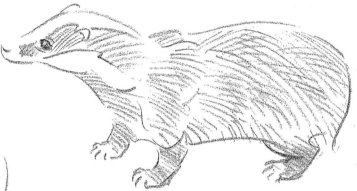

2 You can then work strongly into your drawing with charcoal pencil which creates a dark tone instantly. Note how the pale hairs of the badger's coat have dark tips, which outline the fur masses and seem to radiate downwards from the back.

1 Work out the pose you want in pencil first, emphasizing the forward lunge of the badger's body and the blunt muzzle.

3 Continue working up the badger's coat until you achieve the tone you want. Notice the characteristic white stripes beneath the chin and over the head.

The otter
Like its cousins, the stoat and the badger, the otter has a long body and short legs. Unlike them, however, it has taken to the water; its long tail and webbed feet have developed to steer and propel it as it plunges after fish. It is an intelligent animal and spends much of its time in play.

Drawing an otter
The full length of the otter's body and neck is revealed when it stands, propped up by its 'rudder' tail, to look around the landscape, as shown in the group of pictures on this page.

In this pose the sides of its body are virtually parallel and the tail is at a right angle which makes an easy shape to see, and thus to draw. The small fore-limbs are about one third down its body, and its folded legs occupy about a quarter of the body length. Its head is turned slightly towards us and tilted up, emphasizing its flatness and showing us a view of its muzzle and chin. The small eyes and ears are in line with the nostrils.

In the finished standing pose, its fur is damp rather than wet. This results in a radial pattern which emphasizes contour and delineates roundness and form. The lines of the fur also carry the eye down the flow of the body.

1 Begin your otter with an outline sketch, putting down the parallel lines of the upright form.

2 Work into your sketch, building up the fur and adding details such as the eye. Carbon pencil could be a good medium to use because of its granular depth of tone.

3 To complete the drawing, build up the forms of the round lower limbs, being aware of the way in which they link into the tail, which curves out and around, away from the otter's body. Work over your drawing to bring out the spikes of fur, spiralling and criss-crossing over the body contours, and complete any unfinished details of the head.

The roe deer

A graceful inhabitant of fields, scrub and woodland, the roe deer is a browser of vegetation. For this purpose, it has a heavy muzzle and long legs. It will vanish silently into the undergrowth or bound away if surprised, which is rare for it has a large, dark eye set high on each side of the head for all-round vision and large ears – all especially useful at dusk. In the autumn the stag develops antlers, protected by a 'velvet' covering.

Drawing a roe deer

In the drawings below, you can see a roe deer in an alert but casual pose. The first sketch shows the essential lines which characterize the animal – the high carriage of the head on its long neck, and the solid body for digesting its diet. The hind legs set well back for maximum stride, and the strong hind-quarters suggest that the animal might leap away at any sign of danger.

1 First note down the deer's essential form, in particular, the 'question mark' shape of the leg, and the powerful, linear thrust of the rear of the body.

2 The deer's coat may now be roughly filled in – charcoal is an ideal medium for conveying the velvety quality of the fur.

3 Finally, the charcoal may be worked over with white pastel to create highlights, and background details, such as bushes and grass, may be added.

Looking at Features

On these pages are a few facial features from the infinite variations the animal world presents to us. Take a closer look at them and compare their differences, and similarities. Each of the finished drawings is accompanied by an earlier sketch, showing how the feature may be broken down into its basic shapes.

Eyes
Their shape and colour may vary, but eyes are almost universal in their structure. Both birds and mammals have an eyeball consisting of a cornea, a pupil and an iris. The shape and size of the pupil changes according to the amount of light available.

Owls have eyes mounted to face forward – this is to help them to assess the location of their prey. By night, they can expand the pupil to fill the eye in order to see as much as possible. By day, the pupil contracts to reveal, in the case of this long-eared owl *(right)*, its rather wild-looking iris. When drawing an eye, remember to leave part of the area white for a reflected highlight.

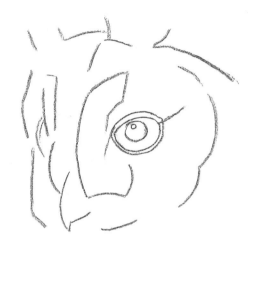

Deer are not hunters, so they must keep a good look-out for predators. Their eyes are large, placed high and on the side for all-round vision. When the animal relaxes, it may semi-close its eye, producing a half-moon shape when the eye is viewed from the front *(right)*. Notice how the bones of the skull have developed to house and protect the eye.

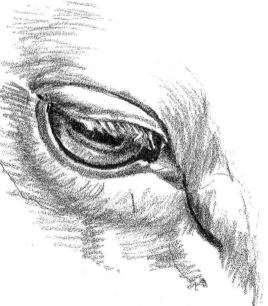

Ears

The ears of birds are concealed under their feathers, but mammals have developed convoluted, trumpet-like structures. Those that are likely to be preyed upon have large ears. They are alive to the smallest nuances of sound – a high-pitched squeak or a crushed leaf can warn of danger.

For the artist, the shapes these organs make assist in giving each animal its own particular character. The drawings here show what to look for – how to construct the ear, and how to give it its distinctive look.

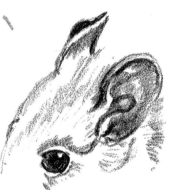

The wood mouse has huge ears in relation to its small bulk *(above* and *right)*. They are round and relatively simple in form.

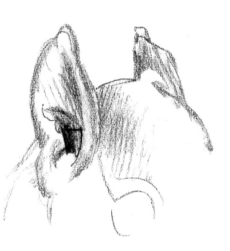

The squirrel's ears *(far left* and *left)* are leaf-shaped and pointed. Seen from this angle, the ear at the back appears to fold over on itself, in a figure-of-eight.

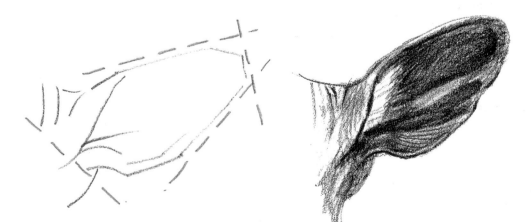

The deer has large, wedge-shaped 'flappers' *(right* and *far right)* that move constantly to focus on and evaluate sounds.

Noses and beaks

Noses and beaks can vary enormously in shape, as you can see from the drawings here. Nothing could be more different than the noses of the polecat and the fallow deer, for example. The two fish-eating birds – the puffin and the grebe – demonstrate how different beaks can be, even when the birds pursue similar prey.

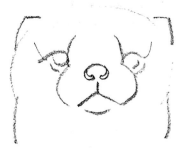 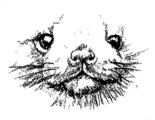

The deer's muzzle *(below and below right)* is bulky and square. The nostrils, again teardrop-shaped like those of the polecat, are large to scent and to take in air, and the jaws are large for cropping herbage.

The polecat's small nostrils and muzzle *(above and above right)* are typical of the Mustelid family. The nostrils fold under the button nose like two teardrops, and the division in the upper jaw almost links up with them.

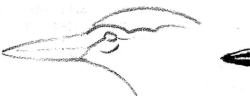 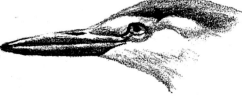

The grebe catches fish singly to bring back to its young. Its bill is dagger-like, and its head narrow *(far left and left)*. Notice how the eye is linked to the bill.

The puffin's bill is triangular – a simple extension of its chin and forehead *(right and far right)*. The bird is capable of carrying a number of fish crosswise in its beak to bring back to the nest.

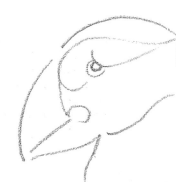 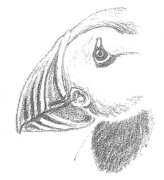

Feet and claws

Perching birds have a long hind toe, and three toes at the front, to enable them to grip twigs and branches. Game birds, being mainly walkers, have largely dispensed with the hind toe. They have three large toes at the front, each with two joints; the middle toe is longest.

Mammals have evolved differently. The rabbit, for example, has paws with four toes at the front, the rear one having become redundant. Badgers have powerful feet with long claws for digging, rooting and burrowing. The claws radiate out over the pad. With its modified cloven hoof, the deer walks virtually on tiptoe.

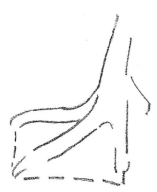

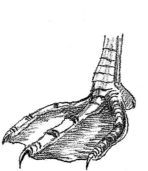

It is easy to work out the way the web on the duck's foot is to be drawn:

simply join up the three toes at the tips (*above left* and *above*).

When drawing rabbits' feet, you need only hint at the toe divisions as the close fur obscures details (*right* and *below*).

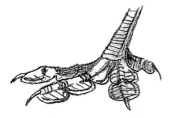

The bone structure of a coot's foot (*left*) is similar to the duck's, but the bird has developed a different means to propel itself through the water. Its toes are palmate, equipped with individual paddles which give them the appearance of leaves with a stalk. Remember that the far 'leaves' will be hidden when viewed from the side.

The fur on a badger's foot (*left*) is dark but glossy, so there is an arc of highlight on it over the toes.

When spread, a bird's foot forms a 'stand' to support it, as in the foot of this perching bird (*right*).

In the deer's foot (*right*), two toes have become a 'cloven hoof', the redundant toes lying up the leg. The deer walks as if an imaginary heel is supporting the foot.

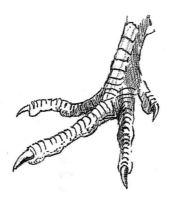

Structure and Form

The process of drawing birds and animals is made a lot easier if you understand something of their physical structure.

Wings and feathers
Birds have individual feathers that are laid over each other, like roof tiles, to resist wind, rain and dust, yet slide open to provide aerodynamic surfaces for instant flight.

Around the head, the feathers are small and close-fitting, and are almost indistinguishable from one another. They get generally larger towards the wing-tips and tail. They fall into recognizable masses, a feature which makes it easier to produce quick sketches, and means that you don't have to draw every feather.

When a bird's wing is folded, the flight feathers – the *primaries* and *secondaries* – slot under the upper wing *coverts*; these then slide under the *scapulars*, which in turn slide under the *mantle*. When closed, the feathers in the tail slip away under the middle and widest tail feather. In flight, the wing feathers are fully extended and the various feather panels are clearly visible.

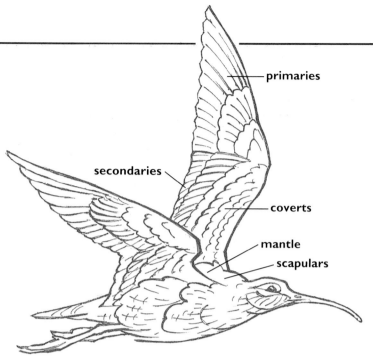

primaries

secondaries

coverts

mantle

scapulars

When drawing a bird in flight, you will find it useful to imagine the wing as a solid shape, like a knife, cutting the air. You can place less emphasis on the feather detail than I have in this pen-and-ink drawing of a curlew (*above*), and more on capturing the lines of feathers that most help the feeling of buoyancy.

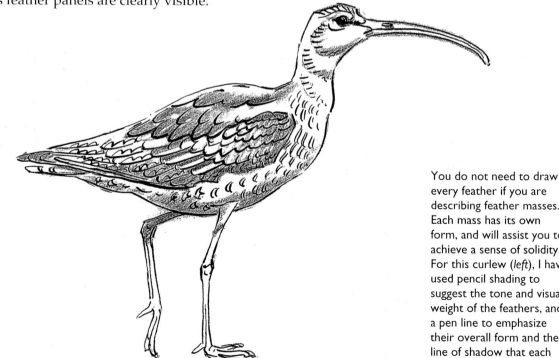

You do not need to draw every feather if you are describing feather masses. Each mass has its own form, and will assist you to achieve a sense of solidity. For this curlew (*left*), I have used pencil shading to suggest the tone and visual weight of the feathers, and a pen line to emphasize their overall form and the line of shadow that each feather creates.

Birds' legs

Initial confusion may attach to the bird's backwards 'knee'. A bird's leg works very much like the back legs of most four-footed animals; it is just that we cannot see the thigh and all of the *tibia* (the part of the leg below the bird's real knee) – they are hidden by the flank feathers, as I have shown in the drawing of a wheatear below. What looks like a knee is actually the joint at the top of the *tarsus* – which, in turn, is really an extended foot, the bird's 'foot' being formed from its toes.

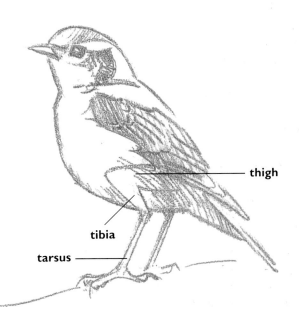

I drew this wheatear (*right*) with a 2B 'clutch' pencil which gives a fine and continuous line. I suggested tone with 'cross-hatching', or overlapping strokes. I have also shown where the 'knee' would be if it were not covered by flank feathers.

thigh

tibia

tarsus

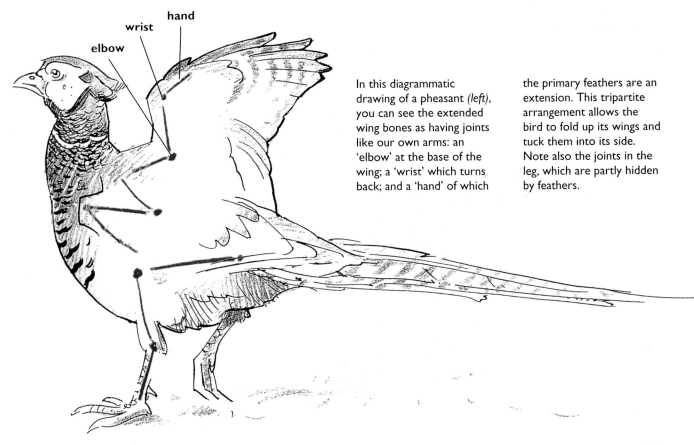

elbow

wrist

hand

In this diagrammatic drawing of a pheasant *(left)*, you can see the extended wing bones as having joints like our own arms: an 'elbow' at the base of the wing; a 'wrist' which turns back; and a 'hand' of which the primary feathers are an extension. This tripartite arrangement allows the bird to fold up its wings and tuck them into its side. Note also the joints in the leg, which are partly hidden by feathers.

Shaped for survival

The appearance of each animal is determined by the niche it occupies in the natural world. Animals divide roughly into hunters and the hunted, and this has a strong influence on the structure of their body.

The deer, for example, is one of the hunted. Forever on the look-out for danger, its main survival tactic is rapid escape. To this end, it has developed long, springy legs which let it flee quickly from any threat. Its nimbleness is further enhanced by the fact that it stands 'on its toes' all the time, like a ballet dancer. The bones of the foot begin higher up, and this accounts for the angle at which the foot joins the ground.

If you study the drawings below, you will see that, as with birds, the bone system of the deer's rear and front legs is tripartite; an angular Z-shape which can fold up or straighten out.

Suppleness and strength

The elasticity of the deer's body depends on the suspension of its bone structure and the large muscles which control it. The muscles controlling the legs work around the bones, developing into ligaments attached to leverage

extensions on each joint. This is particularly noticeable in the rear leg where the animal needs to have most power.

Adapted for grazing

Because the deer is a grazing animal, its body has a large rib cage to contain two stomachs, a long neck to browse vegetation, and a long jaw with which to chew it.

The redundant toes in the deer's cloven hoof are visible as knobs protruding behind the leg (right). This actually gives a high-heel-shoe effect to the shape of the foot. The two bones leading to the hoof are visible under the hide (far right).

These two drawings show, in approximate form, the disposition of muscles (below left) and bone (below). The bulk of muscle is found at the top of the limbs on the thigh where the strength is needed. Knowledge of this underlying structure will aid your drawing.

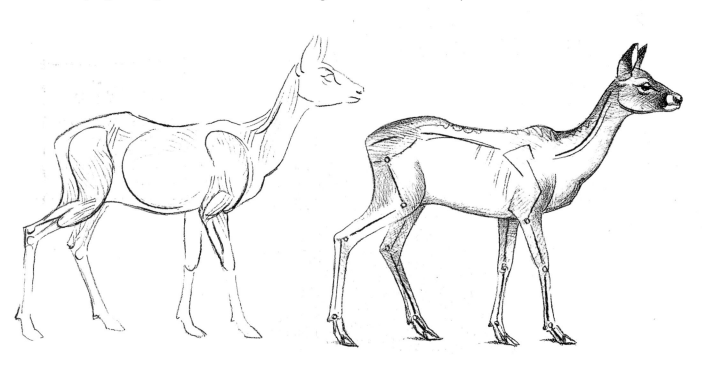

Short profile

The rabbit is another gourmet of herbage. Being a rodent, it nibbles grass with its front teeth, the upper two being highly developed. It digests these small scissored pieces without much chewing, so its jaw – and hence its profile – is shorter and more compact than that of the deer. It shares the characteristic features of grazing animals – the large eyes and ears with which to detect danger.

Flexible legs

Like other mammals, the rabbit has a three-part bone articulation in its legs which makes them very flexible. It has short front legs which enable its mouth to reach down to the grass easily. When standing or crouched to graze, it rests on its well-developed feet for stability, its legs folded on each side like a cat's.

When it stands up, its front legs straighten out to support it. Its long feet force it to hop when it moves and to bound when travelling at speed, using its toes.

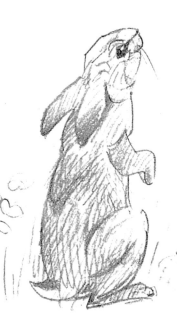

I drew these rabbits with a 9B pencil, using the technique of cross-hatching. I began with long strokes curving across the body to suggest contour. I continued with shorter strokes and smaller dashes to suggest the texture of fur, and used more pressure on the pencil to deepen the tone of the eye.

Artist's Tip

Use the rhythmic Z-shape of a mammal's leg as a useful way of introducing a sense of movement into action poses.

Proportion

To produce convincing drawings of birds or animals, it is essential to get their proportions right – the way in which the different parts of the body relate to each other in size and shape. Although, in reality, proportions remain constant, they may *appear* to alter depending on the artist's viewpoint. This is all due to an illusion known as *foreshortening* – the telescopic effect that occurs when you look along an object from behind or in front, rather than from the side.

The effects of foreshortening

On this page, I have used the stoat to illustrate how foreshortening affects proportion. Because it is not always easy or convenient to draw from a live animal, these studies were based on a stuffed specimen, of the kind available for reference in museums.

Any cylinder, as it turns towards us, becomes compressed in shape. In this foreshortened front view, we can see the stoat becoming a series of concentric circles. Viewed from the front, the head

and 'bib' obscure most of the body, and the front legs and feet dominate.

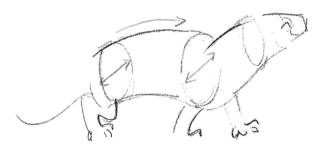

These drawings were done quickly in conté pencil, which produces a charcoal-like textured line. Side-on,

the stoat presents us with a body shape that you can visualize as two long cylinders (*above*).

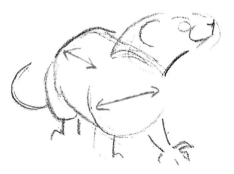

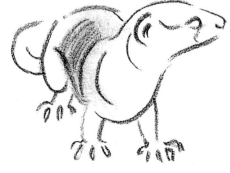

In this three-quarter view, the body cylinder is only partly foreshortened. Seen from this angle, the Z-bend

of the rear leg is not visible and is reduced to a knee bulge instead, with the foot projecting beneath.

Changing shapes

Many birds, such as the duck family, have round bodies and heads. The male tufted duck – in the foreground of the drawing at the bottom of the page – is a glossy black, relieved by well-defined, white flank panels. These fold around the body, half covering the wings. The female behind him shows the high forehead typical of the diving ducks. From the front view, we can see the prominent cheeks on either side of the bill – the eyes have all but disappeared.

From the side, a duck's body looks almost fish-shaped. When the bird swims towards us, however, the shape becomes compressed – a foreshortened, wraparound effect. The wing tips and tail are concealed from us, and the breast area takes up most of the body shape.

As these sketches (*right*) show, I began building up the foreshortened front view of the head with a figure-of-eight line, adding the pyramid-shaped bill. As the head turns, the three-quarter view reveals the eye and shows the full shape of the bill.

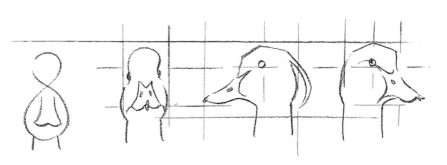

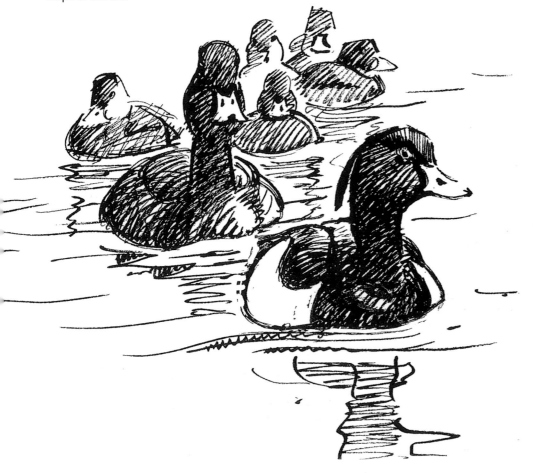

All the ducks in this drawing (*left*) are swimming towards the viewer, and hence have foreshortened bodies. I have, however, used a variety of head positions. This helps, especially with the ducklings, to convey the jerky character of their movements. I sketched the birds quickly in pen line, using a fibre-tipped fountain pen. This gave me interesting variations of thick and thin lines.

Looking at heads

Whether we are looking up or down at a bird or animal, perspective plays its part in defining shape and proportion, and in determining the positioning of individual parts in relation to each other. I have illustrated how this works with various studies of otters' and rabbits' heads.

Placing of features

In the case of the smaller mammals, we usually view them from above, which means that the perspective lines will slant up towards us – rather than downwards – as they converge towards the 'horizon'.

You can see the effects of this in the otters' heads at the bottom of the page. When viewed face-on, the otter's ears and eyes are almost level, so that they fit into the section above the muzzle. When seen in three-quarter or side view, however, the perspective changes, so that the further eye lies higher up the head than the nearer one.

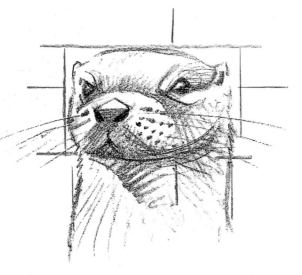

The rectangle I have drawn around this otter's head (*above*) demonstrates the proportion of height to length. I've marked off a line for the eye which, in this view, shows it to be near the nose.

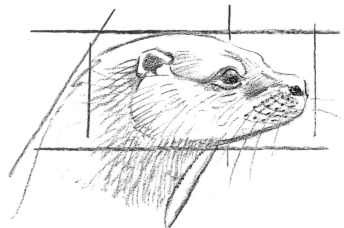

This side view of an otter's head (*above*) has none of the compressed foreshortening of the head on the left.

We usually look down on swimming otters (*below*). When they are moving directly towards us, their eyes are level. When turned sideways, perspective lines rise to meet the horizon so that the far eye and ear will be higher than the near ones.

Prominent features

The drawings of rabbits' heads below again demonstrate how radically perspective and foreshortening can alter shape, and the relative placing of features. Notice, too, how different parts become more or less prominent, depending on where they are viewed from.

Seen from the front, the rabbit's muzzle is prominent, but, when the animal turns its head to the side, the cheek appears larger and assumes greater importance. Seen from above, the rounded forehead dominates.

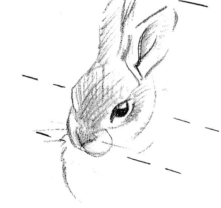

From the side, the rabbit's head presents a full triangular shape *(far left)*; in the front view *(left)*, the muzzle is compressed and appears proportionately larger; while from the rear *(right)*, it becomes so foreshortened as almost to have disappeared.

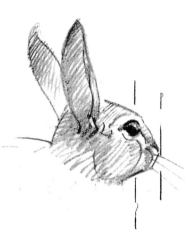

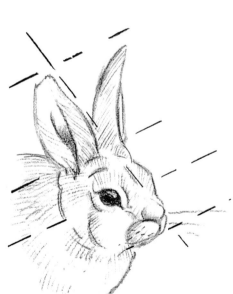

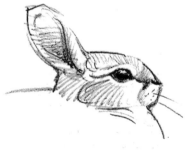

These three rabbit heads *(above)* show how perspective affects the relative position of features such as eyes, ears and nose, depending on the onlooker's viewpoint.

Artist's Tip

Young animals have different relative proportions – the eyes being larger, and ears and noses smaller than their adult counterparts.

Light and Shade

Once you understand how light falls on birds and animals, you can create atmosphere and mood. Light cast from the side, for instance, suggests evening and tranquillity; strong sunlight can bring out solidity so that your images jump from the page.

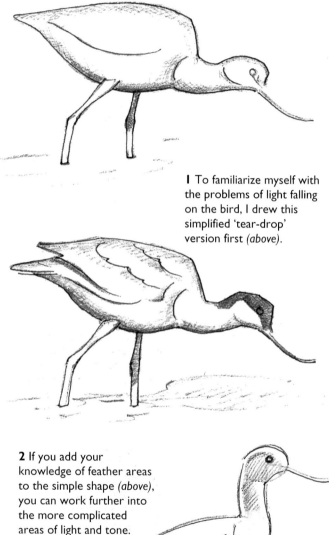

I To familiarize myself with the problems of light falling on the bird, I drew this simplified 'tear-drop' version first *(above)*.

2 If you add your knowledge of feather areas to the simple shape *(above)*, you can work further into the more complicated areas of light and tone.

I In this simplified model of an avocet *(right)*, the light is falling from above.

Light direction

When you start your drawing, you should first decide what direction the light in the picture is coming from. The studies of an avocet below show how a different light direction affects the mood of the finished drawings. Notice that the parts nearest to the light source are the brightest; as the light glances away over and under the body, the form gets darker, with the darkest areas underneath.

Variations in light and shade

In the midday sun, the bird's upper parts will be brightest, and the shaded areas will progressively darken under the wings, tail and body. If a bird is mostly white, however, like the avocet, it may reflect light from the ground, which will lighten the tones on the underparts.

Plumage colours, and sometimes glossy feathers, make the patterns of light and shade quite complicated. Take your sketchbook with you when you go out, to note all the variations.

2 Here *(below)*, you can see how the contrast between light and shade is often strongest where they meet – though any reflected light will shine back into the shadow and mitigate the tone.

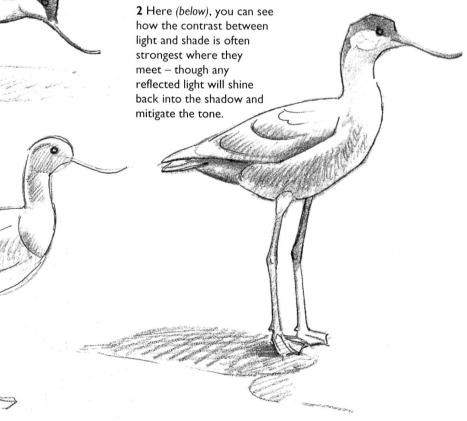

Light and shade on fur

When you come to draw mammals you can see that the same principles apply to them as to birds. This is complicated, of course, by the varied textures of fur – glossy or rough, long or short. If light glances along the fur, its tone is lighter. If the fur is raised, as it often is on folded limbs, then the light disappears into the fur and the effect is dark – you can observe this on your own domestic tabby.

The fox below is lit from behind and above. Again you can do a simple study to work out the main tonal areas. The study reveals how the neck fits the body, how the ears will take shadow and the way in which they, in turn, cast shadow on the forehead. The darkest areas are under the tail and legs where there is little reflected light. The fox's underparts tend to be lighter and its 'bib' is white, so there is opportunity to include reflected light which will give greater luminosity to your drawing.

In the drawing of the vole, the most interesting area is the head where the big ears take the shadow, the cheek is lit up, and the large spherical eye casts its own shadow on the nose. Its fur is glossy – note the shadow under its tail and deeper tones between its rump and the ground it is on.

1 Even a small mammal like this vole can be divided up into areas of light and dark.

2 The completed drawing of the vole: note how the shadow beneath it 'anchors' it to the ground.

1 I began this drawing of a fox by doing a simplified model, in which I blocked in the main areas of light and shade (*below left*).

2 I finished the drawing with cross-hatched lines to convey the fur's thickness, leaving a highlight along the rump and tail (*below right*).

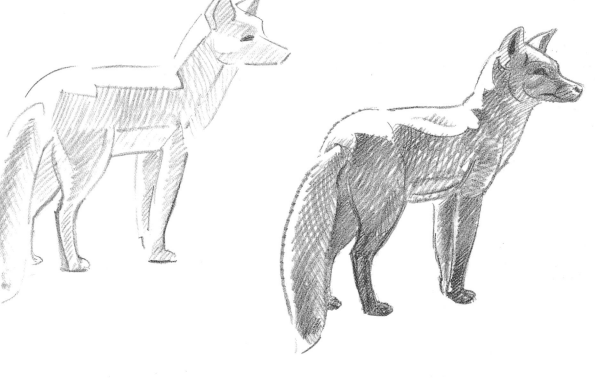

Texture and Pattern

To depict texture, you need to convey a sense of what it *feels* like to touch a bird or animal – does it feel smooth and silky, or rough and prickly, for example?

Looking at fur

Fur can be matt or glossy, depending on the length of the coat. Glossy fur reflects the light around it; matt fur, as you may have observed from your pets, reflects light when it lies flat but absorbs it when it is ruffled.

The pine marten, shown on this page, has long, fluffy hair along its body, limbs and tail. The darkness of tone along its back is matched by that of the hairs raised on end when the limbs are folded. The light disappears into the hair. On its head, the fur is glossy and short, and appears dark or light depending on the growth direction.

When you have decided what 'kind' of fur you are dealing with, you need to choose materials that will produce a similar effect. To create the silky-soft look of the marten's coat, I used a watercolour wash, with several brushes: the chisel, or square-tipped, the point, and a 'rigger' or 'liner' brush, which gives long, fine lines and is very useful for making the gestural rhythmic curves I needed here.

Pine martens are rarely seen – this is where it is useful to tape any video footage from wildlife programmes.

To do these drawings (*above* and *below*), I worked from a number of photographs. I did some careful pencil drawings beforehand to work out the final poses.

Before beginning the finished pieces, I damped the surface of the 'not' watercolour paper. I mixed up a wash of neutral colour (Payne's Grey would do), and made sure that my brush was fully charged with paint before each stroke. I controlled the spread of paint in some lines by mixing it with gum arabic instead of water.

Depicting spines

To look at spines closely is like examining a magnified area of normal fur, and it shows some of the same characteristics. The hedgehog is a very familiar 'spiny' animal: it has evolved its protective coat by combining clumps of hairs (almost as if they had been glued together) into spikes. These can be raised to form a prickly barrier to ward off attack.

On the right, the artist has done a close-up study of these spines end-on. As we look into them, light is absorbed into the coat, as in all up-ended hair. As the light glances over laid-back spines, it is reflected and so the area appears lighter. In the case of the hedgehog, this effect is further enhanced by the pale tip to each spine.

In his sketch of the complete animal below, the artist has conveyed these spotty highlights and dense shadows with a series of pencil marks,

some of which are large dots of tone along and under the side. He has then used lighter dashes as the eye moves over the animal. The 'skirt' of long hairs is light in tone and he has treated this area with restraint.

In his study of the 'portrait head', the soft pencil demonstrates the wide variety of possible textures of eye, hair, hide and bristle. The eye is glossy and deep, the hair around it conveyed with short light strokes, and the flow of spines over the back consists of thicker strokes, drawn with heavier pressure.

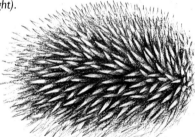

Here *(right)* lines of varying lengths and thicknesses convey the subtle variations in the hedgehog's coat.

I This sketch *(below)* captures the hedgehog's essential form.

Flecks of white paint have been used to highlight the tips of the spines *(right)*.

Artist's Tip

Always do a light sketch first — working out which area you intend to concentrate on. This will help you to decide where to put your pencil strokes and textures.

2 In the finished drawing, the artist has indicated the spines with a series of densely black, pencil dashes *(right)*.

Looking at pattern

An extraordinary variety of pattern and colour
has evolved in the animal world. Sometimes this
serves to advertise the presence of a bird or
animal – sometimes to conceal it.

Pattern can vary depending on the season. The
great northern diver, for example, has a lead-
grey plumage in winter, but in summer it dons a
smart, black and white, speckled dress. This
advertises to a prospective mate that it is in good
breeding condition. It also has a double effect as
'dazzle' camouflage.

On this page, the artist has investigated the
diver's patterns and how they blend and distort
with the ripples around it, creating patterns on
the water surface. The bird's neck is divided by
a double collar of white, with black pinstripes
linking up with those on the white breast. The
speckles on its back are formed by the white
centres of the feathers – these white dots and
dashes radiating over the back imitate the ripples
among which the bird swims.

1 The artist has drawn the
image lightly in pencil to
begin the drawing (*below*).
He has worked heavily into
the black areas, taking care
to avoid the white panels in
the radiating feather
pattern.

Artist's Tip

*You can use good
identification guides and
photographs to assist
your understanding of
complex plumage like
this. When you manage
to see the real thing in
the field, you can
compare and contrast it
with your previous ideas.*

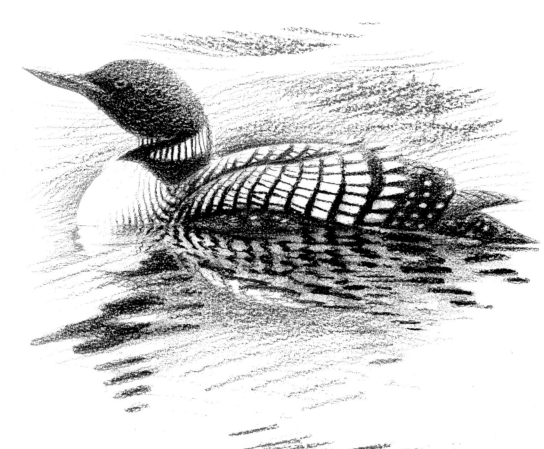

2 To complete the drawing,
the artist has used graphite
stick and charcoal. By
exploring and exploiting the
qualities of these media, he
has been able to express
the feeling of the scene.
Charcoal captures the
depths of black plumage –
graphite the grey waves
around it.

Pattern for concealment

Pattern can be used for concealment by enabling an animal to blend in with the background, as, for example, with young deer or female ducks. At other times, concealment is achieved by breaking up the body shape with bold splashes of contrasting tone. This is called 'disruptive' camouflage.

The long-eared owl on this page relies on what is called 'cryptic' camouflage. Its intricate arrangements of speckles and tones aim to imitate the tree bark and dead leaves among which it roosts by day. This disguise is highly effective – the bird remains well hidden, as anyone who has tried to look for it can testify.

Such cryptic patterns are often breathtaking in their harmony and subtlety. Here, the artist has made careful studies of the owl, one of its feathers, and the wing feathers. He has investigated the way in which the individual designs on each feather echo each other to form a repeating pattern.

To convey the richness of the patterns, he has exploited the qualities of a soft 6B pencil combined with a 'not' watercolour paper that has a slightly rough surface.

In these two richly textured drawings of an owl and its plumage *(above* and *below)*, you can see how the pattern is created not only by the markings on the feathers, but also by the way in which the feathers overlay each other, in strongly contrasting bands of black and white.

This beautifully detailed study clearly shows the speckles and stripes on a single feather *(below)*.

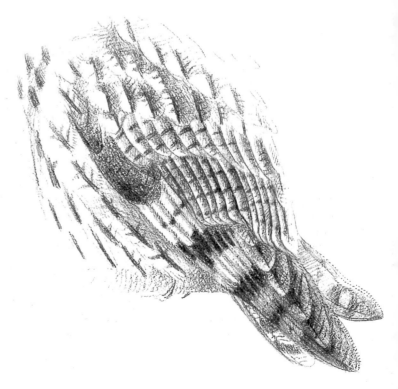

Behaviour

One of the most exciting activities for the wildlife artist is the opportunity to observe and capture the action and drama of animal behaviour.

On such occasions you will sometimes need to scribble for all your worth to get what you have observed down on paper; at other times, you must just sit, observe and commit as much to memory as you can. You will be surprised how much you can remember and re-create if the situation has impressed you.

Portraying aggression

In the drawings on this page, the artist has caught the aggression display of the capercaillie, as it defends its territory. This big gamebird is often brave enough to rush at any human being whom it considers to be an intruder.

In order to appear intimidating, the capercaillie tries to make itself look even bigger – hence the ruffled chin and neck feathers, and the fanned-out tail, like that of its relation, the turkey.

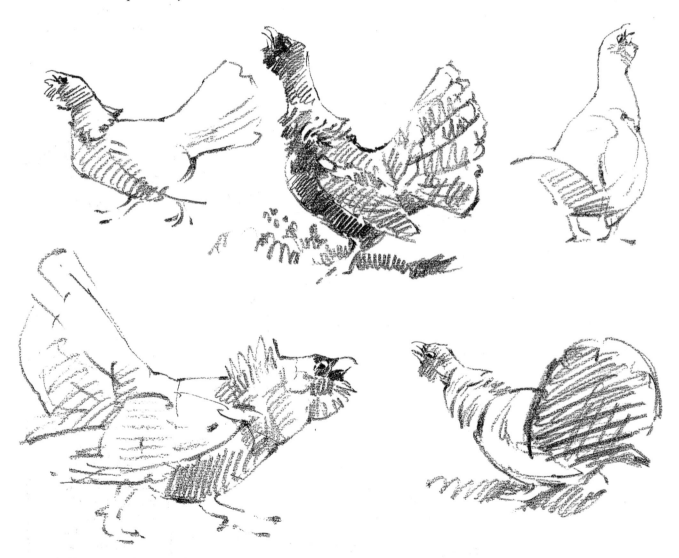

For these sketches, the artist used a soft conté pencil to get line and tone down quickly.

To save time, he has scribbled in areas in some places, and has quickly noted the big shapes, such

as the triangular, side-on forms of the wings and tail, the extended neck and squarish head. From behind,

the tail is semi-circular. The legs and feet are simply rendered as marks and lines, indicating position.

Sketching a mating sequence

On this page, the artist has used a 9B pencil to make quick notes on the mating behaviour of a pair of great crested grebes. The softness of the pencil can put down line tones without effort.

Once rare, these grebes are now fully protected, and the species is a common sight on lakes and rivers, where it dives after fish. It is graceful and exotic; in summer it has a crest and a 'tippet' of dark feathers around the neck that can be raised when the bird is alarmed or excited.

In the first drawing, we see the pair swimming towards each other. In the second drawing, the ritual begins: the male rests, his head and long neck coiled back into the body, while the female elicits a display response from him by grunting and rigidly extending her neck over the water-line. After displaying to each other like a pair of book-ends, the male adopts a typically serpentine pose as they are about to mate.

These sketches (*above, left* and *below*) are small in scale – they are meant to jog the memory for more ambitious works later. It is amazing how useful such notes, the product of a short time spent observing, can be.

Artist's Tip

Sometimes it's better to relax and simply observe. Get your impressions down as soon afterwards as possible. You may miss something if you draw on the instant.

Capturing a fleeting pose

Few things epitomize the exuberance of spring as much as a party of 'mad March hares' gathered together in frenzied activity to mate in the pastures.

Often it is not so much the males fighting to establish dominance as the females repelling the advances of unfancied males that causes these 'boxing matches'.

To begin with, it will be difficult to capture these exciting but rapidly changing poses. The first thing to note is the one feature that is common to all – the typically upraised ears. Your increasing understanding of animal form will allow you eventually to fit the limbs and their articulations into all sorts of unexpected positions.

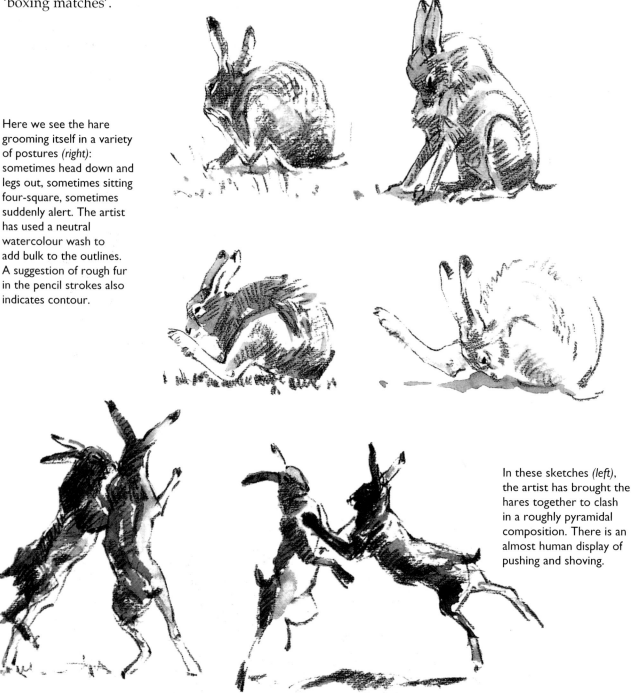

Here we see the hare grooming itself in a variety of postures *(right)*: sometimes head down and legs out, sometimes sitting four-square, sometimes suddenly alert. The artist has used a neutral watercolour wash to add bulk to the outlines. A suggestion of rough fur in the pencil strokes also indicates contour.

In these sketches *(left)*, the artist has brought the hares together to clash in a roughly pyramidal composition. There is an almost human display of pushing and shoving.

An ideal subject

The fallow deer is larger and bulkier than the roe. Its antlers are long and wide, spreading in area like outstretched wings. It is commonly kept in parks, which makes it a convenient subject for drawing. The studies below were done from sketches and worked up to finished drawings. The artist has used a medium-soft pencil – a 4B – and worked on watercolour paper which adds its own texture to the strokes.

Looking at grooming behaviour

On the right, we see a study of the animal grooming, in which the leg is brought forward to scratch at its nape. You can see clearly how the the front legs spread to counterbalance the action and to prevent the animal toppling over.

Looking at mating behaviour

In the autumn, the stag gathers a group of hinds and the rut takes place. In the drawing at the bottom of the page, we see fallow deer pre-nuptials where the stag caresses the doe, testing by scent to see if she is ready to mate.

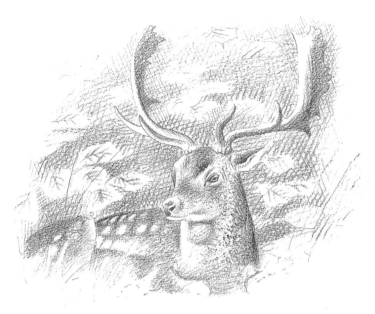

The artist has used a dark conté pencil on rough paper to express the solidity and textured hide of the fallow deer. He shows a stag resting up during the day, concealed among foliage *(top)*; a deer grooming *(centre)*; and a pair about to mate *(below)*.

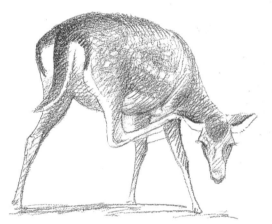

Movement

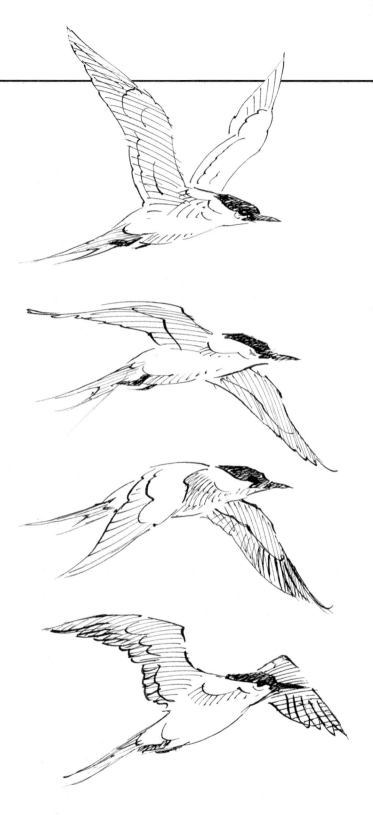

Birds and animals are constantly moving – even at rest, they may engage in grooming, for instance; it is only in sleep that they totally relax. When they are out and about – walking, running, trotting or flying – their movement creates a rhythm. This rhythm is determined by the length of their steps, or the number of wing-beats required to keep them aloft.

The tern in flight

On this page I have drawn four terns, sea birds that live by diving from a height into the water to catch small fish. Terns have long wings and aerodynamic bodies to make use of the wind. They often need only a few shallow strokes to propel themselves along, whereas smaller birds, such as the sparrow, have to use sheer wing-power to get them from A to B.

Flight sequence

Each tern demonstrates a stage in one of its millions of wing-beats. As the wings begin the down-beat in the first drawing, we see the feathers of the under-surface pressed close together to create a solid plane. The wings are fully spread in a high V-shape. You can see feather details on both upper and lower surfaces of the wing.

The second bird shows the wing descending and the *pinions* – the primary feathers – bending up with the downward pressure. (The pinions give the flick to the wing that drives the bird forward.) The bird's head rises a little.

The third bird shows the wing at its lowest position, with the pinions bent up. The head is held high. Once more we have views of the upper and lower surfaces. The nearest wing is foreshortened because we are looking along it.

In the fourth drawing we have a view of the wings being raised on the upstroke – ready to return to position one. At this stage, the wing feathers are looser, allowing air through them to reduce upward pressure and to gather air to press on for the downstroke.

I used a fibre-tipped fountain pen with a calligraphic point to draw these terns. The calligraphic nib gives the stark line interesting variations of pressure and thickness. I did a few light pencil strokes first to guide me; I then used whiting-out fluid to erase any pen lines I didn't like. Note how the wing position of the fourth bird means that the arm of the far wing is concealed by the body.

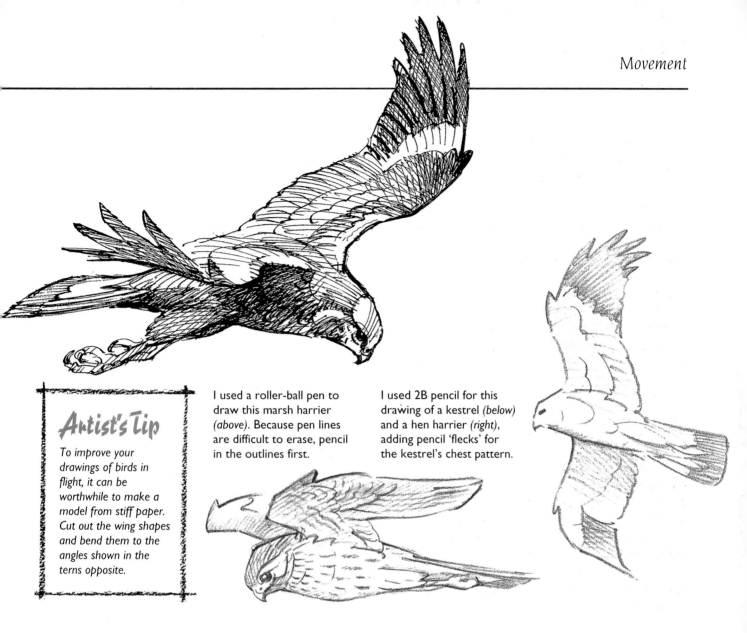

Artist's Tip

To improve your drawings of birds in flight, it can be worthwhile to make a model from stiff paper. Cut out the wing shapes and bend them to the angles shown in the terns opposite.

I used a roller-ball pen to draw this marsh harrier *(above)*. Because pen lines are difficult to erase, pencil in the outlines first.

I used 2B pencil for this drawing of a kestrel *(below)* and a hen harrier *(right)*, adding pencil 'flecks' for the kestrel's chest pattern.

The marsh harrier in flight

Soaring on thermals, hovering on the wind, or dropping dramatically on their quarry, birds of prey are the great masters of the air currents.

On this page, I have done a pen drawing of a marsh harrier, poised on the breeze. The bird works slowly upwind. It uses its sharp ears and eyes to scan the reed beds and hunt down its prey. (Peering, head-down, is a characteristic of many hawks. Other birds, such as pigeons and waders, fly with their heads up.)

The drawing shows the near wing end-on so that it is extremely foreshortened: the long 'fingers' of the primary feathers, the zig-zag of the bent wing with its elbow and 'wrist' become condensed in shape.

The hen harrier in flight

When fully stretched, the wings of the hen harrier are the same shape as those of the marsh harrier. Notice how they turn forward from the 'elbow', where they join the body, back at the 'wrist', and back again to the primaries.

The kestrel in flight

The kestrel's habit is to hover. In a high wind, it has to streamline itself to remain in the same place. Its wings are bent forward, up, and back, with the *alula* or 'little wing' on the outer edge slotted out to reduce turbulence. The body itself has an aerofoil-like surge to its shape.

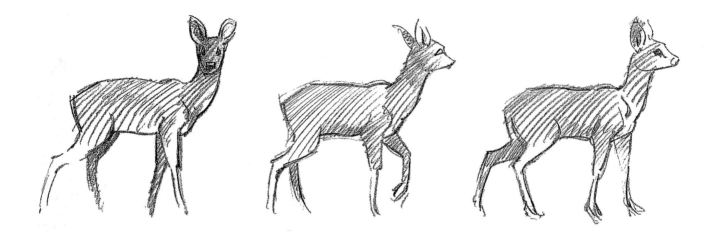

The deer in motion

Long-legged animals such as the deer are obviously quite able to stand four-square with a leg on each 'corner', but this stance is rare. In fact, in its normal standing position, the deer will have the two feet on one side of its body closer together than those on the other side. You can see this in the first pose in the sequence of movements above and below: the feet on the far side are closer as the legs come together, while the feet on the viewer's side are splayed outwards.

This arrangement enables the deer to remain stable as it lifts its feet on alternate 'corners', as in the second movement of the sequence. It shifts its weight forwards, carrying the stationary limbs with it – to arrive at the third pose, in which the feet are closer together on the viewer's side.

This sequence will continue as the deer walks forward into the fourth pose, the rhythm unchanging as long as the animal is not alerted.

Picking up speed

If the deer starts to run, as in the fifth drawing, it picks up speed by cantering. The rear legs tend to thrust together, and the two front legs still work alternately to assist its onward movement.

Bounding along

If the deer picks up real speed, it begins to bound, as in the movements six, seven and eight. This allows it to cover greater distances, and to avoid broken branches and ground litter.

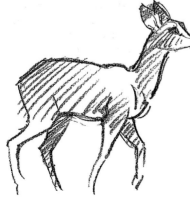

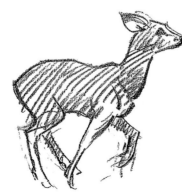

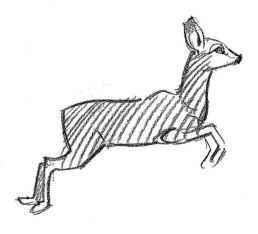

As it bounds away through the woodland, its body stretches out and the limbs lift to maximum height and width, with front and back limbs working in unison. As it comes down to land again, it 'puts on the brakes', with its body contracting like a spring to spread its weight across all four feet.

Using photographic reference

Capturing movement by watching a live bird or animal can be difficult – most of these creatures move too quickly for the human eye to follow. This is where photographs or, better still, videos, can be an invaluable source of reference. If you have an appropriate video, you could 'freeze-frame' a moving sequence at intervals, and sketch what you see.

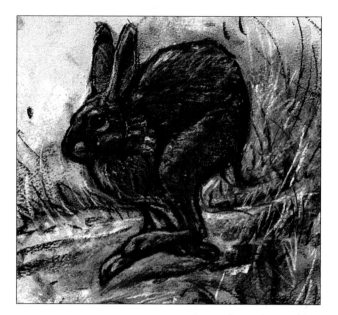

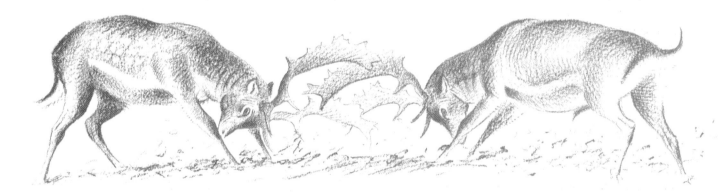

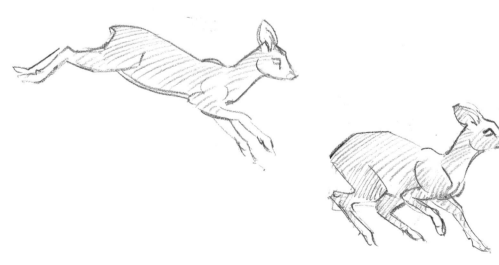

To capture subjects that might move too fast for the eye to follow – such as the jumping hare *(top)* or the stags *(above)* – freezing a single 'frame' in a wildlife video can provide the reference you need.

The Complete Picture

Having learned about the various elements that contribute to the distinctive character of different birds and animals, now is the time to put this knowledge into practice by looking more closely at two individual creatures – in this case, the golden eagle and the fox.

The golden eagle

This romantic bird is an inhabitant of crag and moor, where it lives by its hunting skills. Its huge feet are adapted to grasping its prey, such as hare and ptarmigan. It is usually to be seen only at a distance in the wild, but many bird collections will have an example, where you can get a chance to draw at close range.

Wings and feathers

The golden eagle's flight feathers are large and all of them seem to emphasize the ruggedness and strength of this magnificent bird. The great 'fingered' wings that carry it up on thermals fold up when not in use, to give the bird a rectangular appearance.

Its plumage is carried loosely. Each of the bird's movements is enhanced by twists and flows of the feather masses as they change their patterns and directions.

2 I built up the drawing by blocking in the feather masses *(below)*. These may be viewed as a series of overlapping 'leaves', folding in towards the centre back.

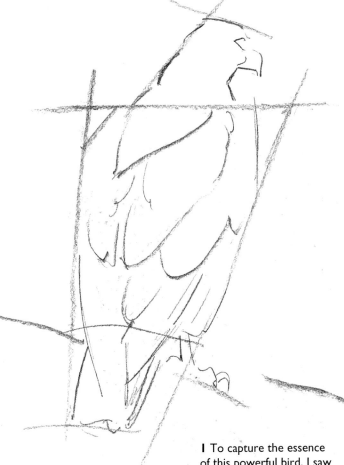

1 To capture the essence of this powerful bird, I saw its angular shape as an abstract, geometric form – a triangle beginning at its shoulders *(above)*.

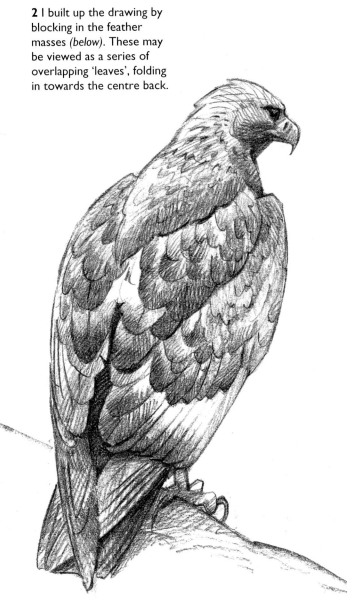

Head and beak

If the body suggests power, the head is even more impressive. The crown is flattish and the hooked beak grows out in a continuous line from the brow. The gape (the visible mouth area behind the beak) is large for swallowing chunks of meat and stretches back under the eye.

The eye is large and deep-set, and its fierce appearance is emphasized by the sternness of the brow. In profile, the eye continues the line of the beak. The cheek feathers sweep up to cover those growing down from the crown and the neck, and seem to counter-balance the downward thrust of the hooked beak.

1 To begin this head *(right)*, I emphasized the flat crown and the way in which the beak 'grows' out of it. The bottom line of the beak and the bird's chin are virtually one, stretching right back under the eye.

2 I drew the cheek feathers radiating out from beneath the eye and down into the neck, where they change direction and move into a downward flow *(far right)*.

2 I began suggesting the smaller-scale feathers on the neck with a lattice pattern and worked up to the head – regarding beak and face as one shape *(below)*. In this pose, the legs appear to link up with the neck.

1 Using a soft 6B pencil, I began sketching the construction lines in lightly *(above)*. I used a triangular shape which I marked off with feather masses stressing angularity, and continued this approach up into head and neck.

The fox

The fox is a hunter, both graceful and intelligent. It lives off its wits, despite persecution. It has gradually colonized the suburbs, and this has given us greater opportunities to observe it.

The fox is a member of the dog family, but has some cat-like qualities, such as nimbleness, forward-facing eyes, a small muzzle, a long tail, and big ears.

Looking at the head

On these pages I explain how to go about drawing the fox from basics. The male has a well-developed, bushy head and nape which provide a useful bulk to work with. These can be simplified by drawing them within a pentagon, with one corner pointing down for the nose, and the large triangular ears with their rounded tips emerging from the top two corners.

The eyes and the muzzle link up to form a single pattern, and the forehead is quite high. When leaving highlights in the eyes, remember that the transparent upper half of the eyeball is in shade cast by the brow. The second drawing of the head below explains the principal fur masses as they grow up and over the head. They coincide with certain muscles, such as the ones behind and in front of the ears.

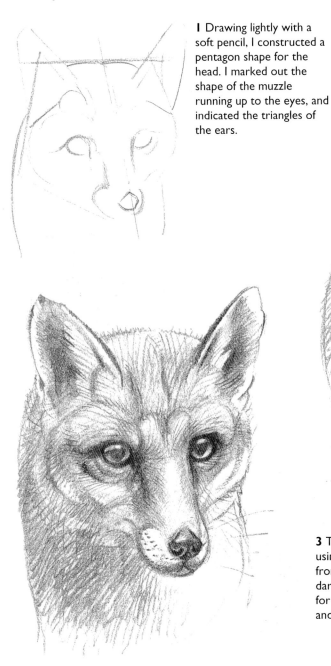

1 Drawing lightly with a soft pencil, I constructed a pentagon shape for the head. I marked out the shape of the muzzle running up to the eyes, and indicated the triangles of the ears.

2 I worked into the head with more detail, strengthening the tone, and suggesting fur directions and masses. I began the pupils in the eyes and created highlights by leaving the paper blank.

3 The finished drawing, using a full range of tones from a 9B pencil: the darkest ones are reserved for inside the ears, the eyes and the nose.

Artist's Tip

The simplest way to define the rear leg shape of a fox (or any other similar animal) is to draw a 'question mark'. The front legs can be rendered with a zig-zag line, which straightens out at the end of each step.

The fox in movement

When drawing the animal on the move, it is important to capture its fluidity of line, heightened by the line of its long bushy tail. In the pose here, showing a fox moving at a cautious pace, I show the tail and body in virtually one rhythmic line moving to meet the neck. The neck itself curves up to the head, which, with its pointed muzzle, suggests a narrow triangle.

Alternate movements

Most long-legged mammals walk in a similar way to the fox. The feet come together on one side and part on the other alternately with each pace.

1 The walking fox – quickly sketched – emphasizing flow and movement. Notice the strong line of the body curving up from the tail and the way in which the neck curves up into the chin.

2 A study in fur directions – such lines can suggest movement and contour, and can give a three-dimensional feel to a drawing. Areas of tone in the fur are beginning to suggest themselves.

3 A change of medium to the soft effect of charcoal: I enlarged the original sketch and worked on it using the side and end of a charcoal stick, sometimes rubbing in the charcoal with my finger. A putty eraser can lift out overworked areas.

Sketching

Try to get into the habit of sketching as often as you can. Filling up your sketchbook in this way will not only improve your drawing skills, but will also provide an invaluable source of reference for later use. You can sketch almost anywhere – on holiday, on a day out, in the park, or simply in your own back garden.

The basic kit

Keep your sketching kit as light as possible. I have a camera-type shoulder bag. In it I carry a tube containing a couple of brushes (one a medium-sized, pointed brush, the other a square-tip), two pencils, an eraser, and a pencil sharpener. A few tissues for sponging up paint can go in the pocket. My bag also holds a small, cheap paintbox, a plastic water bottle and cup, and last, but most importantly, my A5 (15 × 22cm/6 × 8½in) hardback sketchbook.

Some birds can be attracted within drawing range by a garden feeder. I sketched this woodpecker *(above)* at my feeder.

Quietly feeding hedgehogs make good subjects *(below)*. Tempt them with meat and water, not bread and milk.

Sketchbooks are useful for noting characteristic behaviour, such as that of this song thrush *(above)*, smashing a snail shell.

Artist's Tip

You can sketch garden birds from your kitchen window if you set up a feeder. They move quickly, but your many sketches, even if only squiggles, will add to your knowledge.

Extra equipment

If you want to make larger studies of reeds and water, say, for a drawing of ducks, take out a small, light (3-ply) drawing board with your cartridge or watercolour paper taped to it.

Make sure that you carry waterproof clothing; a blow-up cushion is also useful for sitting on the ground. You will need binoculars, of course, and a telescope, if you have one, so that you can keep your subject in the frame while drawing.

Observation posts

Cars make good observation posts – but make sure that you check your mirror before you slow down to watch that deer you've spotted! Nature reserves offer wonderful opportunities to work from hides, at your ease, unobserved by the birds and animals.

Look out for unusual effects to record in your sketchbook. The silhouette of this heron *(above)* was reflected in the mirror-like surface of the water below.

Seals are obliging subjects *(above)*. These inquiring creatures will follow you, swimming offshore, as you walk along the beach.

I watched this female goosander *(above)* through binoculars, as she rested on rocks by a stream.

Seals are gregarious – the young stay close to their mother. When they are not fishing, they bask on exposed rocks, providing an opportunity for some discreet sketching *(right)*.

Framing and Composition

'Framing' refers to the way in which you select an area of what you see for your drawing, or give a subject more or less space by altering the picture's borders. 'Composition' is simply the means by which you can organize the images within the picture area to give maximum visual effect to the idea or mood you wish to express.

Trying out different compositions

When planning your composition, never accept the first arrangement that comes to mind: do various little thumbnail sketches to try out different placings before making a final choice.

Placing your subject

You are free, of course, to place your main subject anywhere you like within the picture's frame. The one place it's best to avoid, however, is bang in the middle – a position both static and boring to the eye, which always seeks a sense of movement. The trick is to place your subject somewhere off-centre, as I have done with the single swan and cygnets. Some artists favour placing the subject on the classic 'third' – that is, a third of the way into the picture. This treatment gives space for potential movement, so important in wildlife pictures.

Getting a balance

When you begin working up the background to your subject, it's important to get a balance between the two. Never make these background details too distracting or dominant – they should be just strong enough to suggest space and depth, without competing with your subject. In the drawings on this page, I have introduced rushes, meadowsweet and alders to provide a natural frame for the birds.

In my first trial sketch *(below left)*, I filled the frame with the whole swan family. This composition produces a feeling of activity and movement. In the second sketch *(below)*, a single swan and cygnets are framed to give them more space, creating a mood of quietness and peace.

Artist's Tip

Cut out two large L-shaped pieces of card or thick paper, and lay them around your drawing to make a frame. You can then move this frame around, widening or reducing the picture area inside, to find the best place for the borders.

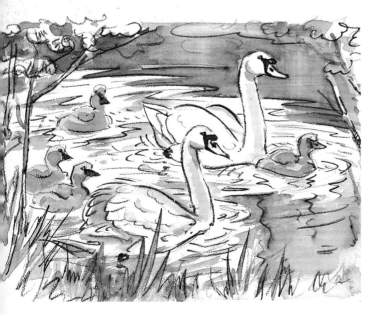

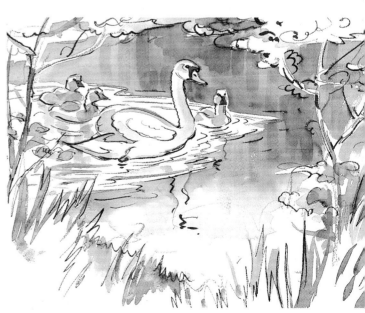

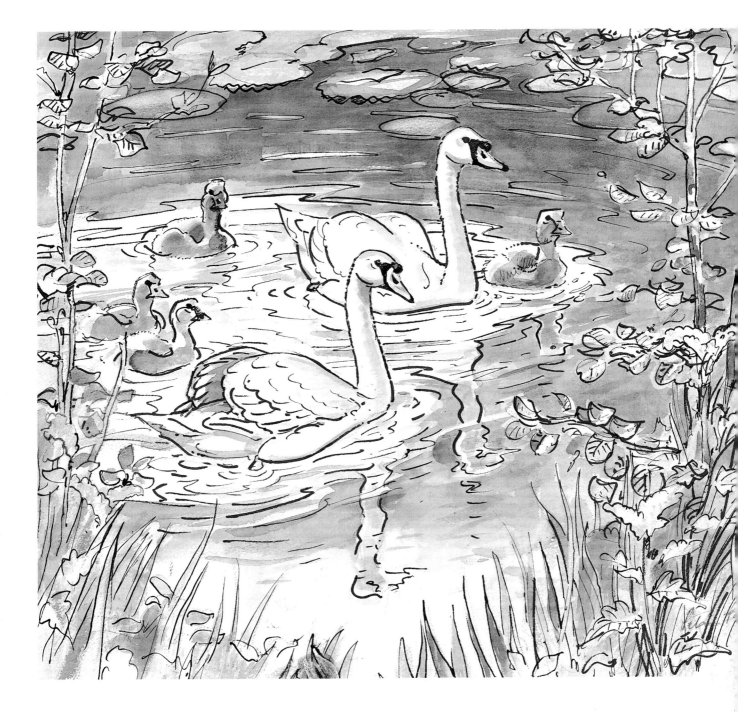

By playing around with my trial sketches and adjusting the framing, I arrived at a compromise between the two sketches *(above)*. The group itself had to remain a coherent whole, yet at the same time had to be visually interesting.

The arrangement is essentially a V-shape. The swan in the foreground turns away from us, while the second turns in to block this movement. Two of the young birds are headed towards us, which helps to involve the viewer.

In Setting

It is fascinating to draw and study a bird or animal in isolation, yet somehow a picture means more if it shows something of the creature's habitat. This need be no more than a suggestion, such as a few pencil or pen strokes indicating reeds or pebbles, or even a shadow cast on the ground. In the drawings below, for instance, I show how a few carefully drawn leaves can frame a finch.

Thinking about scale

A sense of scale in your picture is very important. At close range, a small bird like the greenfinch will be surrounded by relatively large leaves – the scale of the leaves indicates the bird's size. If, on the other hand, you are showing a distant fox in a large field, details like leaves should shrink and merge into the larger shapes of tree and hedgerow. Textures like pebbles or cornstalks can be rendered with small marks made by pencil, pen or brush. Loose charcoal marks or smudged effects on textured paper can convey distance and atmosphere.

Planning the setting

A simple setting like the lilac leaves I have used for the greenfinch need careful thought as you plan your drawing. I drew the leaves first,

A floating water bird like this mallard will always show some sort of reflection, which in a drawing at once places the bird in space and indicates its natural setting.

The duck has an unbroken reflection as it rests on the calm water. It needs only a few fine lines where its feathers and water meet and a slight distortion of the reflected image to convey water surface. Even in the reflection, the tones of its plumage are visible.

copying some in my garden, and taking note of their shape lengthways and end-on as they splayed out. Foreshortening made their heart-shapes even more interesting. I placed the bird centrally, but by giving the pose a twist to change its direction I have suggested space outside the drawing. This twist is emphasized by the unexpected angle at which the bird grasps the twig.

My initial pencil sketch of this greenfinch (far left) shows the outward and upward flow of the lilac leaves. The direction of the bird's gaze suggests space outside the drawn area.

I used a fine-pointed, felt-tip pen in my finished drawing (left) to sketch the delicate leaves, with their flowing lines. I carried this line through into the bird, using cross-hatching to describe its rotundity and to fill areas of shadow.

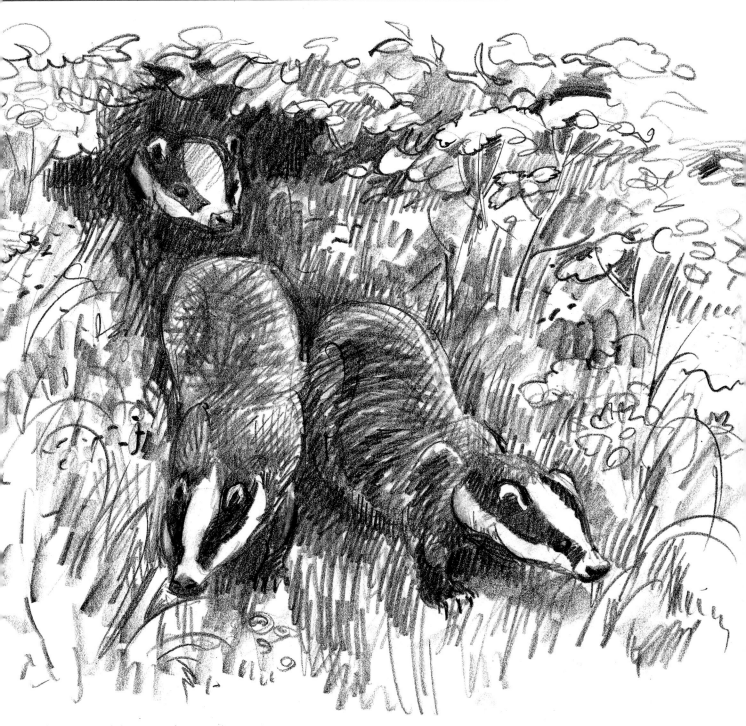

Observational drawing and
field sketches, combined
with a growing knowledge
of animal behaviour, will
add authenticity to your
pictures, whether you are
depicting a badger in its
woodland, or a pheasant in
its brambles.

Working from Photographs

Artists have always made use of photographs, and film and video can provide the wildlife artist with more information than ever before.

I always carry a still camera with me on my trips, but use it mostly for recording background detail: I never rely on the camera entirely and always sketch as well. Photographs offer us only one small moment in time; sketching can capture movement, space and continuity, as our eyes scan the whole scene.

If you want to sketch in comfort, modern wildlife films, recorded on video, provide the ideal opportunity. Although both camera and animal move, the freeze-frame facility will allow you to stop the film at any point to draw the animal carefully.

A starting point

We do not have to be slaves to the photo: it can be a departure point for a range of approaches. Here, I show a photo of a grey seal pup, taken on a remote island where the species breeds, and show two different ways of using it.

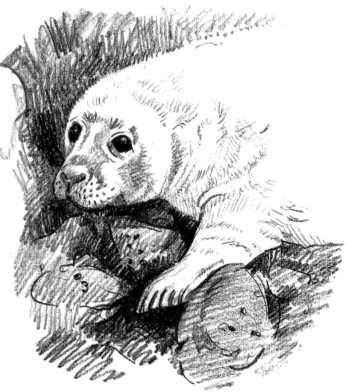

I began the pencil portrait *(top right)* by looking closely at the seal's features – its large eyes, its nostrils and its muzzle, and the way in which they relate to each other to create character.

I used a soft 9B pencil to explore the tonal contrasts, adding to them carefully *(right)*. I kept the negative shapes of the dark rocks in mind; these helped to create the seal's shape.

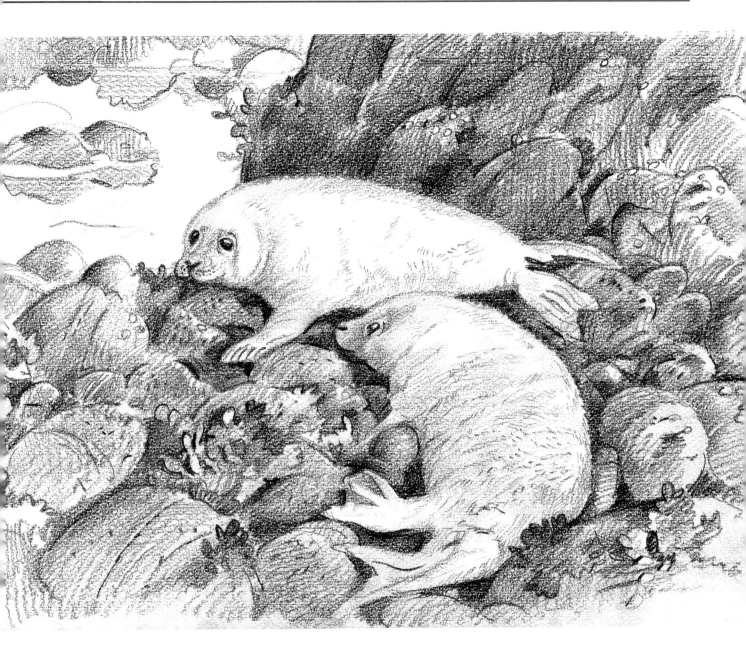

Varying the composition

The drawing above has extended the simple portrait opposite into a more complex composition. The two seals are, in fact, the same animal, shown from different angles. I used the curved rhythmic shape of the seal in front to lead the eye to the focal point of the second seal's face. The rock behind was, I felt, too solid, so I used 'artistic licence' to break it up with a gap suggesting a tidal pool.

For this drawing, I chose a soft, waxed carbon pencil on a textured watercolour paper. This combination enabled me to build up the texture of the seals' coats without losing their pale tone, and to work heavily into the wave-rounded boulders into which the seals fit so snugly.

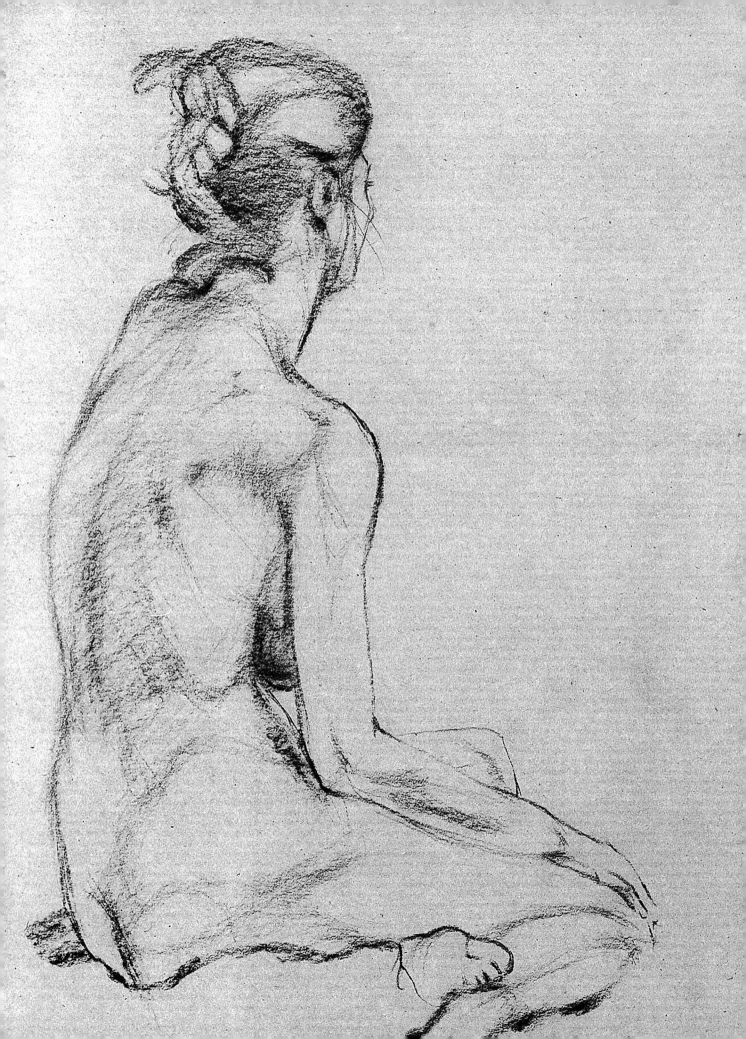

People

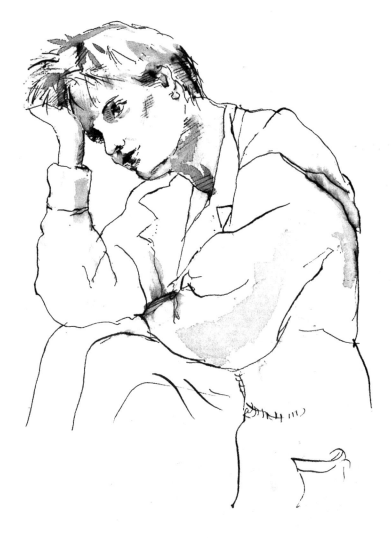

Philip Patenall

Choosing the Right Medium

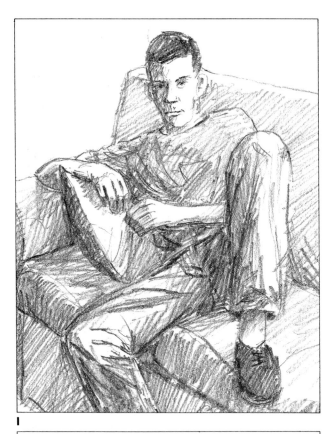

I

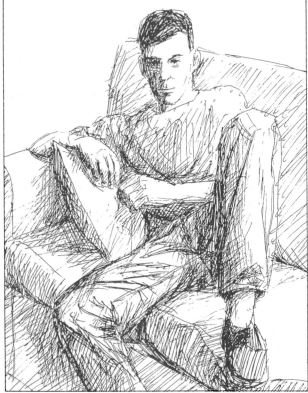

2

Choosing the right medium in which to work is very important, especially if there is a particular effect you want to create or a particular mood you wish to convey. Different combinations of tools will result in work of varying styles and emphases. You can see this by looking at the drawings on these pages. They are all of the same man in the same pose, yet they are all very different.

You can see that ball-point pen on Bristol board (**2**) gives very sharp, clean lines. Compare this with either the soft-pencil portrait (**1**) or the charcoal one (**5**). Though the lines of neither are as sharp, tone and contrast (see pp. 78–9) have been used to great effect in both. They also seem to express a much softer, more melancholy mood.

Familiarize yourself with combinations of different media and different surfaces. You'll soon find you can quickly call to mind the ideal combination to express a particular feeling or effect.

The drawings on these pages were made with the following combinations of media and surfaces:
I Soft pencil on cartridge paper
2 Ball-point pen on Bristol board
3 Dip pen and ink wash on thick cartridge paper
4 Hard pencil on tracing paper
5 Charcoal on textured paper
6 Watercolour on watercolour paper

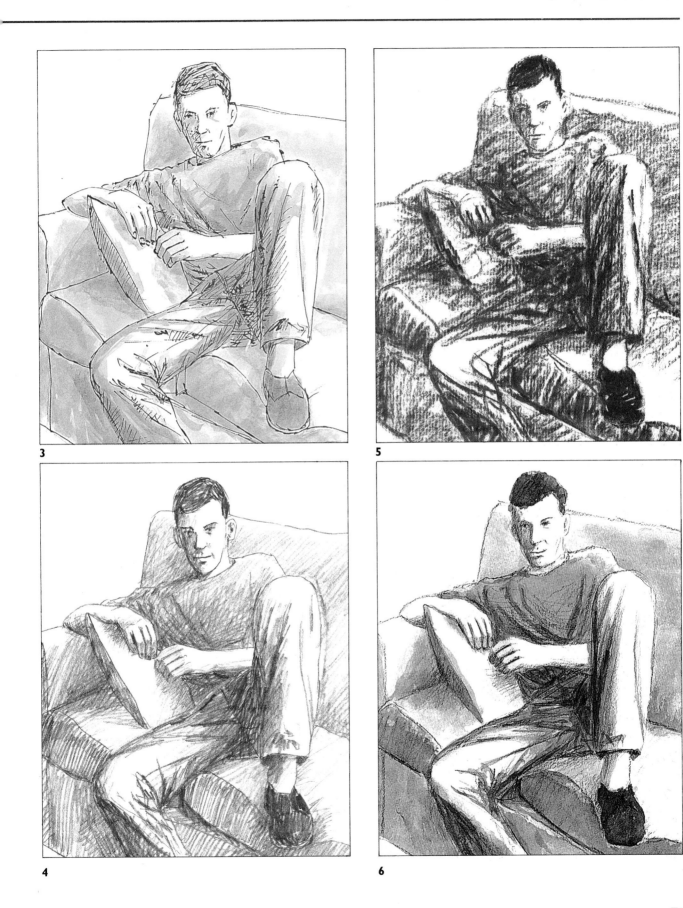

3

5

4

6

Measuring in Drawing

Pencil measuring

Use a pencil for measuring. If, for example, you want to check the gap between the subject's waist and the top of the head, hold a pencil upright in your hand, thumb uppermost (*left*). Then, closing one eye to prevent double vision, line up the pencil point with the head and align the top of your thumb with the waist. Keeping your thumb in place, move the pencil to your paper to transfer the measurement. Use the same method to check widths, and incline your pencil to measure limbs that are at an angle.

Beginners are often disappointed that sketches of people don't 'look right'. This may be because the relative proportions of the face or body are wrong. Luckily, it's easy to get them right.

I began by drawing the central vertical and horizontal axes. I then added some shorter lines at right angles (*below left*), using pencil measuring

Once my grid was detailed enough, I sketched in the main shapes (*below*), checking the proportions with my pencil as I did so

Verticals and horizontals

To achieve the correct proportions in a drawing, it helps to position its parts on a simple grid. First find the main axis of your subject – a horizontal one for a sleeping figure or a vertical axis for a standing or sitting one – and mark it as a faint line on your paper. Add shorter lines at right angles to the main axis to complete the grid; you may need diagonals for some parts. These lines will form reference points against which you'll be measuring constantly to place elements of the sketch accurately. Identify lines relating to distinctive, easily recognized elements, such as a belt or the line formed by the centre of the nose. Use pencil measuring to mark in features and to check that the proportions are correct.

Next, I added the main details, such as the facial features (*below*)

In the finished drawing (*right*), I gave depth and shape to the image by adding finer detail and tones. I constantly checked the proportions, at all stages, by using pencil measuring

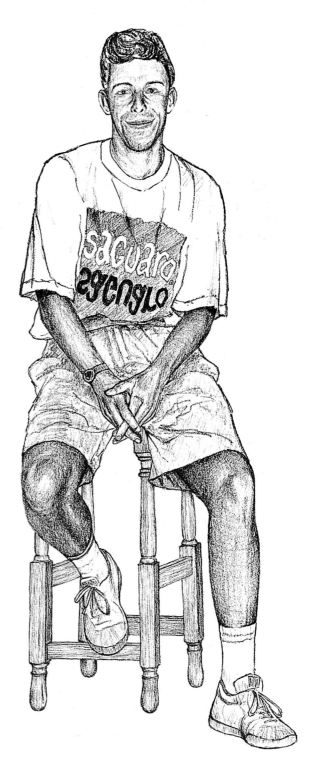

Proportion and Shapes

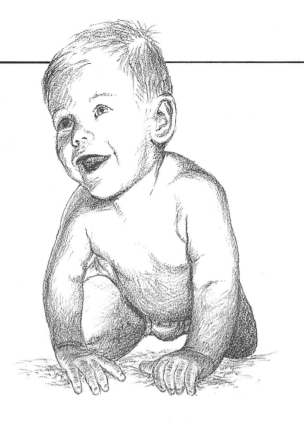

Observation over the years has led artists to develop an idealized human body, each part of which has a set size proportionate to the rest of the body. A knowledge of this ideal form may help you to draw people whose bodies are hidden by clothes. But don't be a slave to such ideals – few of us look like gods or goddesses and no two people are identical; some have long or short legs, others are fat or thin. The figures on these pages show how anatomical proportions alter with age. Observing how reality deviates from such ideals can be an aid to realistic figure drawing.

At different stages of maturity, the height of a person in head-lengths (*below* and *opposite*) is as follows:

1 3–4-year-old: five
2 7–8-year-old: six
3 10–12-year-old: seven
4 Adolescent: seven and a half
5 and 6 Adult: eight

These figures (*below*) show how limbs lengthen in relation to the head as people mature. The legs of a 3–4-year-old (1) are about 2 head-lengths long compared with a ratio of 4:1 in a mature figure (5 and 6)

This simple B-pencil drawing of a baby (*right*) shows how large its head is in relation to its body

1

2

3

Children

When compared with its body, a child's head is far larger than an adult's. As a child grows up the head gets smaller in relation to the body. Girls reach puberty first, but in both sexes it heralds more muscularity, and losses and gains of fat in different parts of the body.

Adults

By adulthood, men are taller than women but both are about eight head-lengths tall. From this ideal head-to-body relationship we can roughly gauge the relative sizes of other parts of the body. A male torso is three head-lengths long, the thirds being approximately marked by the chin, nipples, waist and crotch; the hips are half-way up the body. The upper and lower legs are each two head-lengths long and the shoulders are just over two head-lengths wide. A woman's proportions are slightly different. Her torso is a little longer than a man's but her legs are slightly shorter. Her waist-to-shoulder measurement is shorter but her waist-to-thigh measurement is slightly longer.

4

5

6

Just as the relative vertical proportions of mature men and women differ, so do their horizontal proportions, giving them their distinctive shapes.

Male and female body shapes

The widest part of the average man is across his shoulders – they are about two and a third head-lengths wide. The average woman, however, has shoulders only about two head-lengths wide; she is broadest across her hips. If you study and compare the sketches on the right and below, you can see the differences in shape. Note that the woman's waist (*below*) is far more evident than the man's (*right*).

These figures (*below* and *right*) were drawn in soft pencil on cartridge paper. They show quite clearly the difference between the shapes of a woman's head and torso, and those of a man

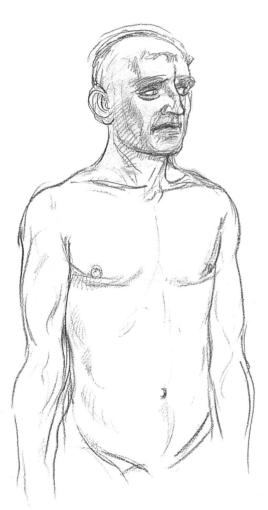

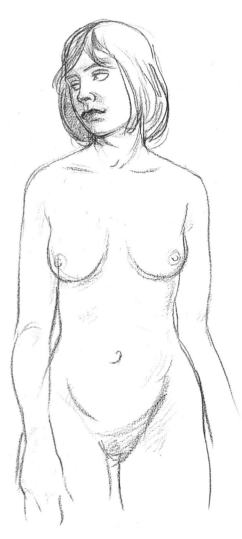

Using shapes in drawing

It's easy to reduce a complex posture to simple shapes that you can then elaborate into finished figures. To reveal underlying shapes and structures, try to develop 'X-ray vision' to see through the superficial clutter of clothing.

Always look at the space around a figure and surrounding objects or other people. A line made by a limb or body forms a shape with the surface it touches. You will find that most of the shapes you see will be triangles, rectangles and spheres. Underlying triangular forms are often found in reclining figures, such as in the one opposite, because of the joints in limbs. You must also remember that parts of a figure that are close to you may appear larger than those further away.

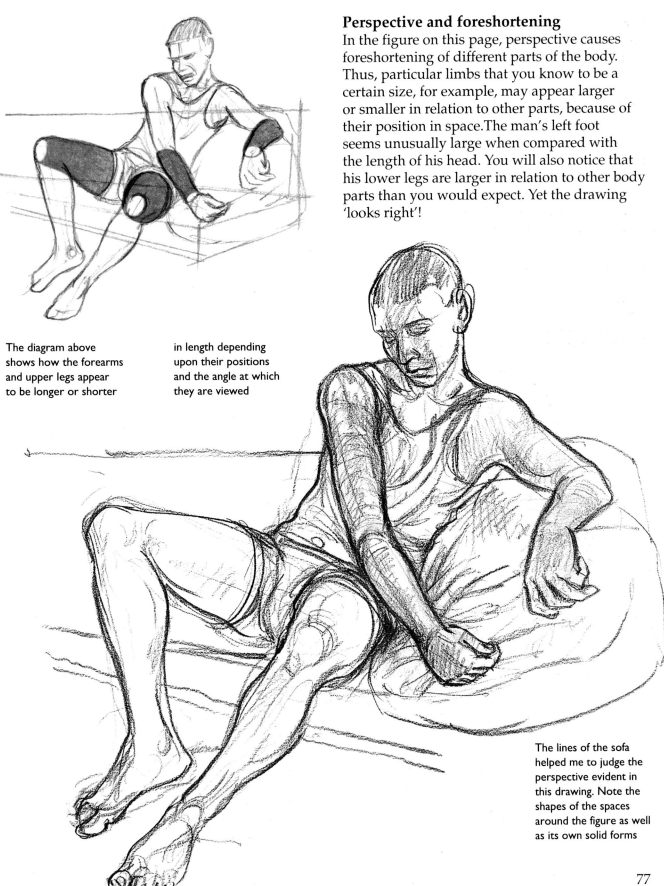

Perspective and foreshortening

In the figure on this page, perspective causes foreshortening of different parts of the body. Thus, particular limbs that you know to be a certain size, for example, may appear larger or smaller in relation to other parts, because of their position in space. The man's left foot seems unusually large when compared with the length of his head. You will also notice that his lower legs are larger in relation to other body parts than you would expect. Yet the drawing 'looks right'!

The diagram above shows how the forearms and upper legs appear to be longer or shorter in length depending upon their positions and the angle at which they are viewed

The lines of the sofa helped me to judge the perspective evident in this drawing. Note the shapes of the spaces around the figure as well as its own solid forms

Light and Shade

To portray a figure's receding and protruding forms you need to explore the effect of light on its surface. Skilful use of light and dark tones can emphasize shape and depth, and is especially important in drawings where features, such as the nose, are difficult to show without tone.

Using tone in shapes

Use the block method to help your shadow studies. To simplify faces or figures, draw them as a series of flat planes, as though your subject were made of cardboard.

The difference in tone on this cube (*right*) is shown very clearly. Only three tones are used. This method of shadow study helped me to judge more easily the play of light on the head (*below*) and the nude (*far right*)

A fully modelled figure drawing is quite complex, so limit yourself at first to white, black and a mid grey. With practice, you'll soon be able to handle a wider tonal range.

Here, depicting the head and nude as a series of planes makes it easier to see which areas are darkest and which are lightest

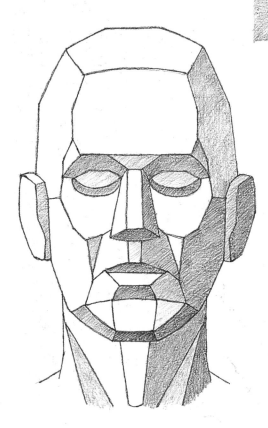

Use the darkest tones for parts that lie in cast shadow, lighter tones for planes facing away from the light and leave areas affected by direct light white. Bright light from a single source creates strong shadow and highlights. A wide range of grey tones lies between these extremes, but use only as many tones as you feel necessary. If light falls on a subject from more than one direction it tends to reduce contrast, resulting in lighter areas of shadow.

Try sketching someone lit from a variety of sources – use an adjustable desk lamp – to see how they change your subject's appearance.

The light shining on the sphere (*right*) appears to come from the top left because its left side is brighter than its right. You can see a similar effect on the head (*below*) and on the nude (*far right*)

The contrast between dark and light emphasizes the curves and angles of the man's face (*bottom*), giving it shape and depth.

A similar effect can be seen in the nude figure below. Note how cast shadows darken those areas already in shadow

79

Structure and Form

Relationships between parts of the body
Anatomical knowledge is not essential to draw figures, but you should understand how the main body parts – head and neck, torso and limbs – articulate together. The neck, for example, is not a vertical tube joining the torso and head – it is angled forward.

Various ways of simplifying the human body, to facilitate the study of structure and form, are shown on these pages. It's more useful to see how jointed bones move against each other than to be able to draw their shapes. A matchstick figure can show how the main joints pivot in any posture.

The skeleton, tin-can and silhouette studies below helped me to understand the subject's posture and the relationships between different parts of the body

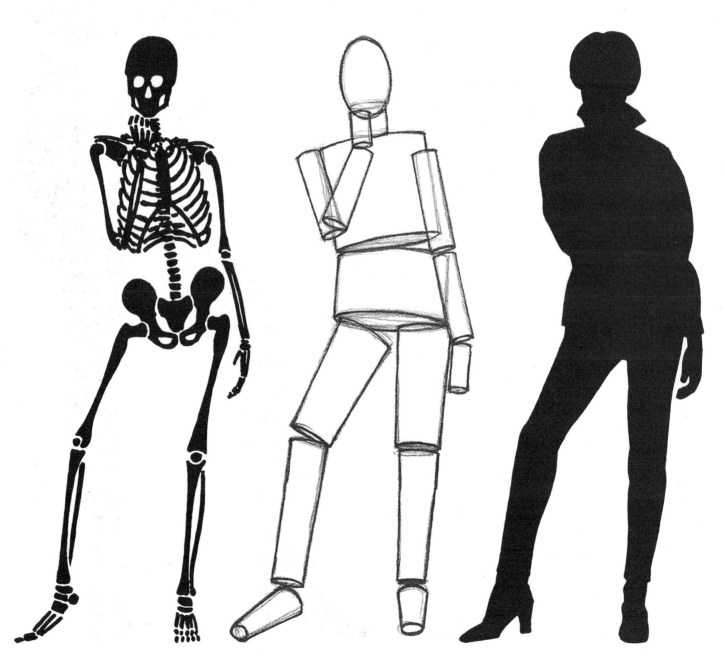

Even such a simple device will look 'wrong' if you don't observe the correct relationships between the different skeletal parts.

Skeletal study

A basic knowledge of the skeleton can help you portray realistic movement; its axis, the spine, limits the movement of the main forms joined to it. It is especially useful to be aware of bones that are apparent under stretched skin. Elbow, wrist, knee and ankle joints are always visible, as is the spine, which is very prominent just above the shoulder blades and where it meets the pelvis. Shoulder blades, collar bones and the upper pelvis rim are also distinctive. Remember that some poses accentuate bone structures – raising the arms, for example, causes the ribcage to become more prominent.

Tin-can study

A tin-can figure, using cylindrical shapes, is a good way to represent people simply. Its great advantage is that cylinders are easier to draw in perspective than complex forms such as thighs. You can modify these cylinders into truncated cones, which bear a closer resemblance to real limbs.

A basic tin-can figure is sufficiently convincing to form the basis for a fleshed-out, fully clothed form. To ease the task of fleshing out, an anatomical drawing from a book will help you to understand underlying shapes of muscles and how they stretch and contract.

Silhouette study

The solid form of a silhouette ignores the distracting detail of clothes and surface textures, and serves to remind you of the general proportions of the body. As well as looking at the shape of the body, look at the shapes formed between different parts of, and around, the body to help you get your proportions correct.

I practised drawing tin-can figures until I felt confident enough about shape and form to produce the finished drawing (*right*). It was drawn with a 2B pencil on cartridge paper

1

Drawing figures in stages

Drawing figures in positions other than simple standing poses tends to intimidate beginners. It helps to look for simple shapes. You will be able to see triangular shapes around joints; kneecaps and elbows can be seen as circles at the end of cylindrically shaped limbs. You can see, for instance, that triangles have been used as the basis on which the drawing opposite was built.

Concentrate on drawing different tin-can figure postures at first; don't begin to add detail until you feel happy with your basic figures. You'll need to master the tin-can figure so, if you're not sure about cylindrical perspective, practise perspective sketches of a tin can seen from every possible viewpoint, paying particular attention to foreshortening. Use pencil measuring to check angles and proportions.

2

3

Here, you can see how I built up the drawing from a series of rhombuses (for the chair), triangles and circles (**1**). I then fleshed out the figure (**2**). Finally, detail and tone were added (**3**)

1

2

Begin by drawing the main lines of your subject's form; that is, a matchstick figure encompassed by any basic shapes that you can see. Look carefully at the relationships between the shapes and lines of the subject's body, keeping in mind proportions and perspective. Then include the cylindrical tin-can forms to show the beginnings of a fully fleshed-out figure.

When you've established the basic shapes, start to refine the figure's outline. Work on it until you feel that it reflects posture correctly, conveys the perspective of any foreshortened forms and shows accurately how limbs bend. Then you can begin to add major details, such as the hairline, the fingers and toes, and facial features.

Finally, round off the tin cans to produce more realistic fleshed-out forms. Look closely to see how muscles contract or stretch and if skin is folded. Remember that the shape of soft tissue on an arm, for example, changes shape when it comes into contact with a hard surface. Then add tone.

3

I started this picture with a series of triangles (1). The basic tin-can forms were then rounded and I began to add detail (2). The finished drawing (3) was done on cartridge paper in HB pencil

I

Babies

Sex, height, weight and age are variables that you'll learn to identify in adults. But babies differ dramatically from adults and children in terms of physical appearance.

Although the proportions are different, drawing a baby follows much the same stages as for an adult. Much of the skeleton is hidden by fat, but limbs will still look 'wrong' if your basic structure is incorrect. Develop tin-can forms into thin barrel shapes to reflect the shape of real limbs. A baby's feet and hands are large compared to the limbs. The cranium is much larger in relation to the facial area than in an adult but the features are much less prominent.

Babies are unable to keep still for any length of time unless they are asleep. Develop the fluid speed you need to draw them by first sketching adults or older children.

First, I identified the basic shapes that gave the subject form – circles, triangles, and so on (1).

Then I rounded off the shapes (2). Next, I began to add major details, such as the smock's folds (3)

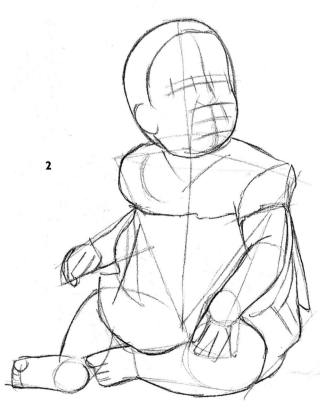

2

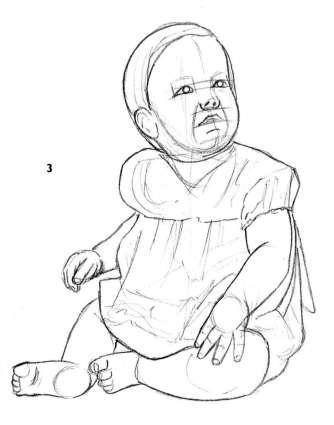

3

The finished drawing was done in H and 2B pencil on cartridge paper. I used shading to give the limbs roundness

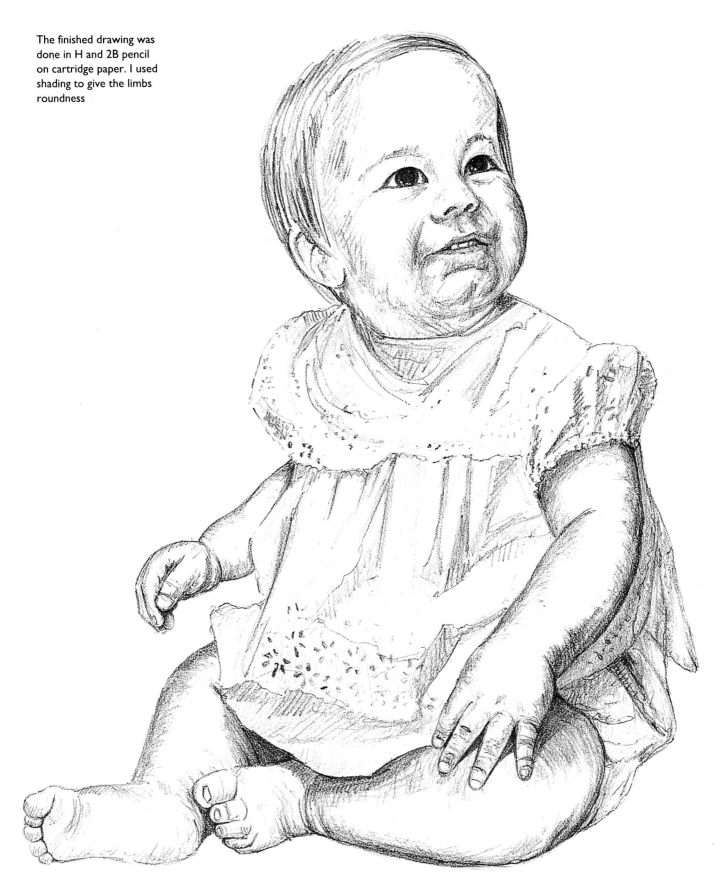

Heads and Facial Features

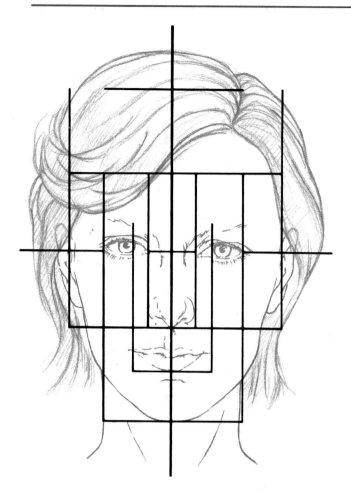

Positioning facial features

Whatever the size of the head or the shape of the face, the relative proportions and positions of the facial features are fairly constant from person to person. The relationships between these can be illustrated by dividing up a frontal view of the face using a grid (*left*). If you look at the central vertical axis, you will notice several things: the facial features are placed symmetrically; the eyes are halfway down; the eyebrows are level with the tops of the ears; the fleshy part of the nose is as wide as the distance between the inside corners of the eyes; and so on. Look at different faces and see how the features relate to one another.

The skull

The skull is integral to the shape of the face. The two studies below illustrate the relationship between the skull and the visible facial features.

I drew a series of lines over the portrait above to help me to understand the relationships between parts of the face and their relative dimensions

These two drawings (*below* and *right*) show the way in which the skull and bones of the neck are positioned and how they affect the visible features

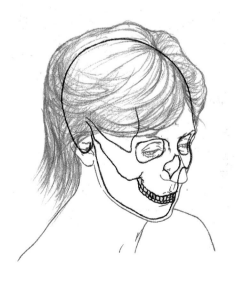

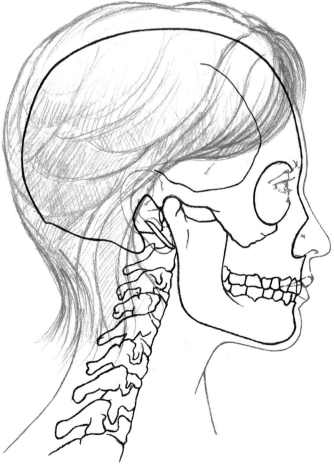

Perspective

To draw faces turned away from you at various angles means drawing facial features in perspective. Continuous curves in perspective are hard to draw, so it helps to make studies of the head using the block method. For a simple study, you could imagine the head as a box – the cheeks as two of the sides, and the underside of the chin, the face, the back and top of the head as the other four. For more complex studies, the head can be represented as a series of planes (*right* and *below*).

Parallel planes and the horizontal lines of the nose, eye or mouth levels are subject to the laws of perspective. For example, not only will the eye that is closest to you look larger but it will also appear to be slightly higher than the one furthest away. Certain features or the whole face will be dramatically foreshortened if drawn from certain angles (*below right*).

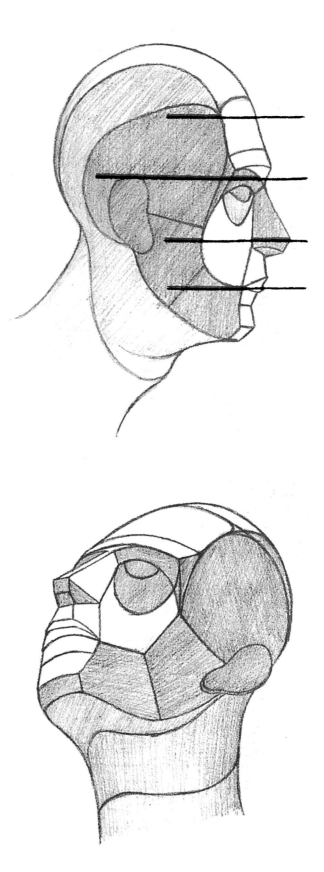

Here, a head has been represented as a series of planes. You can see from the profile (*right*) that the planes marked by the hairline, eyebrows and tops of the ears, nose and mouth are parallel. Even when seen from other angles (*below* and *below right*), these planes still do not converge

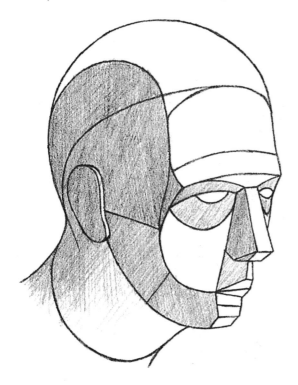

Drawing a realistic portrait of a person takes keen observation as well as an understanding of the theory involved. As with all drawing, practice makes perfect, and nobody will be a more patient model than yourself. Before you use the step-by-step stages given here to draw yourself, become familiar with your own face. Look at yourself in the mirror and feel the bumps, hollows and contours that make up your face. Your nose juts out below your eyelevel. Where the fleshy parts surrounding the nostrils meet the cheeks, there is a distinct dividing line. The other curves on the nose are gentler.

When you draw the eyes, remember that they are spheres held in skull sockets. They appear to be oval because they are partly obscured by the eyelids, which follow the eyeballs' curves. Use a bright light to throw facial forms into strong relief.

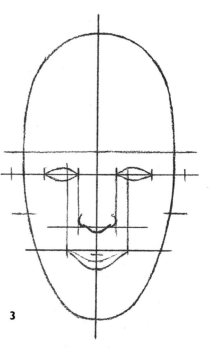

3

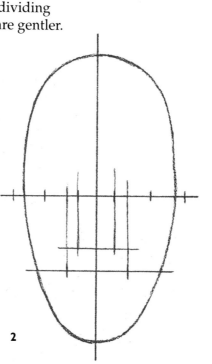

1

2

I divided a rough egg shape with a central vertical line and then with two horizontal lines – one at eyelevel and one to mark the position of the mouth (**1**). I placed the features with the aid of these axes (**2**): the eyes are one-fifth the width of the head; the bridge of the nose is, too, and it ends a third of the way down between the eyes and the chin. I then drew the mouth (**3**), aligning its corners with the inside edges of the irises. Next, I aligned the eyebrows with the tops of the ears (**4**)

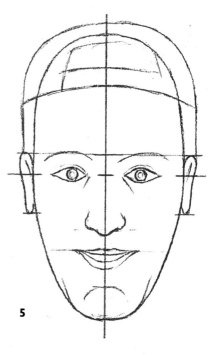

5

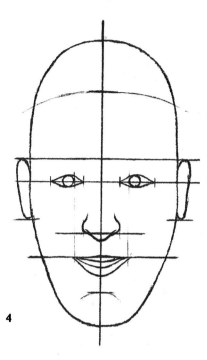

4

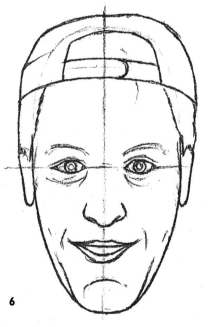

6

7

The last major element to be added was the cap which hid the hairline; then the finer detail of lines and wrinkles was put in (**5** and **6**). If you feel unsure about using tones to give depth to the finished drawing (**7**), do a few tonal studies first

Be guided by general principles, but don't let them dominate your portrait. Draw what you see, not what theory dictates; after all, no face is the same – each has its own individuality. Remember, though, that everyone's features are (generally) arranged symmetrically.

Portraying Expressions

Our feelings are laid bare in our expressions, and convincing facial expression in a portrait will convey more than any amount of meticulous rendering of hair or skin tones. When you make portraits of friends, try to depict typical expressions that sum up their personalities.

Mood is often fleeting and subtle, making it hard to capture. Compare the two women's heads on these pages; neither exhibits extreme emotion and both could convey quiet reflection, yet the smaller portrait suggests calm while the larger depicts a more sombre feeling.

We see little of the eye in this sensitive pastel (*opposite*), yet a slight downturn of the mouth suggests sadness. Subdued lighting adds to the mood

This pencil drawing shows a woman whose eyes and mouth convey a 'neutral' expression, suggesting an enigmatic feel (*above*)

In this smiling face (*right*), certain lines and wrinkles are very prominent. The mouth is wider and the eyes narrower than in the portrait above

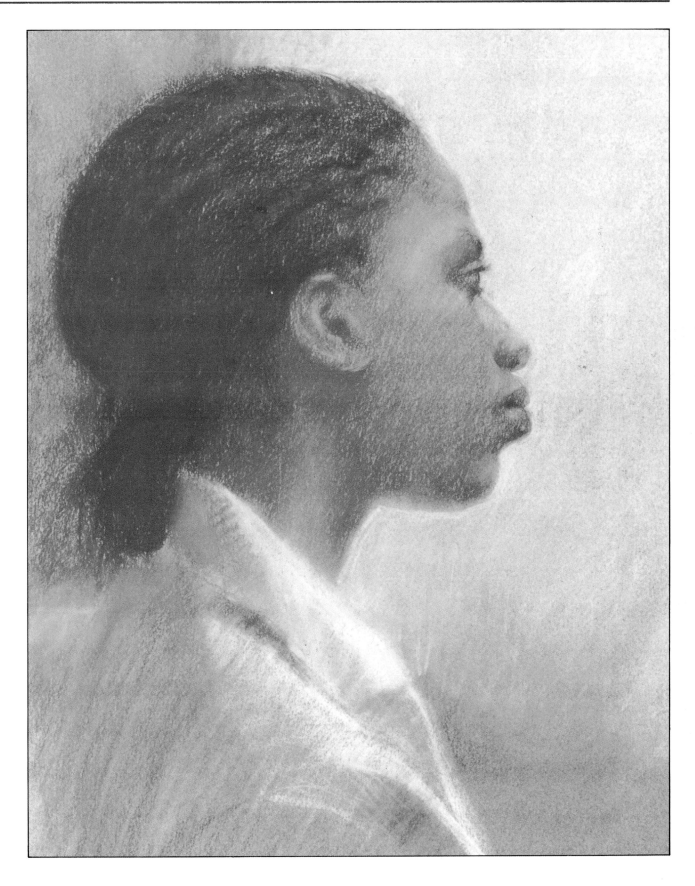

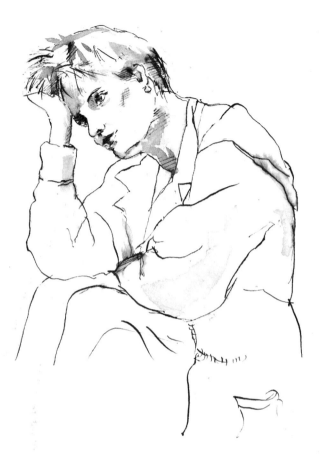

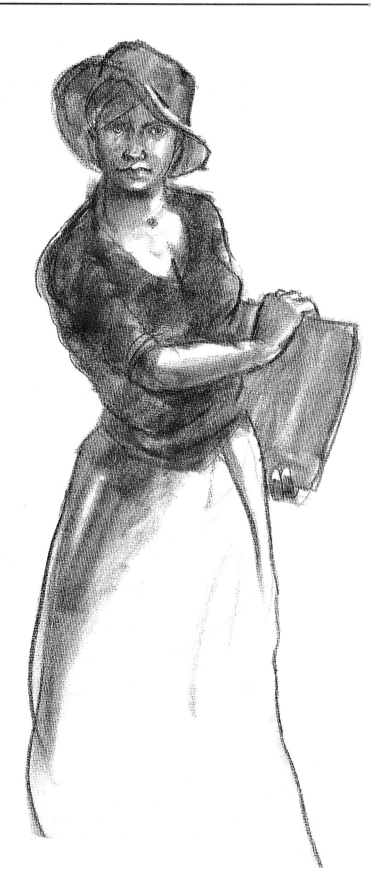

The girl above, in a pensive mood, was drawn in pen and ink on watercolour paper. A little tone was added with a watercolour wash

This young woman (*right*) was drawn in charcoal on textured paper. The cool stare and the way she is holding the object in her hands denote defiance

Just as you examined your own face to learn about facial features, so you can observe different expressions in front of a mirror.

When certain facial expressions are assumed, study how the movement and changing shape of features, such as the eyes and mouth, affect the cheeks, lines around the nose, and so on.

You will find that you will need to make only subtle changes to features to convey many expressions. For example, only a slight alteration to the corners of the mouth of a person who looks indifferent will produce an expression of mild amusement.

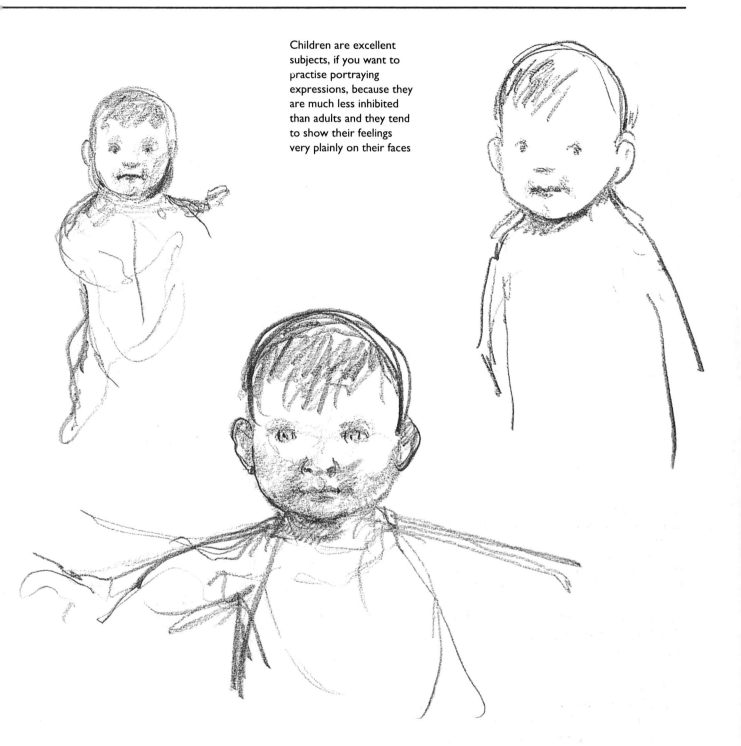

Children are excellent subjects, if you want to practise portraying expressions, because they are much less inhibited than adults and they tend to show their feelings very plainly on their faces

Posture

Posture helps to reinforce an expression. In the drawing of a seated woman opposite, for example, her slouched posture, with her head resting on her hand, seems to confirm the facial expression of tired pensiveness.

Children's expressions

To portray children, you won't be able to make quite so much use of facial lines to convey expression. The ways they show emotion are not as subtle as adults', so changes in the shape of the face, eyes and lips may be readily exploited.

Hands

Hands can reinforce the emotion or mood of a piece of work. For example, a clenched fist might portray anger or tension; hands with the fingers spread apart, tips touching, would suggest a contemplative mood.

Studying hands

Although drawing them requires care, the hands you draw need not be an exact likeness of the subject's. Study them to gain an understanding of the proportions. Note the shapes and differing lengths of the fingers. Remember that fingers have three joints and thumbs have two.

Here, I've drawn the back of my outstretched left hand and a side view of it. I repeated the exercise using the hands of willing friends

Drawing hands

It's best to practise by studying your own hands. First, spread out your hand on a sheet of paper and draw an outline round it to show different finger lengths. Fill in the outline as a silhouette to reveal its overall form. Next, rest your hand on a table to do a freehand sketch of it – note where the joints (the widest parts of the fingers) are and how each finger points in a slightly different direction.

Examine and depict the back of your hand and then the palm. With both, sketch the outline first then add the detail of ridges and lines. Draw a side view of your hand, showing the overlapping forms and the thickest parts. Use what you learn from these simple exercises as aids to drawing hands in different positions.

It helps to remember that the hand is about as long as the distance from your hairline to your chin. The broadest part of it, across the knuckles, is as wide as your middle finger is long.

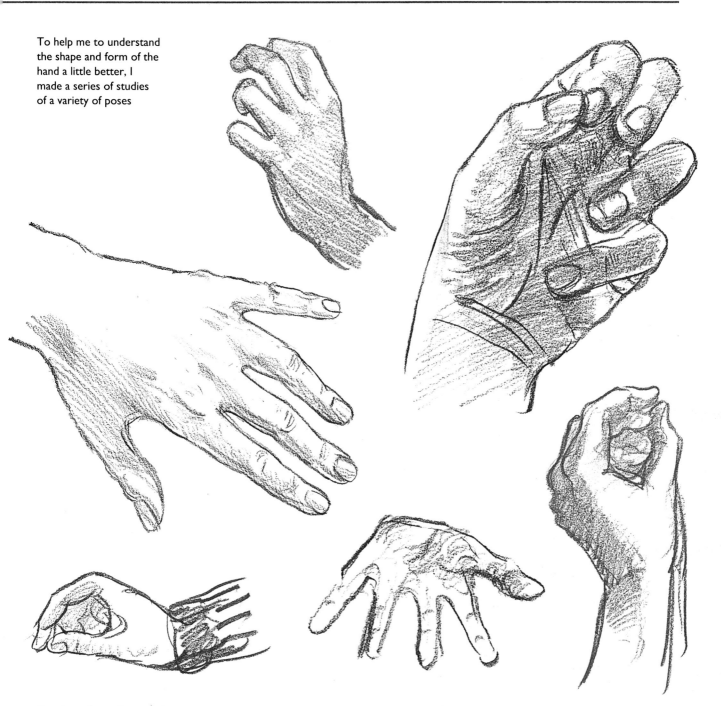

To help me to understand the shape and form of the hand a little better, I made a series of studies of a variety of poses

Seeing hands as shapes

Try to see hands as overall forms – a clenched fist as a sphere or an open hand as a shallow dish; adding fingers one by one rarely gives realistic results. Just as a tin-can figure simplifies the body, so you can draw the fingers of a hand as an assembly of tubes, each with a slightly different alignment and independent articulation at its joints.

Poses and movement

Practise drawing your hand in various poses, sometimes holding implements, and from different viewpoints. Try to 'freeze' different stages of a movement, such as the action of a waving hand. Always remember that the thumb is attached to a large joint near the base of the hand. Look to see how forms overlap and obscure each other.

Feet

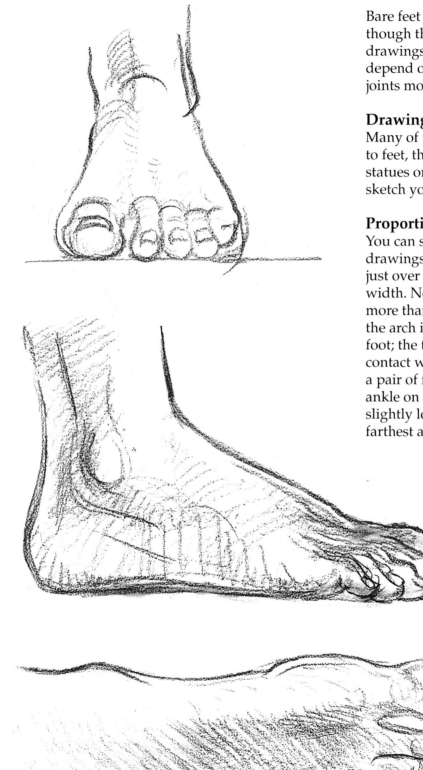

Bare feet are much less flexible than hands. Even though they are usually hidden, realistic drawings of people walking or running in shoes depend on an understanding of how the foot joints move.

Drawing feet
Many of the hints to help you draw hands apply to feet, though you'll need to use photographs, statues or friends as models, for it's harder to sketch your own feet than your hands!

Proportions
You can see the widest part of the foot in the drawings on this page; its maximum length is just over two and a half times its maximum width. Note that alignments of the toes vary more than those of the fingers. Remember that the arch is a slight hollow in the underside of the foot; the toe tips of a standing foot are all in contact with the ground. If you choose to depict a pair of feet from the side, don't forget that the ankle on the outside of the foot closest to you is slightly lower than the inside ankle of the foot farthest away.

With the toes at eye-level, the study at the top of the page shows severe foreshortening of the body of the foot and its toes

A side view of the foot reveals its depth at the instep, the length of the toes and the way they overlap (*above left*)

When viewed from above (*left*), the widest and narrowest parts of the foot can be seen

96

The feet below were drawn in a variety of poses so that I could refer to them when drawing moving figures

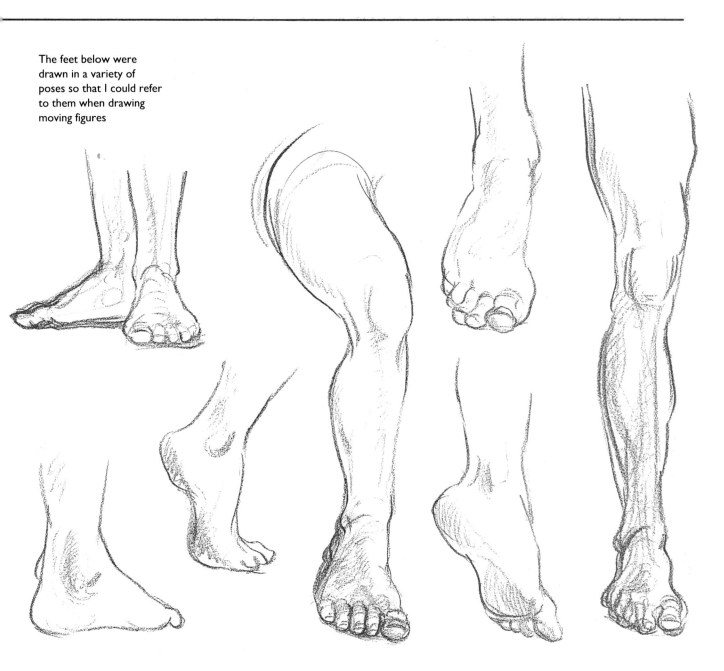

Seeing feet as shapes

As with a hand, look at a foot as a whole – a blunt wedge, hinged at the ankle and where the toes join the main form. The ankle is an ovoid protruding from the lower leg.

Movement

Weight on a walking leg is first transmitted via the heel; it shifts to the ball of the foot as the toes begin to bend. Finally, just before the foot leaves the ground, most of the weight is on the bent toes, and the instep rises vertically above them.

When people walk or run, the feet function as a pair, with the body weight shifting from one to the other. Note how the muscles of the foot tense and relax with the shift of body weight. Study the times at which both feet touch the ground in movement and look at how they are shaped. Only one foot is ever in contact with the ground when a person is running.

If you look down as you move, you will see that, rather than pointing in the direction of movement, your feet point outwards slightly.

Surface Texture

A variety of textures are encountered when drawing people – textures of hair, skin, clothes and so on, all of which come in a wide variety of textures themselves. For example, hair may be curly or straight and skin wrinkled or smooth. You need to be able to depict these accurately to lend realism to your work. Real textures are represented on paper as **invented texture**.

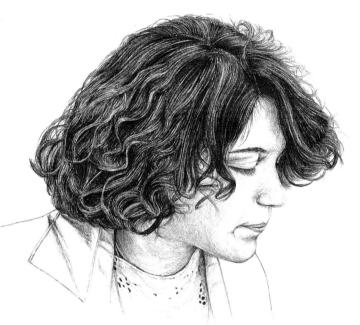

Notice how, in this B-pencil drawing (*left*), the young girl's coat and boots have a reflective quality which is absent from her softer clothing

I used 2B-pencil strokes of varying pressure to show the texture of this girl's hair (*above*). They contrast with the HB-pencil strokes of her face

Invented texture

You can describe various textures by using patterns of lines, and light and shade to emphasize wrinkles and contours. You can also exploit the qualities of your work materials (see pp. 8–15 and 70–1). For example, you can reveal the surface quality of cartridge paper by rubbing a soft pencil over its surface. Much of the texture in the drawing of the fisherman opposite has been represented in this way. And several different textures have been evoked by coupling this method with the judicious use of highlights and shadows.

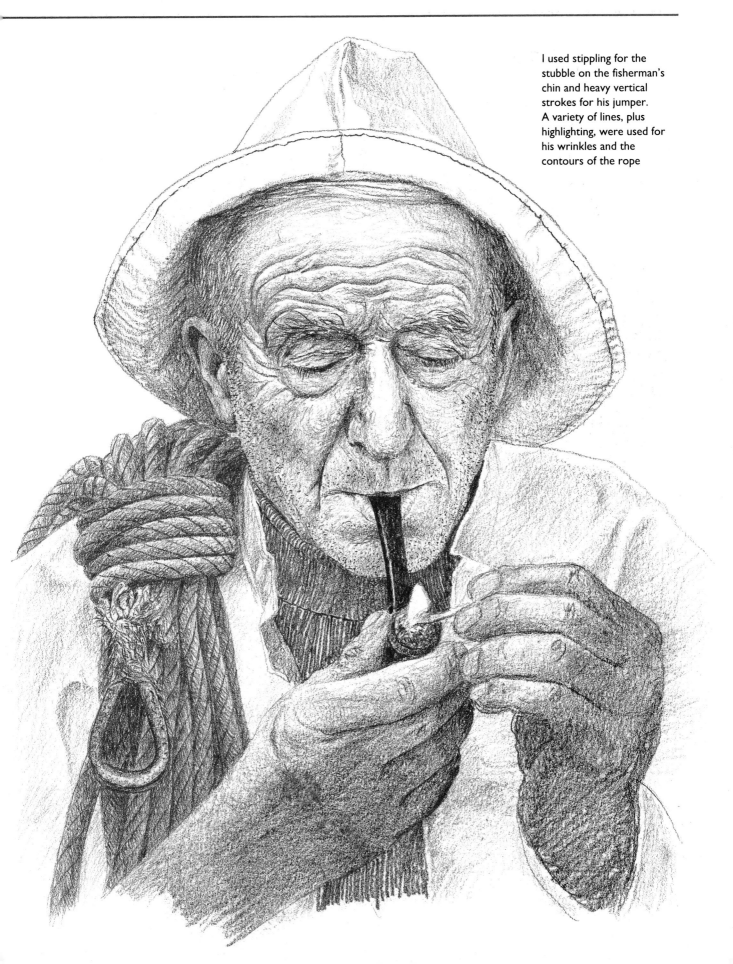

I used stippling for the stubble on the fisherman's chin and heavy vertical strokes for his jumper. A variety of lines, plus highlighting, were used for his wrinkles and the contours of the rope

Sketching

Good drawing flows from keen observation and a confident stroke. Constant sketching is the best way to acquire these skills. Start with people who will stay still long enough to be sketched – pubs, beaches, trains or cafés will provide plenty of subjects. Sketching people in various positions develops your visual understanding of the human figure at rest or in motion.

Don't worry about unfinished sketches and don't get bogged down with detail, especially if people are moving – concentrate on basic forms and try to capture the flow of movement.

Never throw away sketchbooks – they record your progress. You could develop your sketches into more formal drawings, too, at a future date.

The quick sketch of the woman opposite was drawn in soft pencil on rough paper

I rapidly sketched these people walking on a winter's day (*above*) with a conté crayon

Whilst we were sitting and chatting, I captured my friend with quick B-pencil strokes

I visited a kindergarten and made a series of one- and two-minute sketches of the children playing

If you draw moving figures or brief poses, you must work rapidly, concentrating solely on the main forms of the body. You can add detail later. Earlier sketchbook observations or theory can help you to complete any unfinished forms. As well as developing confidence in your sketching abilities, you'll have to train the eye to overlook subjects other than the people you want to sketch. The best way to acquire such skills is by making timed sketches of identical stationary figures, starting with a one-minute sketch and going on to two-, five- and twenty-minute sketches.

The sketches of the miners (*above* and *right*) were both done in under five minutes. I managed to capture more form and movement here than in the sketch on the opposite page

102

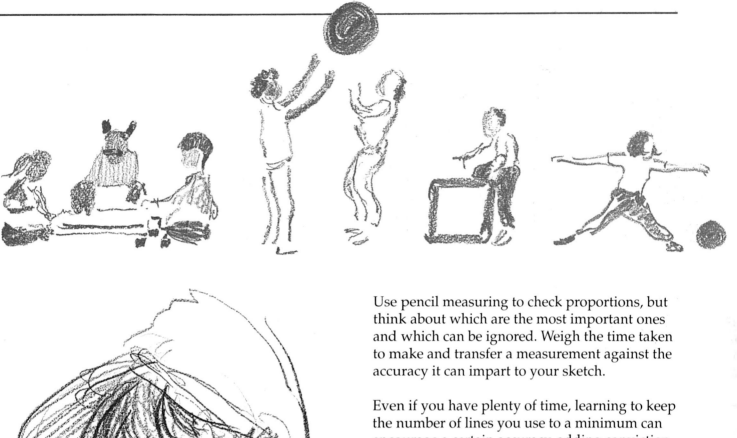

Use pencil measuring to check proportions, but think about which are the most important ones and which can be ignored. Weigh the time taken to make and transfer a measurement against the accuracy it can impart to your sketch.

Even if you have plenty of time, learning to keep the number of lines you use to a minimum can encourage a certain accuracy, adding conviction and strength to your work. Once basic form and movement have been caught, you can spend time on delineating expression and capturing the play of light and shadow upon a figure.

I spent twenty minutes on this soft-pencil sketch of a girl (*left*). After quickly drawing a basic outline, I added the detail of her hands and then used the rest of the time to portray her expression

Body Language

An intimate exchange of gossip is simply sketched in ink on cartridge paper (*right*). The angle of the profiled man's head conveys rapt attention as he leans close to listen to his friend, suggesting a whispered confidence

Oblivious to everything, this man (*below*) focuses all his attention on his newspaper. I sketched him in a local café, using pen and ink on cartridge paper

Body language and mood

Body language may be used to convey mood in a drawing. It can, for example, evoke weather: we shiver in the cold, even stooping slightly to conserve body heat. We strain for balance in strong winds, often leaning into a gale, while in extreme heat we show signs of lethargy.

Watch how certain moods affect people – anxiety and worry tend to produce rigid, tense postures, but relaxation can result in lazy, slumped forms.

Groups of people

Some body language is seen only within a group of people, when it reveals attitudes and status. Compare the postures of strong personalities, such as teachers or popular figures at parties, with the more deferential poses of those around them – look for aggressive stances in a challenge for leadership. Friendship promotes relaxed, open stances, and lovers may cling to each other. Children are interesting, for lack of inhibition tends to result in exaggerated postures. Elderly people are often more reserved, which (coupled with slower movement) creates a different kind of body language.

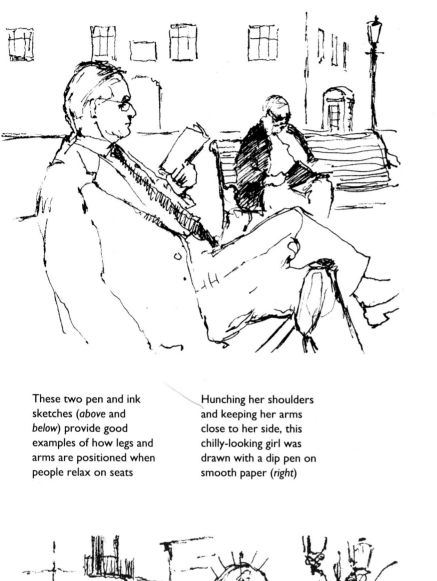

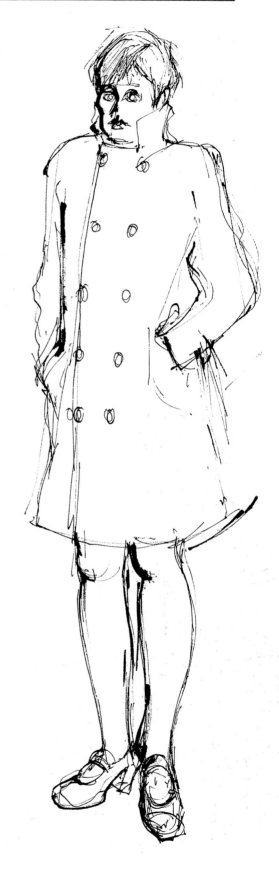

These two pen and ink sketches (*above* and *below*) provide good examples of how legs and arms are positioned when people relax on seats

Hunching her shoulders and keeping her arms close to her side, this chilly-looking girl was drawn with a dip pen on smooth paper (*right*)

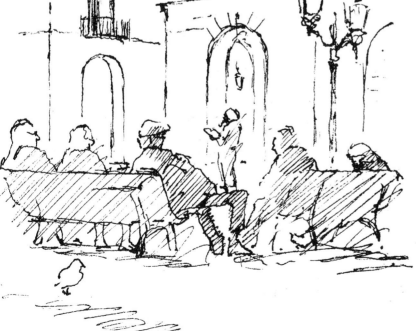

The Figure in Movement

Shifting weight distribution

The weight of a standing, motionless person is generally distributed equally over both feet to give maximum stability. When a person walks, the knees bend, and the head and torso lean forward – the weight of the body shifts from one foot to the other. The arms move, too, acting as stabilizers. To capture motion and to represent it, you need to study how parts of the body move – separately and together. Practise timed sketching to encourage your use of the rapid, fluid strokes needed to capture the figure in movement.

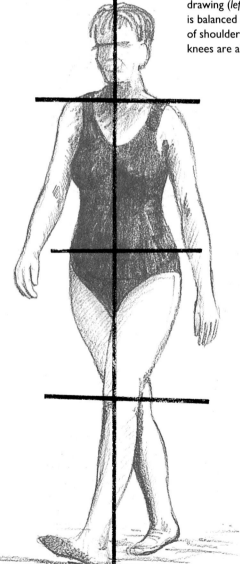

Weight is carried just behind the left foot in this drawing (*left*). The figure is balanced and the lines of shoulders, hips and knees are almost parallel

Begin your study by looking for the line of balance between the head and the feet. Also look for the lines of the shoulders, hips and knees, and the angles at which they slope (if they do). These lines represent the main weight displacement points of the figure – they reveal its balance and direction of momentum.

In the drawing below, the parallel lines show that weight is distributed evenly about the figure – the point of balance is directly below her head

The girl below is putting more weight onto her left foot than her right one; as a result, the lines of the shoulders, hips and knees are not parallel

The diagram (*above*) of the dancer in the main drawing (*left*) shows how she is off balance and has forward momentum. Her outstretched arms help her to balance and her head is up, showing confidence in movement

Drawing leisure activities

Some leisure activities are easier to depict than others. People at a dinner dance, for example, may be simpler to draw than participants in an American football match because their movements are more repetitive and less vigorous. Whatever the type of motion, try to 'freeze' snapshots of it in your mind, then rapidly sketch the image. Make lots of rough studies and refer to them at a future date for your finished composition.

Note the direction in which the body is inclined, the angles of various joints, and the way the lines of the shoulders and hips slope. A firm understanding of body articulation is essential to represent motion.

This pencil study of an American football tussle (*right*) was created from previous sketches to give good form and structure to the figures

Energetic pen and ink and dry brush strokes bring the figures to life, and shadows and highlights add depth (*below right*)

Clothing

Remember that loose clothing echoes movement. It billows out behind the body, as it moves, flowing in the direction of motion. If part of the body abruptly changes direction, the flow of cloth briefly lags behind, caught for an instant at odds with the figure's movement.

Note how movement of these dinner dancers (*above*) is portrayed in the flowing lines of the women's dresses

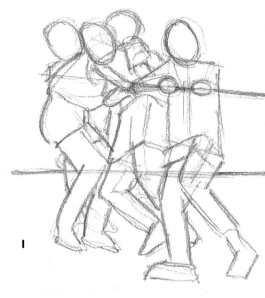

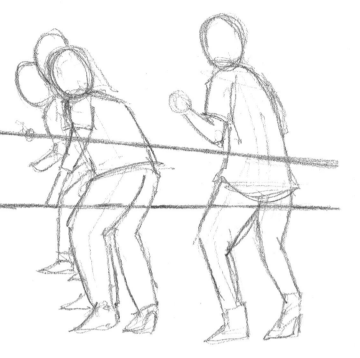

1

1 I roughly sketched the figures in HB pencil, using the horizontal line for the ground and the rope as guidelines to work around

Pushing and pulling

A tug-of-war provides a superb subject for figure drawing, for the opposing teams freeze limbs and bodies in pivoting movements similar to those found in high-speed motion. You'll have time to capture the effort of exertion, but you'll still need to work quickly to exploit the situation fully.

Begin by drawing a horizontal line to represent the ground – this will be your central point of reference. Add the rope, showing the angle at which it is being pulled. Next, use quick, fluid strokes to sketch in the figures. Look for the angles of the lines showing the body parts' points of balance. Ignore detail but begin to add volume to the figures. Take care with joints – exertion makes them bend at extreme angles but not ones that would end in a hospital visit! Contrast the stiff, straight line of a braced leg with the bent form of its twin. Lastly, detail muscle groups. If there's time, try to capture a few faces expressing exertion.

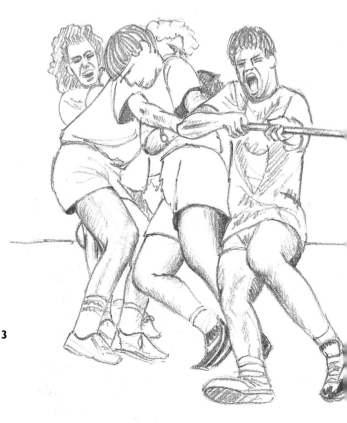

3

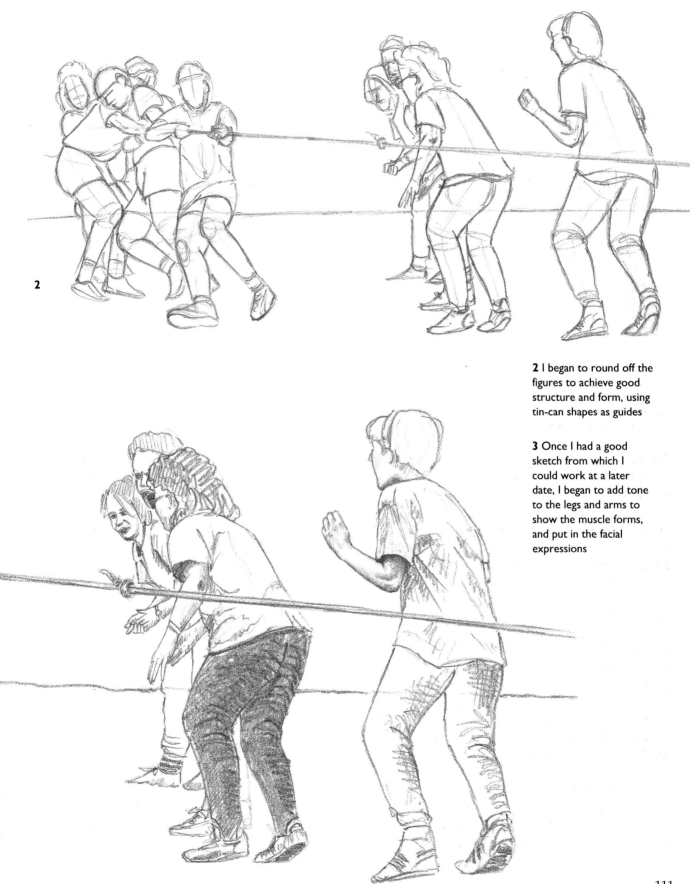

2 I began to round off the figures to achieve good structure and form, using tin-can shapes as guides

3 Once I had a good sketch from which I could work at a later date, I began to add tone to the legs and arms to show the muscle forms, and put in the facial expressions

People Indoors

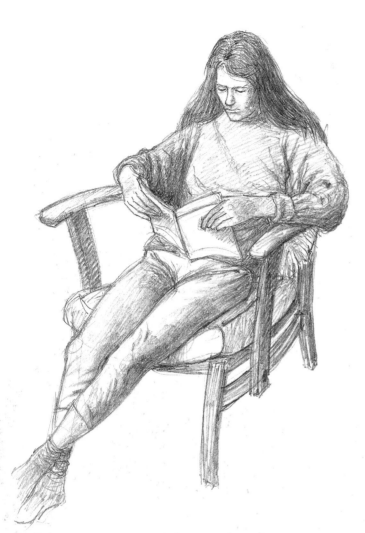

Many figure studies and most drawings, posed or candid, are done indoors. People tend to be stationary for much longer periods of time indoors than when they are outdoors, giving you more time to make detailed studies.

Constant light quality
Indoors, dramatic changes of light do not tend to occur as they do outdoors. This gives you more time to capture the mood of your subject.

Working at home
At home you can use whatever tools you like, including an easel. You can ask people to adopt formal or informal poses. You will produce relaxed and natural-looking drawings, such as the one on the left, if your subjects lounge comfortably on chairs or sofas.

Working inside public places
In public places, you will need to limit yourself to portable equipment, such as a sketchpad and pencil or capped pen, that you can slip into a pocket or small bag. If you decide to sketch people in places such as airports, stations, theatres, cafés and so on, you should ask their permission. They will probably cooperate and try to keep still for you.

Easily held poses tend to result in more natural drawings, such as the one above of a seated woman reading a book

The prone form below was portrayed with brush and ink. Note how I have drawn the pyjama stripes to suggest shape

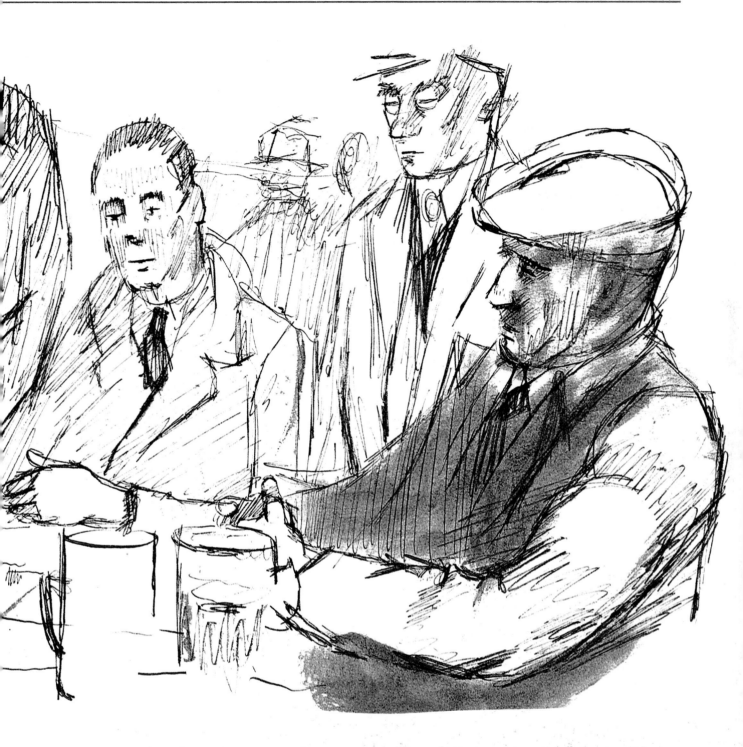

Using a dip pen and ink on cartridge paper, I drew these men at the bar in a pub waiting for their drinks. I sketched them quickly because I knew that they would soon move away

People Outdoors

Don't take heavy equipment on outdoor trips. It's often impractical to carry water and jars for inks or paints, so use pencils or pens; sketchpads make firm drawing surfaces. If you work in a market place, for example, a lightweight folding stool will help. Wherever you sit or stand, look for a good viewpoint but don't get in the way of other people. Candid drawings are best made from unobtrusive positions.

Working quickly

Figurework tends to be more important than portraits outdoors. Parks or sports grounds provide opportunities to sit down and sketch figures. In these places and elsewhere, people are likely to be on the move, so you need to work quickly – use the hints on the human body in motion (pp. 106–11). Practise timed sketching to capture fleeting figures who catch your eye.

A beach in summer was a perfect place for me to practise sketching people. Those below were captured in pen and ink wash on cartridge paper

On a hot day, at the side of a swimming pool, I made quick, rough drawings of sunbathers with a brush and ink on layout paper

114

These figures are of the same boy in various poses (*above*). I sketched him quickly with a dip pen and ink on cartridge paper

Creating busy scenes

Ask willing friends to pose for you in your garden or on a beach or similar open space. The drawing of children's games above was actually drawn using one boy. He was prepared to pose in different positions to create the effect of a busy playground.

Using a camera

A camera will prove invaluable to snap scenes or figures you can't draw from life because of bad weather or lack of time. Try to take a sequence of shots so that you can choose the best when you get home. You can also combine a variety of elements from different photographs.

Countryside

Bruce Robertson

Choosing the Right Medium

The pictures here show the same wooded stream. Yet each illustrates the unique results you can achieve by combining different drawing surfaces with various tools. Combinations like a dip pen on cartridge paper (**6**) obviously convey much fine detail. Others, like the blended pastels on cartridge paper (**7**), cannot match such detail, but may lend a bright or lively quality.

Familiarize yourself with various combinations of surfaces and tools. Once you know what you can achieve with them, you'll find it easy to select those best suited to convey whatever mood or detail attracts you in a landscape.

These drawings were made with the following paper and tool combinations:

1 Charcoal on textured paper
2 6B pencil on cartridge paper
3 Watercolour on watercolour paper
4 Felt-tip pen on cartridge paper
5 Coloured pencil on watercolour paper
6 Dip pen on cartridge paper
7 Pastels on cartridge paper

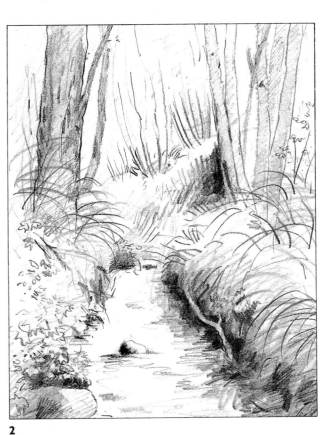

2

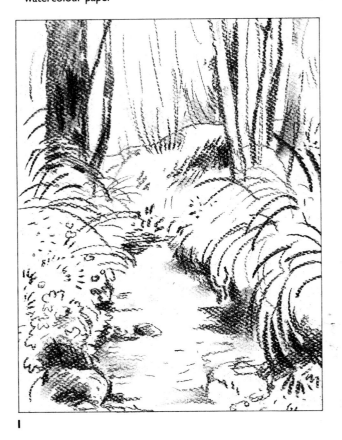

I

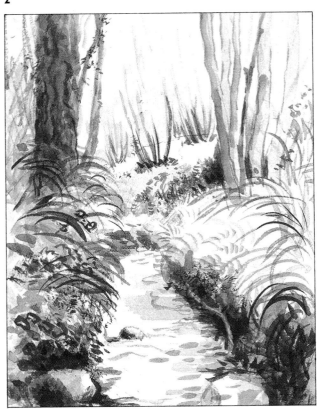

3

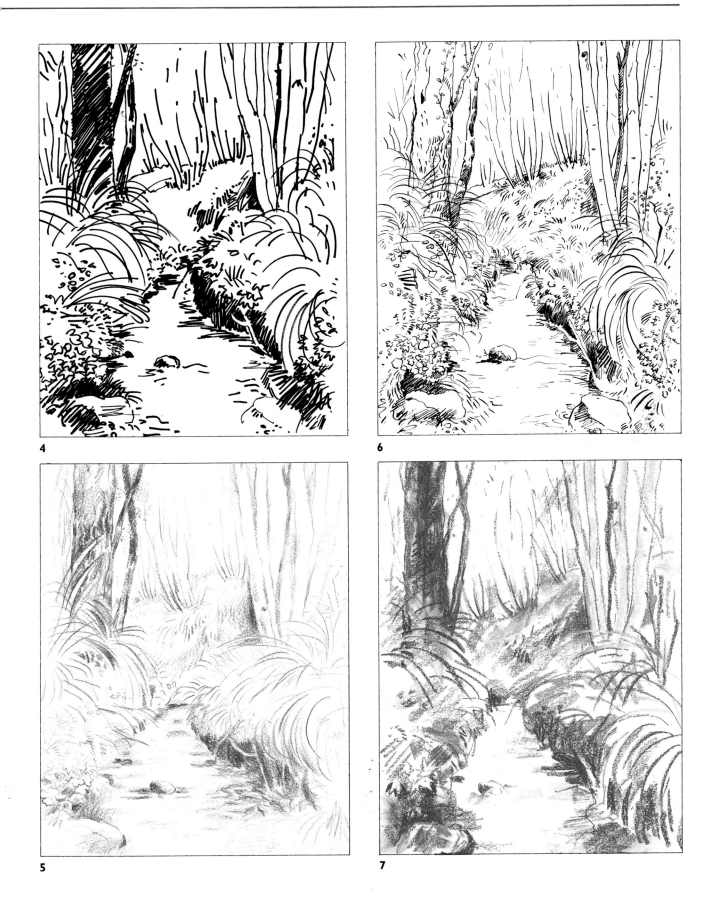

4

6

5

7

Measuring in Drawing

Reproducing what your eyes see is hard, for a realistic landscape drawing accurately depicts relative sizes of distant and close elements.

Pencil measuring

Holding a pencil upright, thumb uppermost, in your outstretched hand (*right*), line up the pencil tip with the top of the object you are measuring. Mark the bottom of the object with your thumb and move the pencil to the paper to transfer the measurement. You can use the same basic method to measure widths. Hold your pencil at a slant to check the angles of slopes.

Verticals and horizontals

A useful aid to drawing objects with their correct relative proportions and positions is a simple grid on which you can locate the main features in your landscape.

First of all, draw a faint horizontal line across the middle of your paper. Now add a central vertical down the paper's length. These central lines of your grid will be reference points against which you position the elements of your landscape. For the vertical measurements, use your pencil to measure above and below your horizontal grid lines. For the horizontal dimensions, transfer your pencil measurements to either side of the relevant vertical grid lines. In this way, you can accurately add horizontals, verticals or inclines to build up the basis of the drawing.

Construct your drawing in a logical way. Try not to do too much at once, otherwise you could confuse your eye and become discouraged. First, lightly outline the main horizontal and vertical structures, such as hedgerows and tree trunks. Once you have the skeletal composition, flesh it out with secondary, smaller structures, using the same measuring techniques. Then, last of all, add fine detail, incorporating light and shade (pp. 124–5) and texture (pp. 126–7). How to build up your sketches in this way is explained and illustrated in detail on pp. 128–33.

I formed my landscape grid (*right*) by using the horizon line as a guide for positioning vertical measurements and the central windmill mast for horizontal ones

Carefully working in sequence against the grid, I used pencil measuring to find the correct positions and proportions of the main elements (*left*)

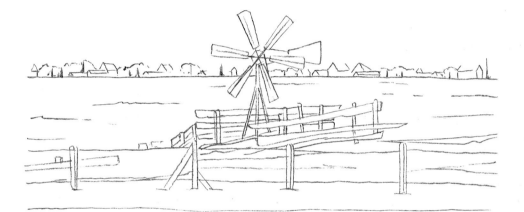

After I'd outlined the main elements, I added details such as the fence boards (*left*)

Once I had included all the forms, I added tone and shading to depict a wintry Dutch landscape accurately in 3B pencil (*below*)

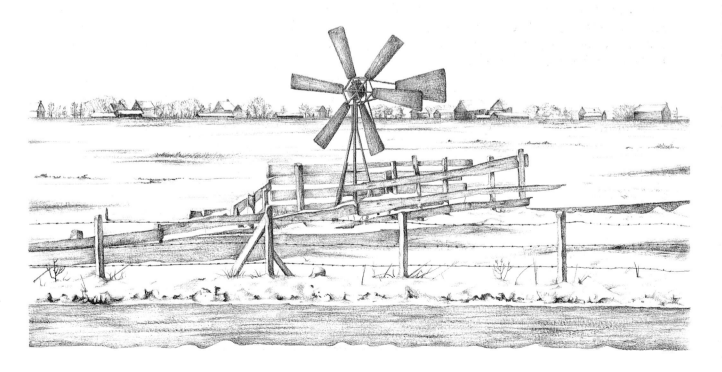

Perspective

Viewpoint and eye-level

The position from which you look at a country scene is called your **viewpoint**. In a flat, uninterrupted landscape, sky and land meet at the horizon. The horizon will be at your **eye-level** – an imaginary horizontal plane running from your eyes as far as you can see.

Vanishing point

Looking at the drawing below and its diagrammatic representation (*right*), you can see that the rough horizontal line formed by the bases of the trees slopes up towards your eye-level. The line formed by the branches, however, slopes down to it. You can also see how all the receding horizontal lines converge on one point – the **vanishing point**.

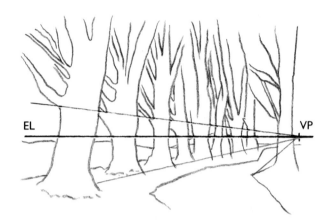

In the drawing below, the trees on the left of the avenue are the main focus. They carry the eye to a vanishing point on the right

You can see, in the diagram above, how the horizontal receding lines converge on a vanishing point (VP) at your eye-level (EL)

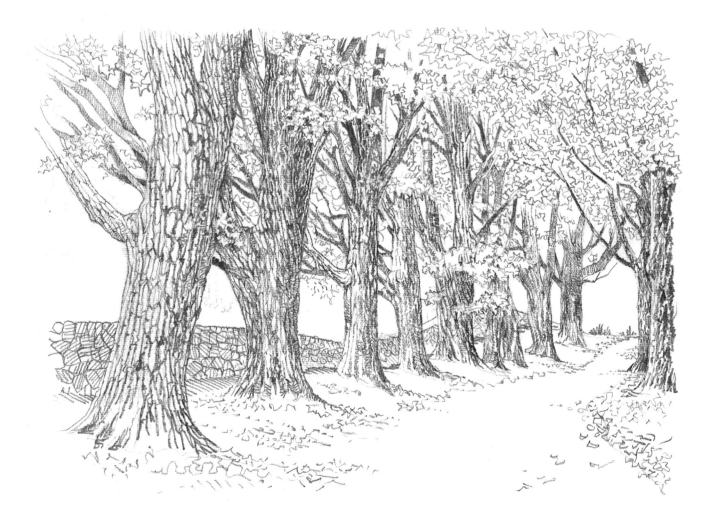

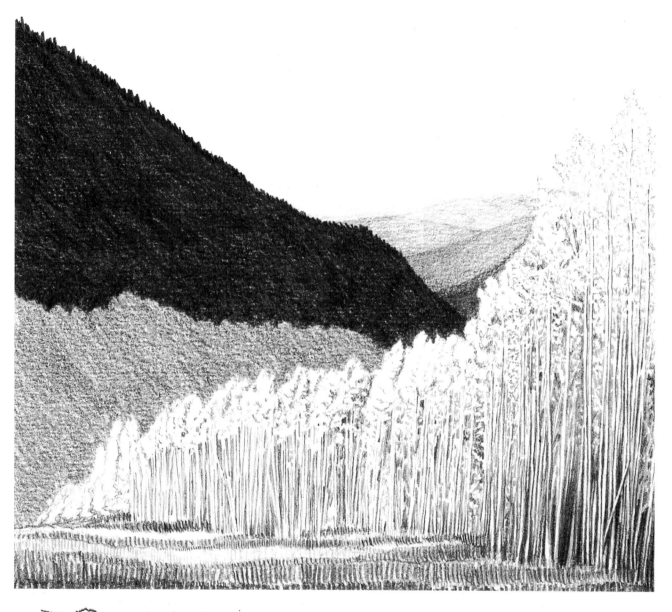

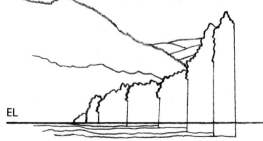

These trees (*top*) become shorter and less distinct as they recede. I used progressively lighter tones on the hills to give depth

In the diagram above, note how overlapping shapes convey size and detail, and objects' relative positions in space

Changing your viewpoint will alter the position of your vanishing point, and the perspective of your composition.

Size, colour and detail

Objects on land and cloud formations in the sky diminish in size and detail the further away they are. Colour, too, is softened and tends to become paler and more blue as objects recede. Spaces between trees, hills and buildings also decrease in size with increasing distance, until objects that are far apart appear to be next to each other.

Light and Shade

Tone
Strong sun on a desert scene produces jet-black shadows and glaring highlights separated by an infinite variety of greys – the scene has **high contrast**. But weaker sunlight will not create such extremes, and so a **low-contrast** range of mid-greys would be seen.

A **high-key** scene, such as a snowscape, contains mainly pale tones; a **low-key** picture, such as the one below, has mainly dark tonal values. Key and contrast can add mood and a sense of time.

Position of the light source
Daytime outdoor scenes have one light source – the sun. When drawing a landscape, ensure you know the sun's position and thus where the light comes from. Make sure each element of the picture is lit from the same direction.

The left side of this cactus (*left*) is 'in shadow' – the light source is on the right. Shading also helps to show its round form

This B-pencil drawing, on textured paper, of a stile (*below*) shows strong shadows cast by bright light over the planks

Shading in drawings can depict shadows on landforms and add a sense of depth to your compositions.

Shadow
There are two types of shadow: a hillside that faces away from the sun is dark – or **in shadow**; when an object obstructs light, it creates a **cast shadow**. Both often overlap; this can be shown by overlaying shading of different strengths. Shading can help to show protruding or receding surfaces.

The sun was low in the sky, behind these hills, when I painted them using watercolour on watercolour paper. I used mottled darker tones for nearer detail; lighter washes were used for the more distant hills

Surface Texture

The countryside possesses a mass of different textures. An accurate depiction of a landscape involves representing these in all their variety – the roughness of bark, the 'fluffiness' or 'featheriness' of a cloud, or the smooth surface of a calm pond.

The seasons affect the texture of the countryside: the soft, rounded, leafy canopies of deciduous trees in summer are vastly different from the sharp angularity of bare branches in winter.

The three different textures of a ploughed field, a sown field and one of wild grasses (*left*) were depicted in pen

I conveyed the different textures of the various plants above by using marks of varying lengths and thicknesses

Representing real texture

A simulated texture is a 'shorthand' way to draw the real texture of, say, every single leaf on a tree. Rather than covering a whole hillside in individual blades of grass, it may be better to suggest these by drawing a few single examples in the foreground of your landscapes. The rest of the hillside's texture can be suggested by using contrasts of light and shade, by exploiting the texture of the paper and the tool you use, or by using patterns of lines. For example, in the foreground of the landscape on the left, individual grasses were drawn in detail to show their texture. In the background, though, detailed representation gave way to the use of stippling to depict the ploughed field and sloping strokes to show a field of wheat.

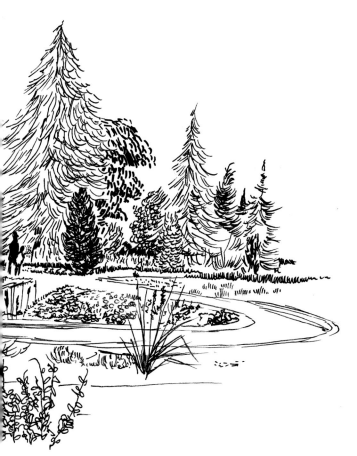

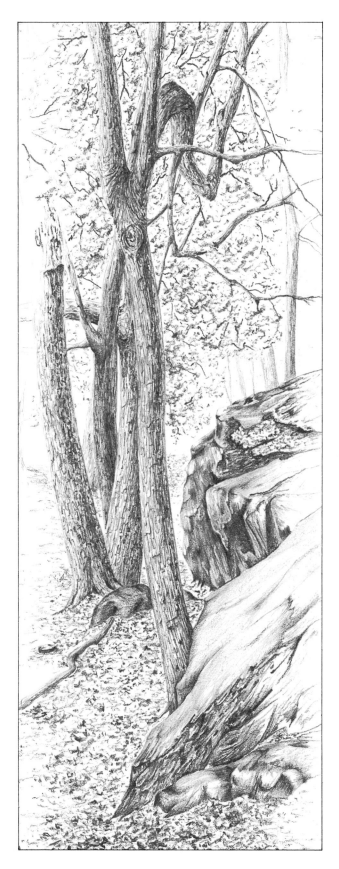

Dead leaves can be shown by simple pencil strokes (*right*). Note that much of the rock surface has been left blank

Try various methods and media to express textures like rocks or leaf and flower forms. Explore different ways to convey the same texture.

Mood and texture

Abstract simulations of texture can be used to lend mood or atmosphere to your drawing. An impending thunderstorm, for example, could perhaps be represented by using the qualities of charcoal on rough, textured paper to show the dark, threatening nature of thunder clouds.

Try inventing textures that don't mimic reality but convey mood. Soon you'll have a wide range of techniques to deploy on any sort of landscape.

Sketching

The 2B-pencil sketch (*above*) shows the use of basic shapes – squares for the buildings and curved shapes for the background foliage

I used a pen to sketch these mesas and buttes (*below*). The light was very hard and bright, thus the contrast is high and the detail clear

Developing your sketching skills

The illustrations in this book can only hint at the infinite variety of drawing styles you can adopt. Art books on great landscape artists can supply more ideas. Experiment in a sketchbook to find your own style.

Open-air sketching is best for developing your powers of observation and your ability to interpret the countryside around you. Try to carry a sketch pad at all times, especially if you visit somewhere for the first time.

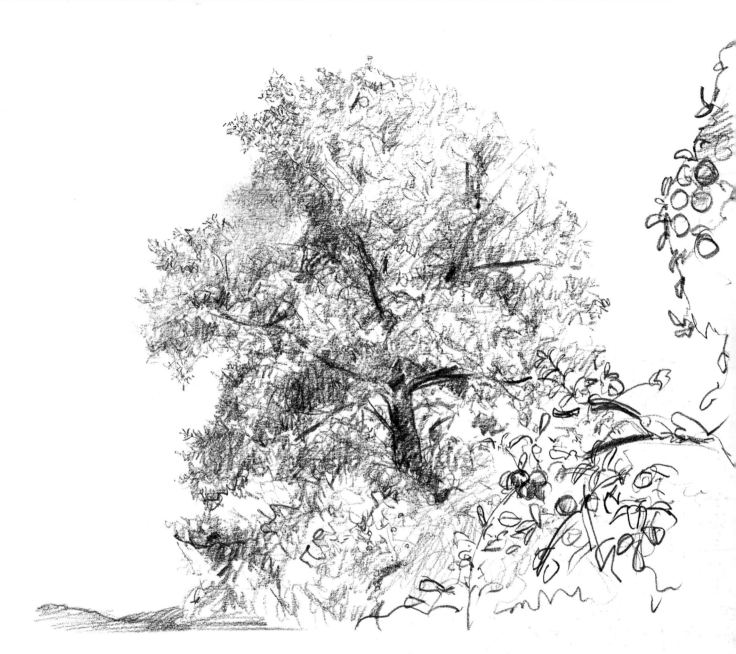

I captured the vitality of
the high-summer foliage
depicted above with rapid
2B-pencil strokes

Keeping your sketches

Your sketchbook will come to include a variety
of material, from careful preparatory studies for
formal landscapes (annotate these with notes on
textures, colours and anything else that may
help you later) to rapid sketches of attractive
details, such as a cloud formation or a twisted
tree. You should never throw away old
sketchbooks – they will make a fascinating
record of your travels, and you'll be able to refer
back to them for details that you can incorporate
in larger pictures.

Timing your sketching

Many attractive subjects appear only fleetingly – towering clouds scudding across the sky, a horse and cart trundling down a leafy lane, or the drama of sunbeams breaking through black storm clouds. Rapid sketching is essential to capture the essence of such transient scenes.

You need to concentrate on the most important parts of a subject if time is short – add detail later, perhaps on another day. A good way to develop speed is with series of timed sketches of the same landscape. Set yourself a time limit of one minute for the first sketch. Then go on to do two-, five- and twenty-minute sketches.

Compare your sketches with the real view, checking that, within your time limits, you focused on the most important elements.

Even if time is unlimited, rapid work can still be beneficial – a spontaneous sketch can convey far more than a laboured, detailed drawing that may be, in the end, stiff and lifeless.

In the two-minute sketch below, I tried to capture the basic shapes of the whole scene, knowing I could fill in the detail later

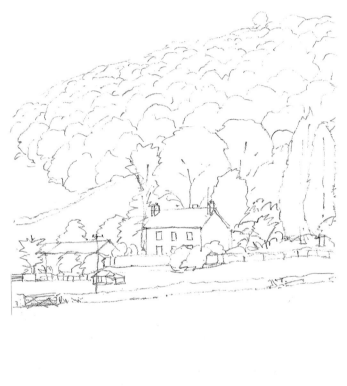

I took five minutes to produce this sketch (*above*). The basic shapes of the tree-tops in the background and details, such as windows, have been added

Giving myself twenty minutes, I worked on portraying the atmosphere of the scene opposite, adding shading and detail with HB and B pencil on cartridge paper

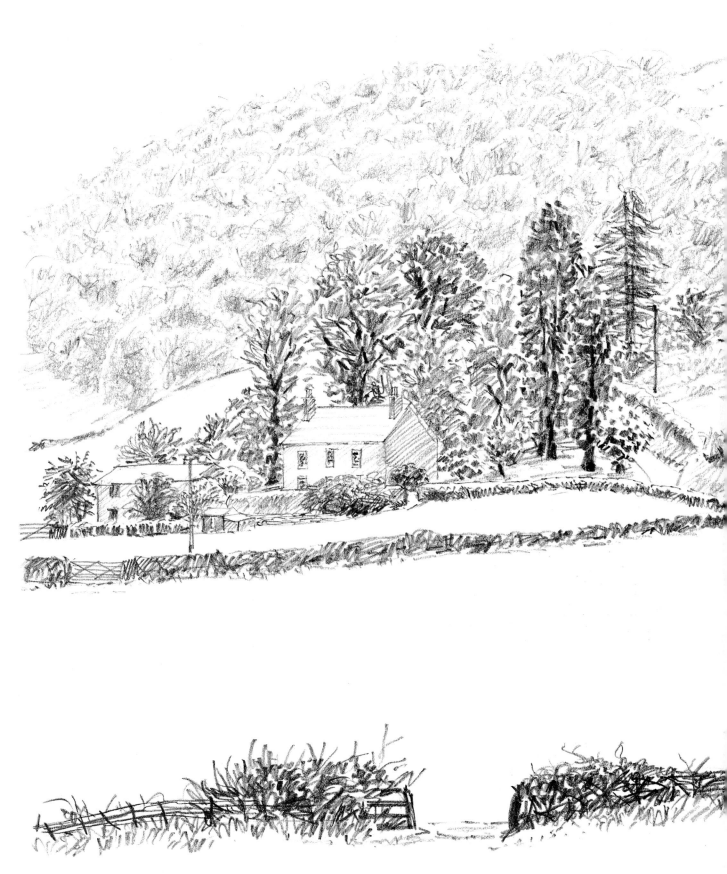

Using shapes in your sketches

Certain views and features may look daunting to sketch. Often, however, seemingly complex scenes break down into simple, easily drawn geometric shapes or solids. By ignoring all confusing surface detail and shading, you'll simplify the process of executing your sketch. Once you have a skeletal composition, with all its main parts in correct relative position and size, you can readily add detail and refine the basic lines of your structures.

The harbour sketched on the opposite page was, first of all, built up using a variety of shapes and forms. Boxes and prisms have been used for the buildings; pyramids, rhombuses, triangles and a crescent or two have gone into making up the quays and sea walls. The rocky headland in the background is a half-sphere which has been textured by using other shapes.

Rounded landforms can be simplified by geometric analysis. Steep-sided cones might form the basis of a mountain range, while foothills might be represented by half-spheres or cones with less steep sides.

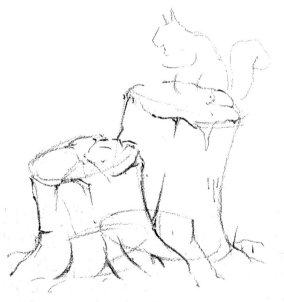

I based this apparently complex tree stump (*right*) on two angled cylinders (*top*). Then I added more form and a squirrel (*above*) – note how even the roots can be seen as thin cylinders.
I used a 6B pencil and ink wash to shade and texture the finished picture (*right*)

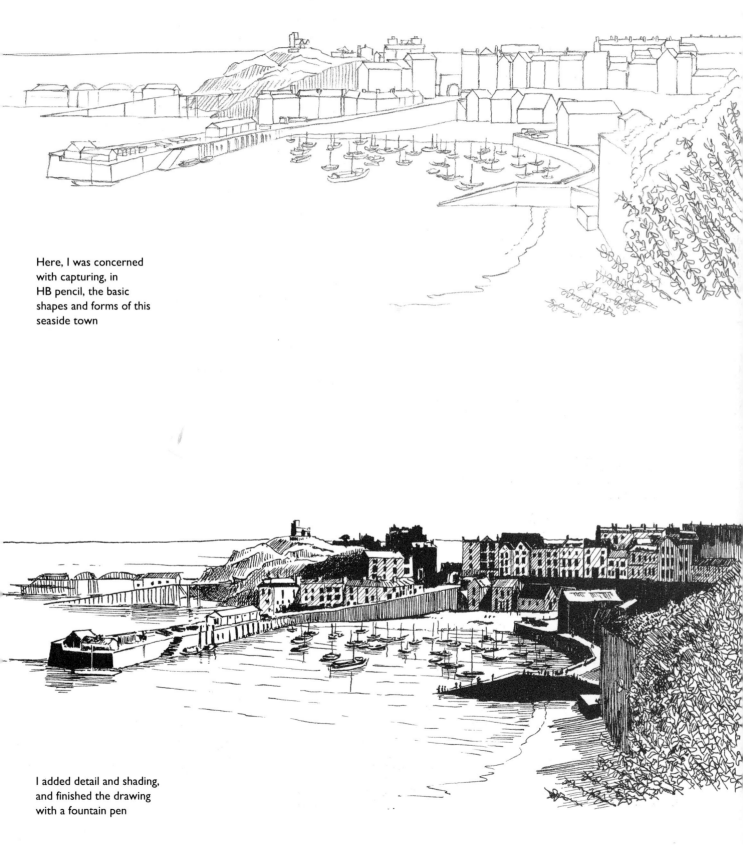

Here, I was concerned
with capturing, in
HB pencil, the basic
shapes and forms of this
seaside town

I added detail and shading,
and finished the drawing
with a fountain pen

Drawing Trees

Single trees or vast forests lend a sense of time to a landscape. Deciduous trees are the best seasonal indicators. Blossom-laden branches denote spring; but in summer, foliage is much more lush. Falling autumn leaves partly expose branch structures and carpet the ground. Finally, winter reveals a tree's skeleton.

I drew this deciduous plum tree (*left*) both in winter and in spring to show how its irregular form becomes more regular when in full blossom

The conifers above were drawn using basic shapes to illustrate their general, regular form. Those that are pictured in detail were sketched in B and 2B pencil

Basic tree shapes

Understanding their basic shapes and patterns of growth can help you to draw trees. Thin, tall conifers, such as firs, often have a symmetrical conical shape. Their twig-bearing branches emerge at regular angles from the trunk. Deciduous trees are shorter in relation to the girth of their branch structure. Their branches divide many times into successively smaller ones that finally end in leaf-bearing twigs, creating less regular shapes.

Gaps between branches are fairly obvious in the foreground; as you move away from a leafy tree, outlines fill in and gaps become less apparent. When drawing a large group of trees that recedes into the distance, make use of this visual quality to give your drawing depth.

Branches, volume and depth

Branches enclose a vast amount of space. If you forget this, you'll draw flat, lifeless trees. Observant handling of the play of light and shade within a branch structure will help create a sense of volume and depth. A branch's cast shadow will briefly cross branches behind it, curving round their forms to create space within the structure and add form to single branches. Foliage can cast shadows on the trunk and branches immediately below it. Don't forget the shadow a tree casts on the ground!

You'll learn a lot about tree structures by regularly working in your sketchbook. Try drawing the same tree at various times of the year and from different positions.

The maple trees below were drawn in winter using pen. Note how the nearest tree is the most detailed one

The spaces between the branches of the conifer in the foreground of this sketch of a copse (*right*) add depth and volume

Environment and growth

Habitats determine the species that grow in them, and may affect the growth of individual trees – for example, exposed trees are often bent or stunted by strong prevailing winds. Tropical swamps and wetlands are homes to trees that thrive in or near water. Trees by rivers often lean steeply towards them, if the water is eroding the river bank on which they grow. Trees by calm water have mirror-like reflections; the reflections of those by choppy water are more distorted.

I used consistent, curving, HB-pencil strokes to echo the regular shape of these mountain conifers (*below*). White space conveys a blanket of snow

Old, fallen trees and exposed roots provide an opportunity to study how shapes and textures lend character. The picture above was drawn in pen and an ink wash was added with a brush

Bark textures and tree age

Sketchbook close-ups of various types of bark – from smooth silver birch to craggy oak – are useful for reference. Most kinds of bark become rougher with age. Deciduous trees' trunks and branches twist and turn more as they get older.

Leaf shapes vary a lot but usually have a symmetrical, bilateral form. Note where leaves branch off a twig – do they alternate from left to right along it or do they have a common source?

Groups of trees

Practise sketching small tree clumps, where separate shapes can be clearly seen, before you try larger tracts of trees. Sketch a group from various positions and at different times of the day or year. Different species with distinctive shapes in nearby groups can be depicted simply with shading, or you can stipple and use lines or a pattern to add leaf textures. Colour and texture of contrasting trees seen further away may be shown as juxtaposed areas of light tones on darker ones. Silhouettes or simple vertical shading of varying height can represent trees seen in the far distance.

Try to draw rows or avenues of similar trees to explore some of the effects of perspective.

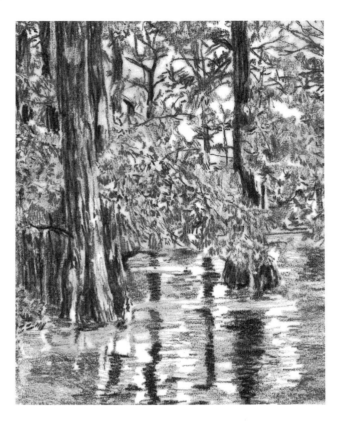

A 2B pencil was used on tracing paper to draw these swampland trees and their calm, watery reflections

I drew this clump of trees on a winter's day with a technical pen on smooth cartridge paper

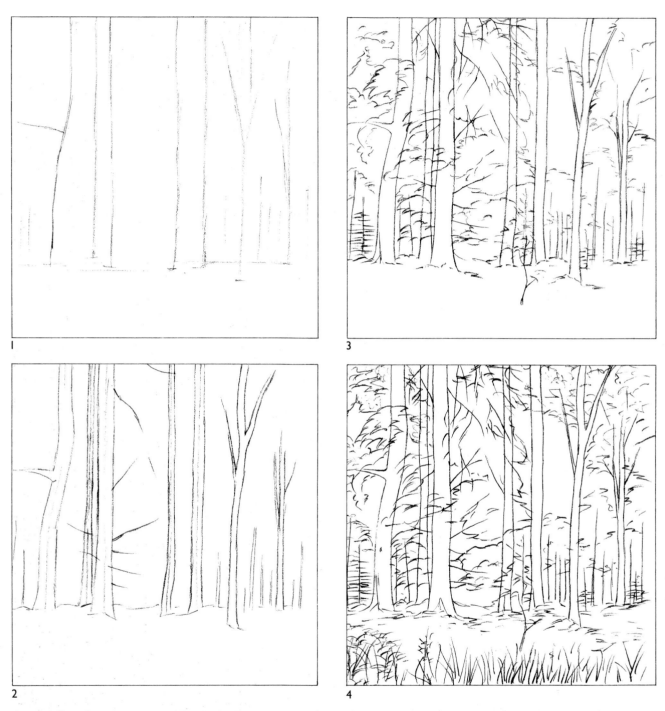

A woodland interior provides a challenging but satisfying chance to explore many textures. You can simplify the task by reducing it to easy stages. When you've composed a view and chosen a focus, lightly sketch rough verticals for the main trees (**1**). Now add the main horizontal outlines and refine the tree shapes (**2**). Once you've done that, begin to sketch in features in

the background (**3**). Follow this with foreground detail such as flowers or shrubs (**4**). Finally, when you've outlined all the elements you need, add surface detail and texture, shading forms to give volume (**5**). Always leave fine detail until last, otherwise it might confuse you as you try to sketch in accurately the positions and proportions of the main elements.

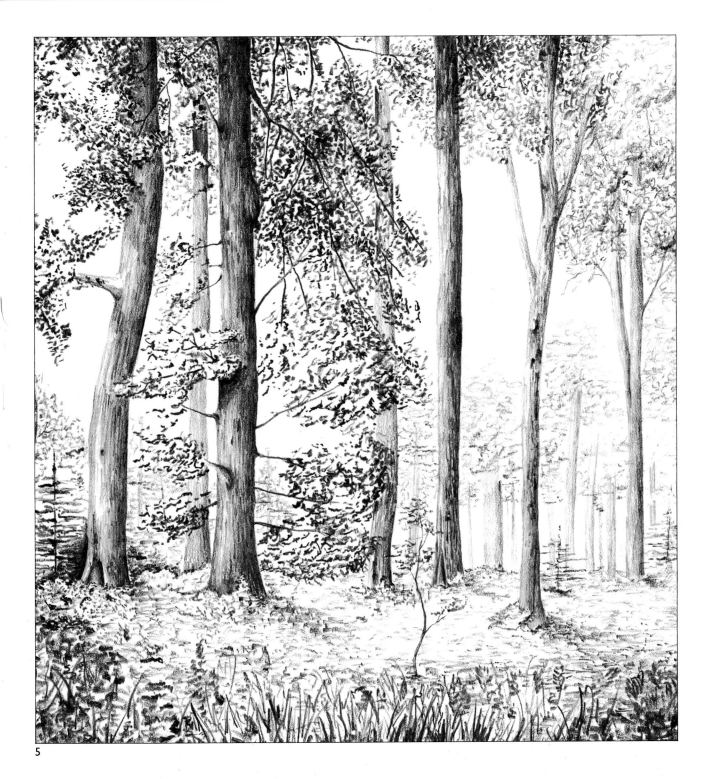

5

Careful use of light and shade is vital for the feel of dappled woodland light. Remember to draw foreground objects in darker tones and more detail than distant ones; eliminate some distant trees if it helps to add an airy feel.

My final drawing was done in 2B pencil on cartridge paper. I left out some trees to avoid background clutter

Drawing Skies

Weather and atmosphere

Sky, in a landscape, adds atmosphere and tells us about the weather. Dark shading drawn at a uniform angle from sky to land suggests distant falling rain. Vigorous strokes in the sky give the appearance of wind, which can be reinforced by bent tree branches. Mist obscures parts of a landscape and diffuses sunlight to render objects as flat, hazy shapes of limited mid-grey tones and weak shadows.

A sky is palest at the horizon and darkest at its zenith, and is usually lighter than the landscape. Avoid creating overwhelmingly dark skies.

The dark 2B-pencil strokes on rough paper below portray dark skies that suggest the impending possibility of heavy rain and high winds

I used light HB-pencil strokes to depict the flat clouds that adorned the peaceful summer's sky in this sketch of country ruins (*above*)

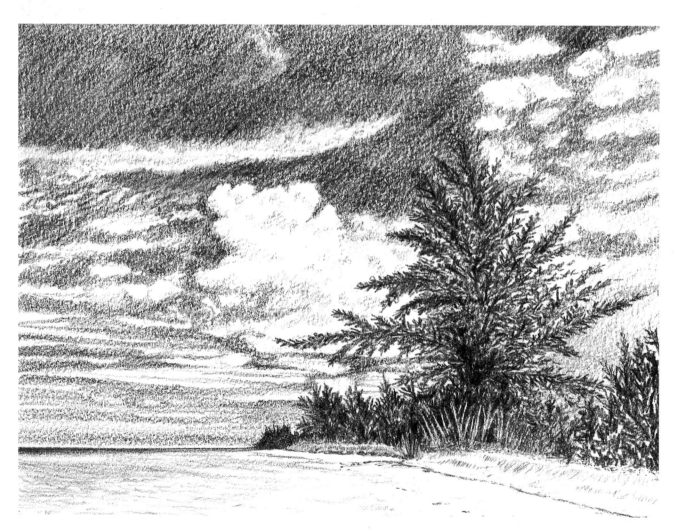

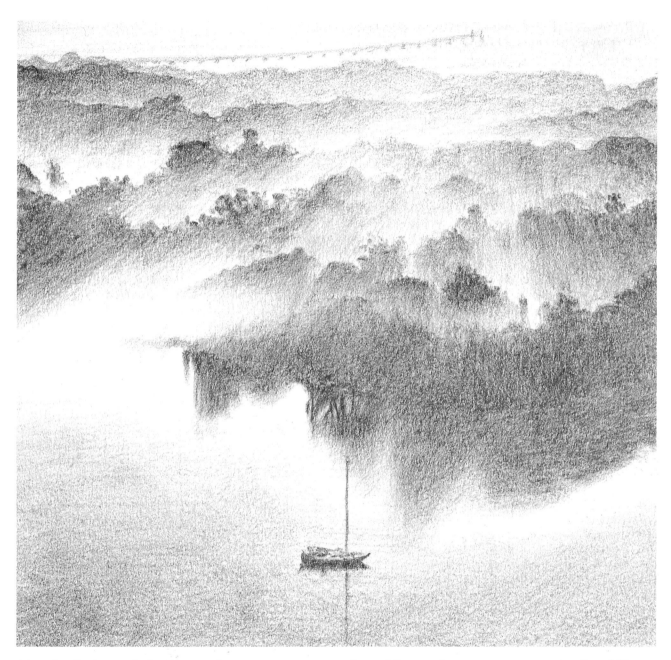

Clouds, light and shadow

An illustrated book on weather will help you to practise sketching various types of cloud. When depicting a real scene, clouds rapidly change, so work quickly. Treat them like solid objects on land; start with outlines and add detail last. Remember that light falls on clouds from one direction, and that size and textural or tonal values diminish with perspective. Use simplified shading of just a mid- and a light grey – pure white paper can indicate luminous light. For a

From a hilltop nearby, I used a B pencil on stationery paper to capture the effect of this sunrise on a misty lakeside forest

feeling of lightness, don't overwork the shading. A landscape echoes its sky. Light strikes the ground through cloud breaks and clouds cast shadows on the land – remember to vary shadow strengths to match different cloud densities.

The light and dark strokes of a B pencil show a mackerel sky highlighted by a sunset over these lakeside lodges (*left*)

The colour and quality of light from the sky are very important in the way they influence the appearance of a landscape. Light and shade affect objects on the ground (p. 124) and clouds in much the same way.

If features in the landscape stand out against the sky, they will have a different appearance depending on whether the sky is light or dark. This is because the balance of contrasts alters.

Sunrises and sunsets

Sunrises and sunsets can be very dramatic, with strong tonal gradations between the dying light of day, on the horizon, and dark night tones higher in the sky. The brightest light may appear above the sun, not around it. Draw elements that are close to you in subdued detail and limited tonal ranges to help you effectively represent dawn or dusk. Objects further away will be in silhouette.

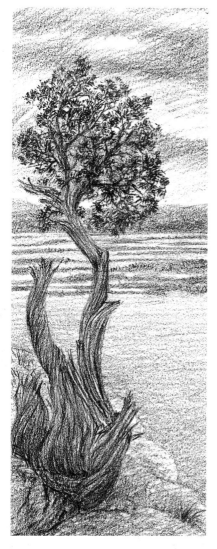

In the drawing of a sunrise over a river above, the strong silhouette in the foreground adds depth

At midday, the same scene above is brightly lit by the sun, so more detail and a lighter tonal range were used

This drawing of the river on a dull day (*above*) required more greys and fewer light and dark tones to convey the gloom

Studying different types of light

Practise sketching the same view at various times of the day and night to study different types of light. You can sketch a local spot in various weather conditions through the year. Note how sky colour and cloud formations affect the landscape. You can work at home, using your own photos for reference, but there's no substitute for open-air sketching – even if it's freezing outside!

Drawing Water

Water in a landscape – puddles and lakes, rivers and waterfalls, or waves crashing on to a beach – adds a fascinating focus. But you can't draw water itself – what you actually draw is usually light reflected on its surface.

Mirror-like reflections

Perspective plays an important part in depicting water. If trees, such as those shown below, are viewed at the water's surface level, their reflections will have dimensions similar to the trees themselves. If your eye-level were raised, you would see a foreshortened reflection – less of the trees would be visible in the water. Allow for the fact that the reflection of an object such as a boulder set back on a river bank (*right*) is interrupted by the bank and its own reflection.

The swampland trees below were drawn in HB pencil on textured paper.

The reflections were broken up by erasing the marks in some places

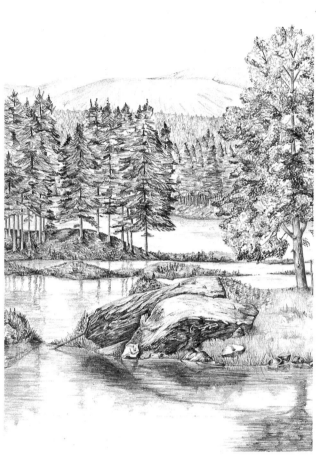

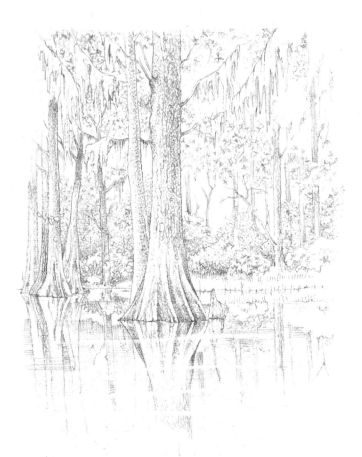

In the drawing above, I conveyed the steady, even current of this river by breaking up the reflections with short, parallel B-pencil strokes

Broken reflections

Ripples 'slice up' reflections, displacing the slices and leaving gaps between them (*left*). A tree's reflection in gentle ripples can still be recognized, but increased rippling would fragment it into abstract patches of colour.

You can depict broken reflections in one of two ways. You can draw a clear, mirror-like image, and then break it up by rubbing out the pencil marks with the sharp edge of a rubber, as in the drawing on the left. Alternatively, the general shapes of the objects reflected can be shaded using short, broken, parallel lines, as in the drawing above – the edges of the reflections are indistinct, conveying the ripples on the water.

Water in shadow

When you see water in shadow, it acquires a transparent appearance. In the drawing below, you can see through the water to the stones at the bottom of the lake. This is only true, though, in shallow water. Large bodies of deep water in shadow will appear dark and gloomy.

The nature of water

Quick sketching, previous observations and an awareness of the forces at work on water can help you to capture its free form. You can watch water in motion by filling a bath – look at how water flows and spreads over the bottom, how it twists as it falls, the way it hits the water surface, and how it runs away as the bath empties. The lessons you learn from sketching these effects may be invaluable for open-air work.

Here, you can see how light and shade affect the transparency of water. I could see the bottom of this lake where the water was in shadow

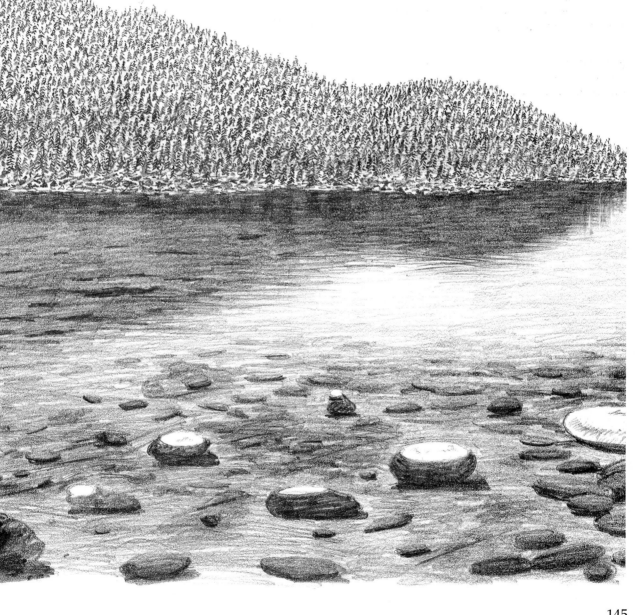

Movement

Water surfaces are animated by a complex mix of winds, currents and turbulence (created as water flows over a river bed). Currents and winds running in the same direction generate parallel waves, but create irregular, choppy ones when they are opposed. You need to be able to illustrate the sluggishness of a slow river or lake current as well as the power of ocean waves.

The ripples or small waves on the surface of a lake or stream indicate the direction of the current. These can be conveyed by using short, parallel strokes. Alternatively, if you need to show the movement of a fast-flowing river or waterfall, you should use longer, freer strokes.

To illustrate waves at sea, use horizontal, undulating lines to represent the crests of the waves. Remember that perspective comes into play. The vertical spaces between the crests become more narrow as they recede into the distance. Don't forget that bodies of water reflect the colour of the sky and nearby landforms.

Short strokes were used for the calm sea below. Curved strokes form the breakers. Undulating lines of stippling mark the extent of the sea foam

Dark and light 2B-pencil strokes gave the contrast needed to show the light reflecting off these waves breaking on cliffs (*below*)

Long, flowing lines, made with an HB pencil on textured paper, capture the movement of these waterfalls (*opposite*)

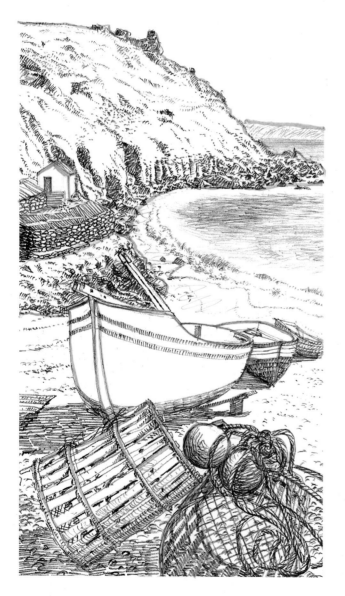

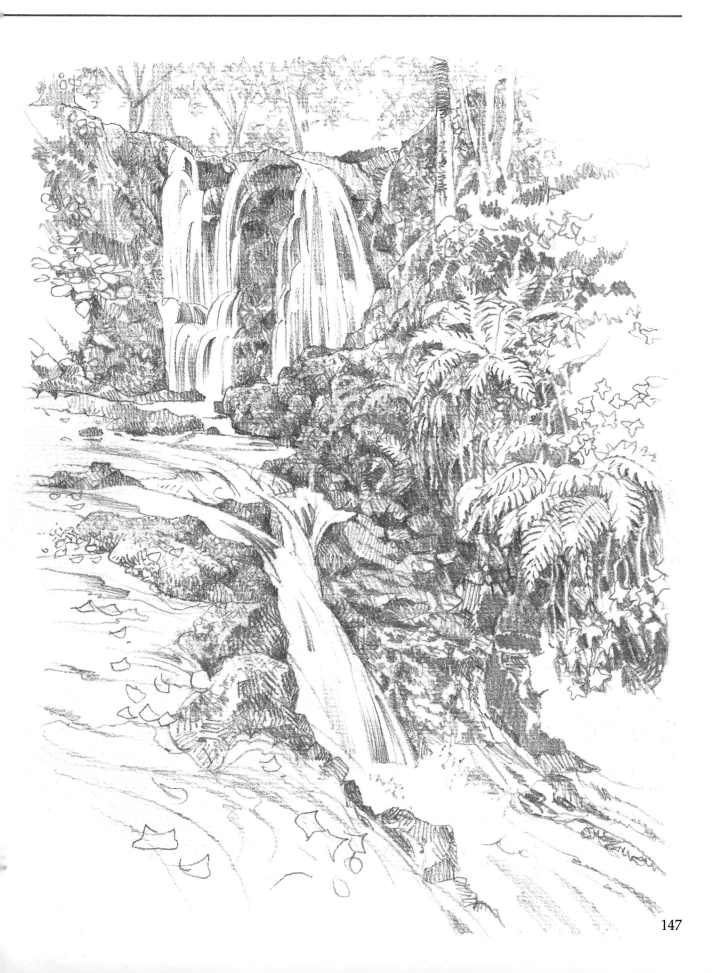

Plants and Flowers

Woodland spring bluebells, red poppies in a summer field, or a hedgerow of red, orange and black autumn berries and seeds add interesting seasonal clues to pictures. Drawing from life ensures a plant has a natural location, but remember, when adding pictures of plants from a sketchbook, to check that you are placing them in the right kind of habitat.

Studying shape and form

Realistic drawing comes from keen observation. Like trees, plant structures – leaves, stalks and flowers – have volume; note how light and shade play on and inside these structures when you begin drawing. Look at the parts of a plant. Most leaves have a bilateral symmetry divided by a central vein; but are they long and thin or teardrop shaped? Are the edges serrated, wavy

This carpet of 'dame's lockets' (below) conveys lush springtime growth in lakeland woods

From a low eye-level, I isolated this plant (right) and drew it in great detail against the sky

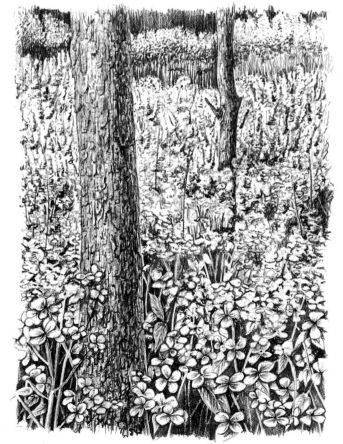

or smooth and are the tips pointed or rounded? Where do leaf stalks branch off the main stem? Many alternate from left to right at regular intervals, but others join in clusters of two, three or more at the same spot. If there are thorns, look for a pattern to their arrangement.

A study of plants soon reveals the importance of spiral forms, from spiral clusters of sunflower seeds to clinging honeysuckle stems. When seen from above, leaves often spiral round a stem to maximize the plant's absorption of sunlight. But don't draw plants as if assembling kit parts or you'll only create lifeless forms. Try to sketch the main forms of a plant in flowing, organic lines, adding detail later.

Practise sketching pot plants at home. A useful exercise is to sketch cut flowers at various stages in their decline, noting changes in form and texture. You can enliven a landscape by mixing living plants with dead or dying ones.

I used a fine ball-point pen
to sketch these poppies
on a hillside

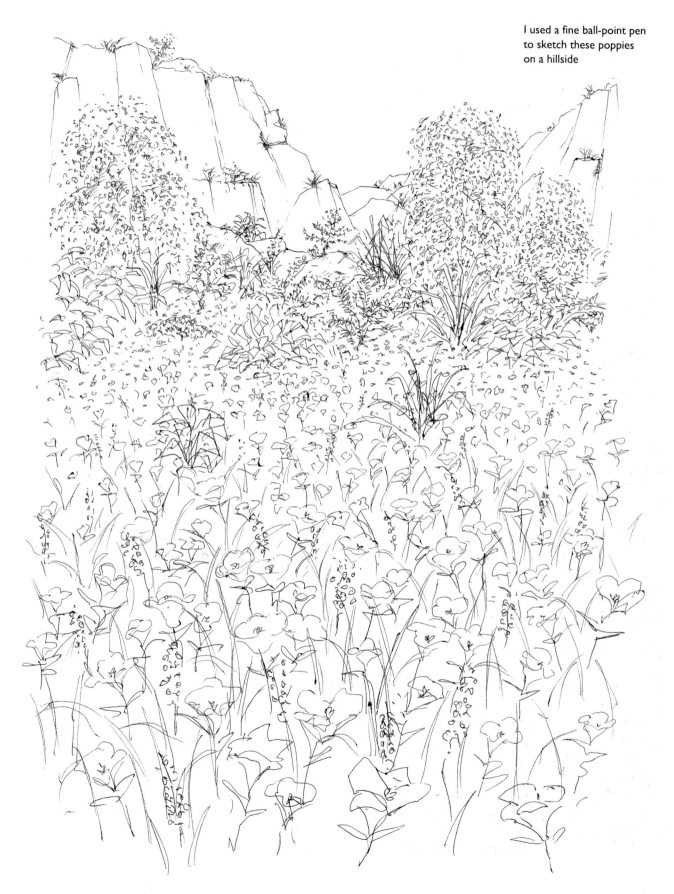

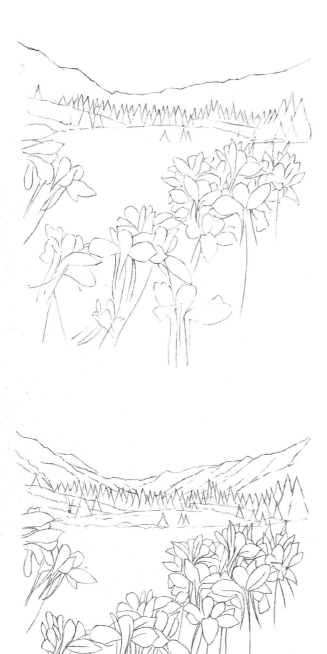

Large expanses of flowers

If you draw plants in large expanses, it is best to draw those nearest in more detail and darker than those further away, which should be seen as a mass receding into the distance. The 'dame's lockets' on p. 148 have been represented thus. In this respect, regular rows of cultivated plants are easier to draw than masses of wild plants. To give depth to such drawings, it is always good to have a few plants and flowers looming large in the foreground, as in the drawing opposite. In this way, the viewer will have an idea of how those further away are supposed to look in terms of detail and texture.

If your focus is on flowers in the foreground, sketch them in first, then look for the main lines of form or shape in your subject to help you in your composition. Add background detail lightly, using perspective and the relative positions of objects to create a sense of volume and depth. Add texture, shading and detail only when you are happy with your initial sketches.

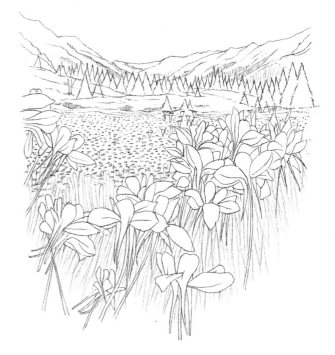

I began by sketching in the main features of my composition (*top*), with an HB pencil

I went on to outline the valley, trees and mountainsides in faint strokes (*above*)

I began to flesh out the sketch by adding light detail to the receding expanse of flowers (*above*)

Darker tones, textures, and final details were added in 2B pencil to complete the drawing opposite

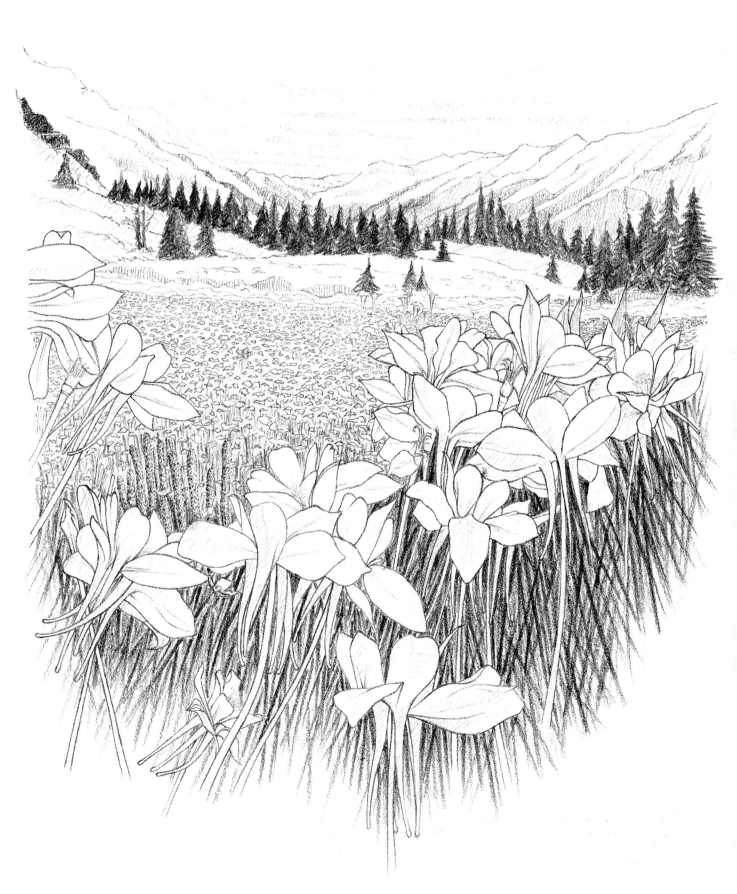

People in the Landscape

We naturally empathize with people in a drawing. However far away they appear to be, they provide scale and add dynamic movement to any landscape. Unless they are in repose people don't stay still for long, so you need to work rapidly to catch the fleeting essence of movement. Observe and draw what you see – don't invent or draw what you think you know; practice will help you to freeze movement in your memory after a subject moves away. Try not to be too conspicuous when you sketch – you're unlikely to frighten people away but you can make them self-conscious, causing them to adopt stiff, unnatural poses.

Whenever possible, I use my sketchbook to note figures which may be useful to add to any compositions that I might create at a future date. Usually, I begin by capturing the essence of a pose; then, if possible, I add detail at a later stage

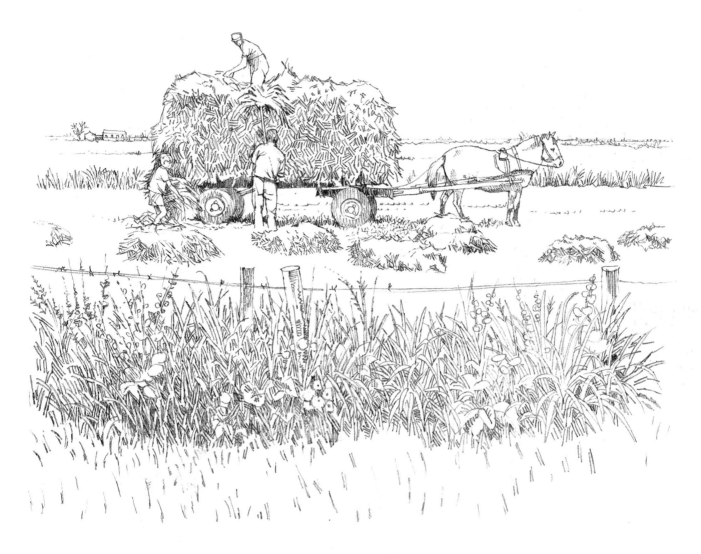

Using an H pencil on layout paper, I drew this scene of the countryside at harvest time. I decided to animate it with people gathering hay

Movement and proportions

You can practise sketching people anywhere – urban studies in a sketchbook easily transpose to a rural landscape. Observe how people walk or run, how they pull or carry heavy loads, and how they relax when they sit down. Try to capture characteristic movements of people at work – the gestures of a farm labourer making hay or herding cows.

Contrast the slow, perhaps painful gait of old people with the sprightly movement of children at play; don't forget that children are not miniature adults – their heads are larger relative to their bodies when compared with the adult physique. Concentrate on capturing body forms and the movement of limbs; facial detail and clothes are less important in landscapes.

Crowds and perspective

Human interest in a landscape can be provided by one or two solitary figures. But you may want to show groups. If so, you'll need to include space around the figures to create a sense of volume and depth. Even people huddled in a tightly packed crowd need space around them – watch how figures overlap and hide the forms of those adjacent to them, and cast shadows on each other. Light should fall on all figures from the same direction. People in the background should appear to be smaller than those in the foreground.

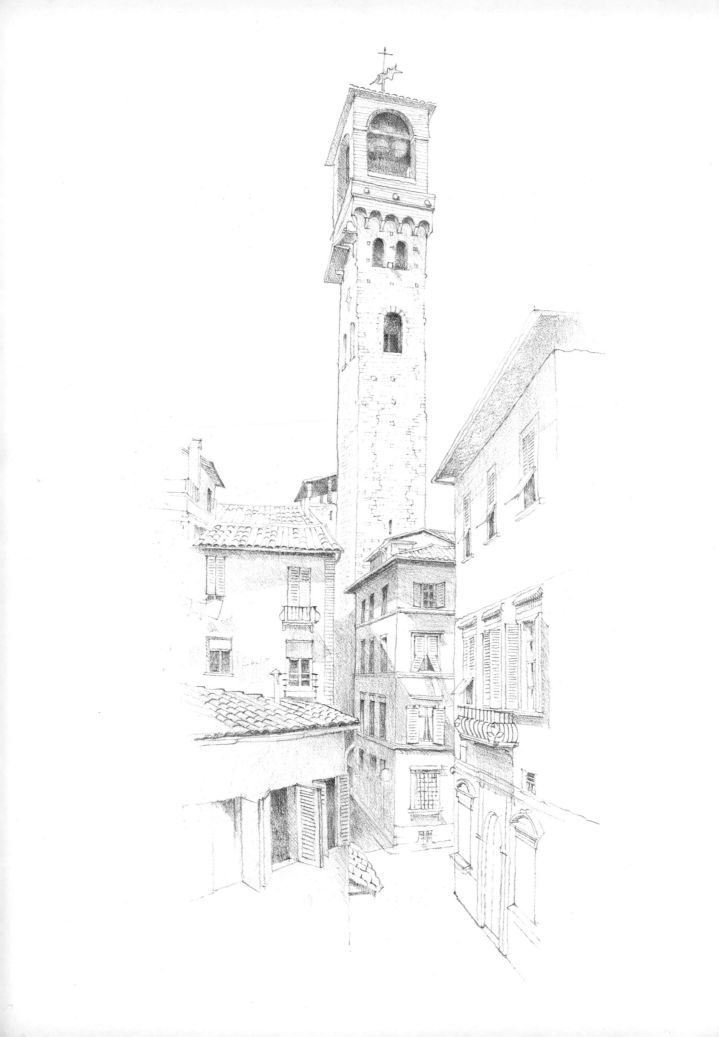

Buildings

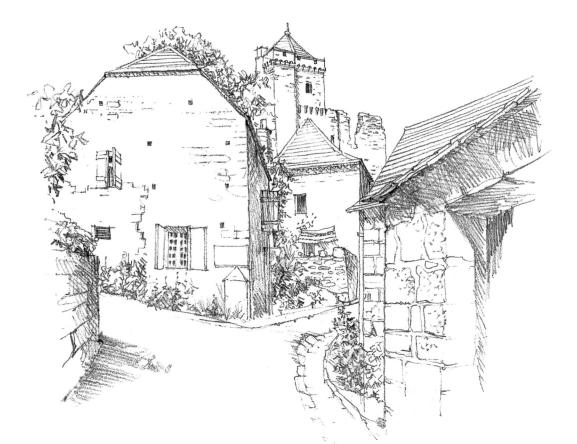

David Cook

Choosing the Right Medium

1

2

3

The drawings on these pages are all of the same half-timbered cottages by a river – yet each is quite different. This is because the different media and techniques used give each of them a unique appearance. Tools and surfaces combine to determine the 'feel' of your final drawing. Pastels and watercolours, for instance, create softer, more blended images, especially when used on soft, absorbent papers. Hard pencils and pens used on tracing paper or smooth board allow more detail and sharper lines, giving the drawing a more precise feel.

The tool you use also affects your technique – the type of marks you make when drawing. Some tools allow you to make many different types of marks. With a pencil, for example, you can make short sketchy lines or you can blend lines together for a softer feel. Dip pens are excellent for sharp, precise lines, as in technical drawings, or for making patterns to create textures.

Drawing tools and surfaces are discussed in more detail on pp. 8–15.

Try to become familiar with a variety of drawing tools and paper surfaces; if you are uncomfortable with your equipment, it will show in your final drawing. Learn which tools and surfaces produce which effects, and before starting your drawing, decide which to use by considering the appearance you want to create.

The drawings on these pages were made with the following combinations of tools and surfaces:
1 Soft pencil on cartridge paper
2 Dip pen on cartridge paper
3 Charcoal on Ingres paper
4 Ball-point pen on Bristol board
5 Watercolour on watercolour paper
6 Coloured pencil on cartridge paper
7 Hard pencil (HB) on tracing paper
8 Pastels on Ingres paper
9 Felt-tip pen on layout paper

4

7

5

8

6

9

Measuring in Drawing

Pencil measuring
Hold your pencil upright in your outstretched hand (*left*), with the thumb uppermost on the pencil. Lining up the top of the pencil with the top of the object you want to measure, use your thumb to mark the bottom of the object. Keeping your thumb in place, move the pencil to the paper to transfer the measurement.

Transferring what you see accurately onto paper is one of the most difficult drawing tasks. There are several simple ways to make this task easier.

Be careful not to misjudge the size of objects in the distance. Check your accuracy by measuring the object. You can do this easily from where you stand by using your hand, a ruler, or your pencil.

To begin drawing the entrance opposite, I first drew a grid with a horizontal line at eye-level and a central vertical line (*below left*). I measured the entrance's proportions with a pencil. Working in sequence, I began to outline the main elements in relation to the grid

As I was working with a soft 2B pencil, the original vertical and horizontal grid lines soon began to disappear into the background as I sketched in the lines that would represent the roof, storeys, columns, windows and recesses of the entrance (*below*)

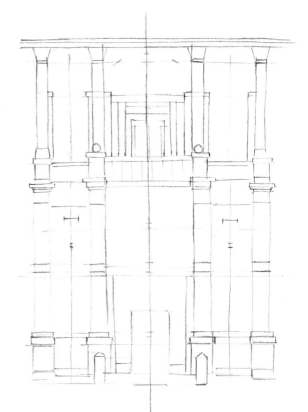

You can check the width of objects by holding the pencil horizontally; incline the pencil to check the angle of slopes.

Verticals and horizontals

To ensure accuracy and correct proportion in your drawing, you can create a grid on which to place all the elements that form your subject.

Measure above and below, and to either side (respectively) when adding the other verticals and horizontals. Use pencil measuring to achieve the correct proportions.

Start by drawing a faint horizontal line across the middle of your paper at eye level. Then draw a vertical line down its length. These lines will be at the centre of your grid; use them as points of reference for the object you are drawing.

Gradually build up your drawing. First, add the other main verticals and horizontals, such as doorways and windows; then go on to add detail to finish it off.

Once I'd outlined the basic structure of the entrance, I started to add details such as blocks and windows (*below*). These should always be drawn last so as not to distract from the proportions of the subject. My finished drawing (*right*) was done with a 2B pencil on Bockingford paper

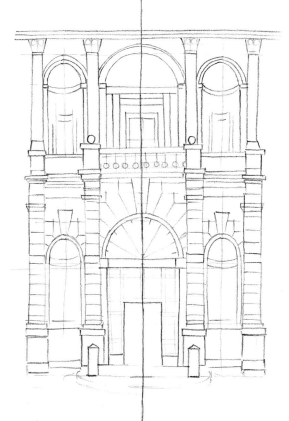

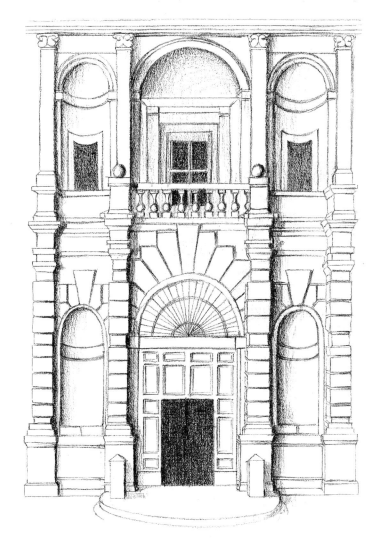

Using Shapes in Drawing

When you begin drawing, you may be overwhelmed by a building's complexity. You may find that the finished drawing doesn't look right and doesn't seem to 'work'. It is helpful to remember that a building consists of various solid forms that have a spatial relationship to each other. Your powers of observation will improve and drawing will become easier once you can understand how these forms and relationships work together.

Reducing a house to a silhouette will make you ignore superficial detail. The silhouette here (*right*) is really just a large square and two

rectangles, yet compare it with the fully detailed house at the bottom of p. 161! I've drawn some more diagrams to help you understand how to illustrate the detail. Compare each one with the detailed version.

This sketch (*right*) expresses the house in vertical lines and emphasizes the vertical spaces between parts of the house. Eliminating the visual distraction of the horizontal gutter under the eaves makes you more aware of the true depth between the roof ridge and windows

Here, the house has been expressed as a series of horizontal strokes (*right*) to show the horizontal spatial relationships. Notice the width of the gaps between the windows

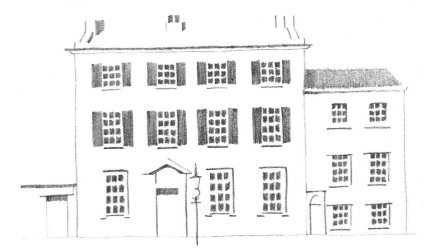

As well as looking at geometric forms, you'll learn a lot about how a building 'works' by reducing it to light and dark areas. You'll see that I've rendered the different shades as either black or white (*left*). I eliminated all lines except the bare minimum needed to hold the shape together

The finished drawing (*below*), complete with shading, was done with a 2B pencil on tracing paper

'Dissect' as many different buildings as possible. Try to use shapes such as circles or triangles, as well as squares and rectangles. You can work from life or use photographs. After a while, your eye will become trained and you'll be able to represent a building accurately without dissecting it.

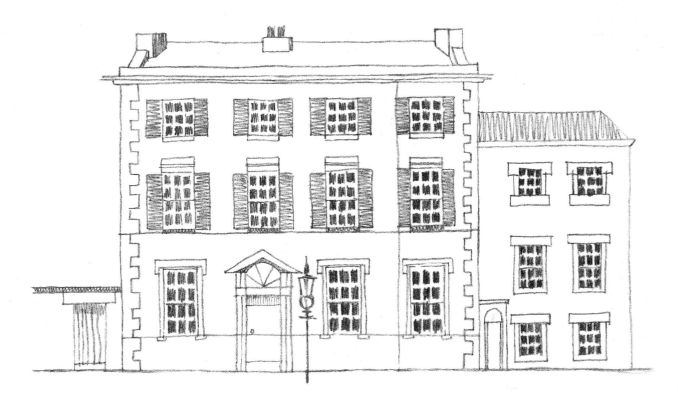

As you analysed the two-dimensional forms of the house, you can now go on to discover how any building can be broken down into simple, easily drawn, solid geometric forms.

It's a good idea to practise drawing basic forms. The main ones you'll need are cubes, cuboids (box shapes with unequal faces), tubes or cylinders, prisms and pyramids. The section on perspective (pp. 164–9) will help you draw them from different viewpoints. Once you can sketch buildings using the simpler shapes, you may feel ambitious enough to use a half sphere as the basis from which to draw a domed building.

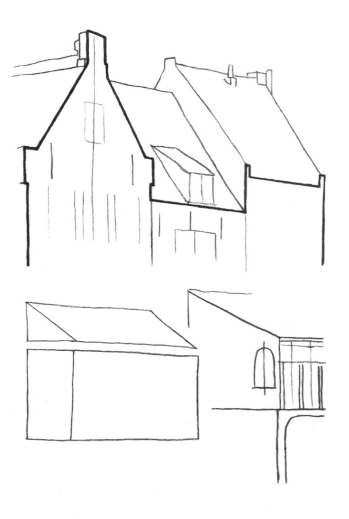

The basic solids you'll need are (*below*) a cylinder, a cuboid, a

cuboid seen from a different viewpoint, a cone and a pyramid

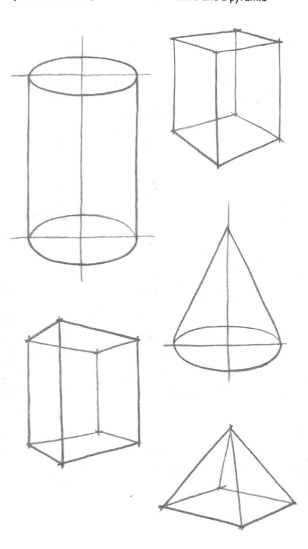

The old houses opposite may look a hopeless confusion of forms, but like any other building, they break down into simple forms (*above*). The wall that supports the main roofs is common to all three houses. It is a single plane to which you can attach all the balconies, which are made up from cuboids and prisms.

I drew these old houses in Enkhuizen, in the Netherlands, with a B pencil on Bristol board. You'll find that even the most complex building or group of buildings can be reduced to basic geometric units

When you feel confident drawing solid shapes, you can use them to create a finished picture of a building. By using one shape as the basis from which to 'build', you can add other geometric shapes until you have the outline of your subject. Then you can add the detail.

Space and Perspective

Space and planes

Representing three-dimensional buildings on a flat, two-dimensional surface (paper) requires an understanding of perspective and space. When looking at objects, those nearer you look larger than those further away. To help you with drawing in perspective, measure the relative sizes of close and distant objects with a pencil.

We can divide the space in which objects lie into three planes: the **far distance** – the furthest plane; the **middle distance** – closer to you; the **foreground** – nearest to you. On paper, you combine these three planes to make your drawing, remembering that objects diminish in size the further they are from you. This view on your paper becomes a fourth plane, the **picture plane,** in which objects near and far appear to be next to each other.

In the diagram (*top*), I have shaded three buildings in the far distance, middle distance and foreground. The same buildings have also been shaded in the plan view of the street above

In the drawing (*left*), you can see the recessional values of space at work, giving depth to the scene

Viewpoint

Your **viewpoint** is the position from which you look at a subject. If you stand below a building you will not be able to see the top of it. If, however, you are level with its top you will see less of its bottom. Therefore, viewpoint is important when selecting a position from which to draw your subject.

Eye-level

Your eye-level is an imaginary horizontal plane running from your eyes for as far as you can see. The horizontal lines of buildings (unless parallel with you) will appear to slope down to a point in the distance, if they are above your eye-level, or slope up to the same point if they are below your eye-level.

As your viewpoint changes, so will objects seen below and above your eye-level.

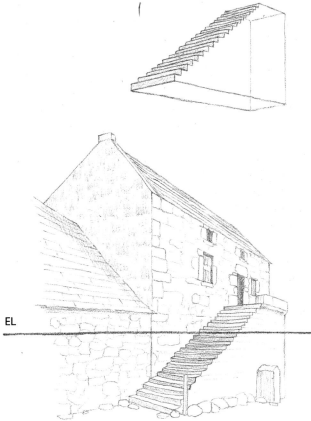

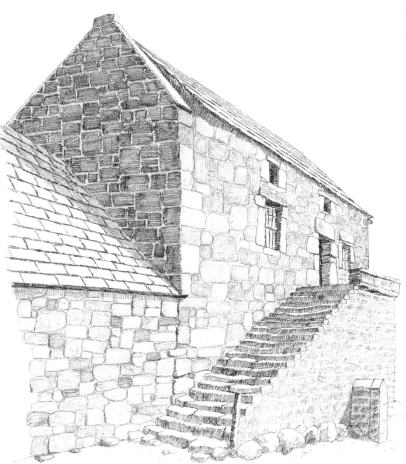

The line EL, in the centre diagram above, represents your eye-level. Note that if you viewed the stairs from a lower viewpoint (*top*) you would not be able to see the top of each step; but you would be able to if you viewed them from a higher viewpoint (*bottom*)

The final drawing was done in B pencil on cartridge paper

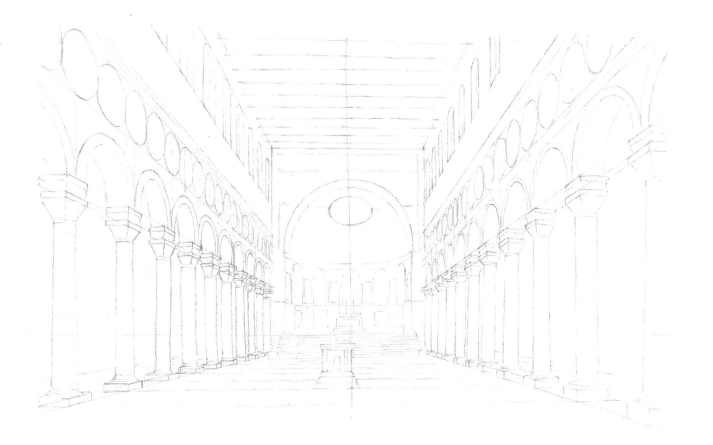

The arches and columns,
drawn lightly in pencil
above, direct the eye to a
central vanishing point

One-point perspective

An understanding of perspective lets you draw
convincing three-dimensional objects. The
sketch above perfectly illustrates **one-point
perspective**. The receding horizontals converge
to a point on your eye-level. This point is the
vanishing point (**1**). The vertical structures are
also affected. The further away they are, the
smaller they appear. They also seem to get closer
together, the spaces between them becoming
more narrow, as they recede.

If you move nearer the pillars on the right (**2**),
the horizontal lines of these pillars will converge
at much steeper angles than those further away,
on the left.

I

2

1 Here, you can see how
the horizontal receding
lines converge to a point
on your eye-level, at the
centre of your vision, the
vanishing point

2 If you move to the right
you see less of the pillars
on the right and more of
those on the left. This
affects the angle of
horizontal convergence

A two-point perspective of the Parthenon in Athens drawn with a 2B pencil on cartridge paper. The main lines of perspective are shown in the simplified diagram (**3**)

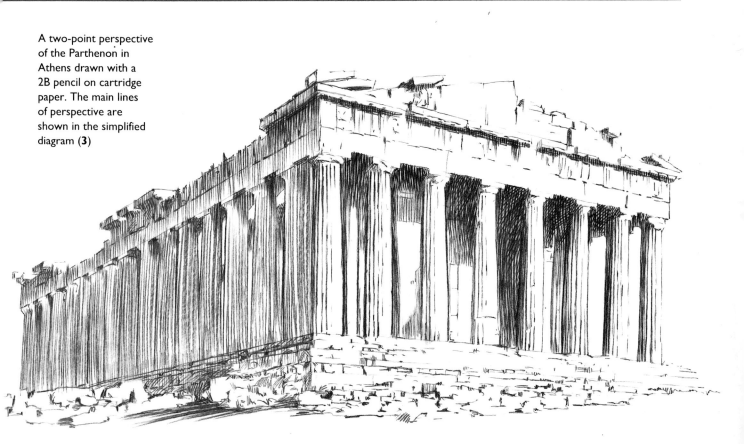

Two-point perspective

If you view a building with one of its vertical corners in the centre of your vision, two of its sides will be visible. The horizontal lines on either side of this central vertical line will converge. There will be two vanishing points – one on either side of the central vertical – and they will both be at eye-level. You will be using a **two-point perspective** if you draw a building from this viewpoint.

Moving vanishing points

Vanishing points change as you move around a building. The horizontal lines on the side that you move towards will converge at a shallower angle, and the vanishing point will be further away, than on the other side. For example, if you moved to the left of the central vertical of the Parthenon (*above*), the vanishing point on its left would seem to move further away as the one on the right would seem to move closer (**4**).

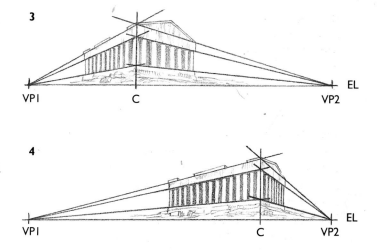

3 This diagram shows two vanishing points, VP1 and VP2, of the Parthenon drawing (*top*). C is the centre of your vision, and EL is your eye-level. Note how the pillars (and the spaces between them) on both sides of C become smaller as they recede

4 As you move around the building to the left, so VP1 will move further away from C and VP2 will move closer. If you were to move so far round that you saw only the left side, the horizontals would be parallel, with no visible vanishing points

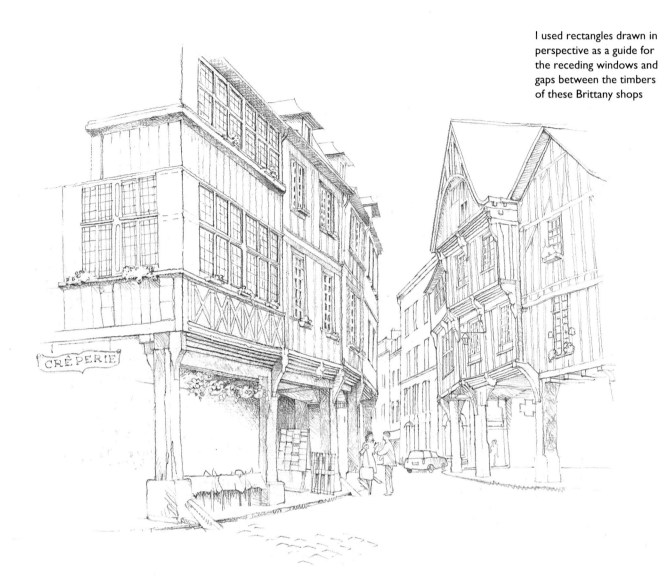

I used rectangles drawn in perspective as a guide for the receding windows and gaps between the timbers of these Brittany shops

These simple construction lines show you how to mark off equal horizontal distances along two parallel lines receding towards a vanishing point

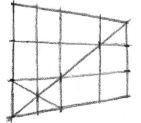

Divisions

Any shape drawn in perspective that is not parallel to the picture plane will be distorted. Luckily, basic geometry shows us how to cope with these distortions.

Diagonals drawn from the corners of a square or rectangle mark the figure's centre where they cross. A vertical and a horizontal line drawn through this centre-point will give the mid-points of the figure's sides. This holds true even on a rectangle drawn in perspective with converging top and bottom sides. This geometric property allows you to draw in perspective a row of windows of equal size.

These ruined arches may look like a nightmare to draw, but once you reduce them to squares seen in perspective, it's really not hard to sketch ellipses inside them to represent half-circles seen in perspective

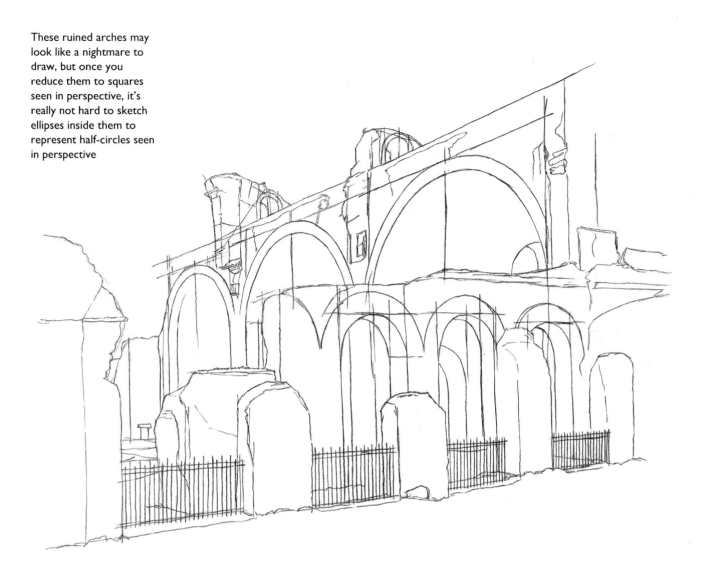

Circles and ellipses

A circle drawn inside a square just touches the sides of the square at their mid-points. A circle seen in perspective becomes an ellipse, but it will still just touch the inside mid-points of the sides of a square drawn round it in perspective. Use these points of contact on the square as guides for drawing a circle or a half-circle in perspective. The resulting ellipse should look as if it lies in the same plane as the square. Use the pencil measuring method to help get the correct proportions of a square in perspective. You are now ready to begin drawing arched windows and doors, arches, round towers and any other circles in perspective.

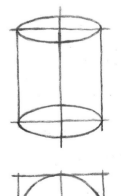

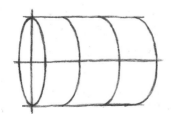

If you look over the rim of a cylinder, the ellipse you can see will fatten into a circle as your viewpoint slowly moves from the cylinder's side to its top

169

Light and Shade

Light and shade

You can show the three-dimensional form of a subject by using tones and shading to represent shadows cast by light. Strong, direct light – such as a brightly shining sun – will create dark, well-defined shadows. More muted light or light from several sources – such as lamps in a room – will create softer, less black shadows.

There are two ways we refer to shadow. The areas which the light does not reach will be dark – these are **in shadow**. The shadows created by objects as light hits them from one side are **cast shadows**. You might have cast shadows on areas in shadow, requiring you to use different degrees of shading.

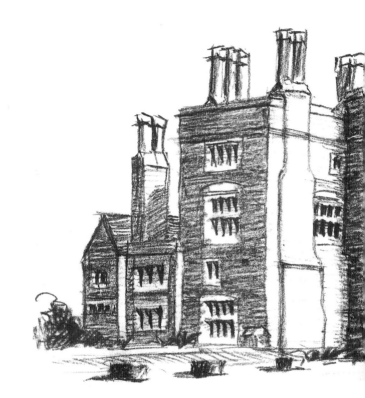

The towers below were drawn on cartridge paper with a 2B pencil. Light from the left leaves the main tower's right side in deepest shadow and casts a shadow along the ground to the right. The curved wall is shown as a series of flat surfaces

A great house such as this (*above*) provides excellent practice for applying light and shade. Charcoal on cartridge paper gave enough variety of tone to convey all the different shadow strengths

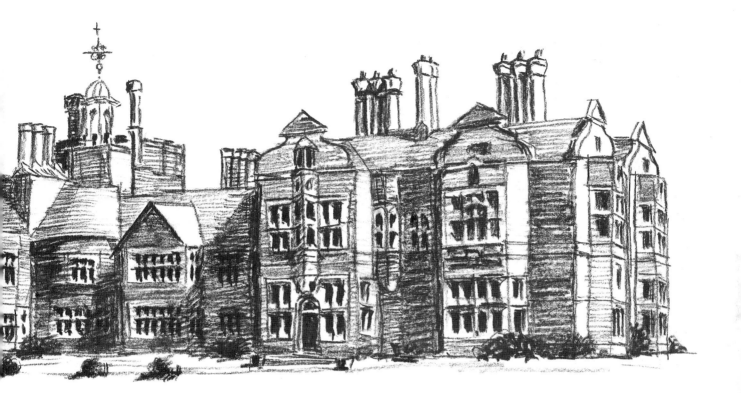

Use your perspective skills to draw a three-dimensional building. Note the light source and how it casts shadows and highlights on your subject. Make sure when you draw several buildings together that they all have one light source coming from the same direction. Treat all items as one picture, not single buildings.

Receding and protruding shapes
The large drawing at the top consists of many different shapes, some large, some small.

You might be put off drawing something that appears so complex. Yet careful observation of the strengths and tones of the different shadows will help you to draw the building in a way that will clearly show which parts protrude and which parts recede.

I brushed ink wash on to smooth paper to create the strong shadows of bright early morning sun on these Sussex seafront buildings. There are no variations of tone between black and white, but the buildings still have shape and form

Surface Texture

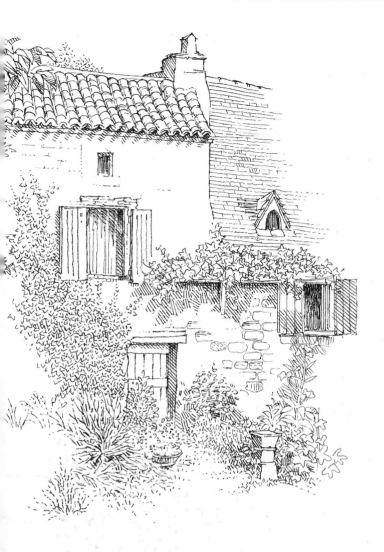

Invented texture

We build texture on paper by describing the tactile qualities of surface textures as patterns of lines, light and shade, using pencils, pens, charcoal, pastels, paints, and so on. When inventing patterns to represent textures, to avoid repetition and to leave something to the imagination, it is a good idea to suggest, for example, just a few bricks in a wall, or a few tiles on a roof (*left*). Thus, drawing a large brick wall will not become a laborious task.

A good way to learn about representing texture is to look at drawings and paintings, in galleries or books, to see what other artists have done. You will notice when doing this that not only do they invent textures to simulate real texture, but they also create texture to convey mood and emotion.

The bold strokes of a 2B pencil on cartridge paper, in this drawing of a group of houses, help to convey strong sunlight, which reflects off the rooftops and creates dark shadow in unlit areas

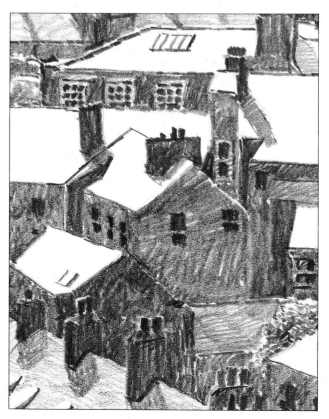

I carefully drew the shapes and textures of the stonework and tiles of this French villa (*above*) on textured paper with a technical pen. You needn't draw in every single stone or leaf to convey texture – I left large areas here blank

We do not usually notice texture unless we touch or feel it; yet, in real life, there are textures all around us. Texture is therefore very important in drawing to help suggest the surfaces of the objects we wish to draw: the roughness of bricks; the smoothness of glass; the glossy, painted surface of a window frame; or the fluffy texture of clouds.

On paper, we represent the real textures of things by using **invented texture**.

Mood and texture

As well as representing tactile qualities, you can invent abstract simulations of texture to convey sensation and mood. To do this, you exploit the qualities of the paper and tools with which you are working. You can then create bold and strong texture, as in the drawing of the group of houses opposite, or light and open texture, as in the drawing of the French villa. Experimentation is the best way to create abstract texture to portray the emotion you want in your drawings.

Fine detail was not used in the drawing of this castle. Rather, the effect produced by HB pencil on textured paper has been exploited

Working Indoors

Drawing indoors imposes fewer constraints than drawing outdoors. You don't have to worry about inconvenient weather conditions, and you can take more time on your drawing. This means you will have more choice of subjects and of media, and it offers the chance to tackle more difficult and detailed drawings.

Drawing in your home

Your own home is a good place to practise drawing interiors. Start by experimenting with foregrounds and backgrounds, aiming to get the correct proportions and relations among objects. Use pencil measuring to test your proportions.

The sketch of furniture and ornaments below was drawn with a B pencil on cartridge paper

You will need to find a comfortable position – either standing at an easel or sitting – that gives you a good, unobstructed view of your subject. Choose a time and position that offer strong natural lighting.

You might practise drawing the same subject from different viewpoints – such as standing, sitting on a chair, and sitting on the ground. Your eye level will change with each position.

Don't feel intimidated by detailed interiors. First get the basic shapes and sense of space. Details can be added later.

Dark but open 2B-pencil strokes on smooth paper convey the airiness of this conservatory (*opposite*)

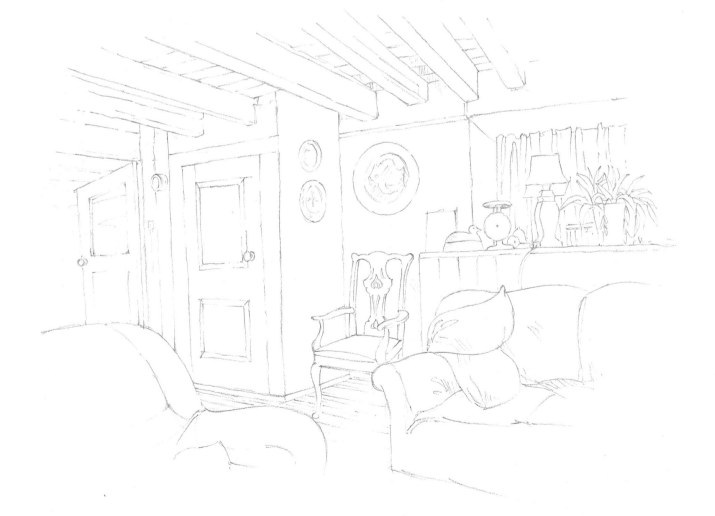

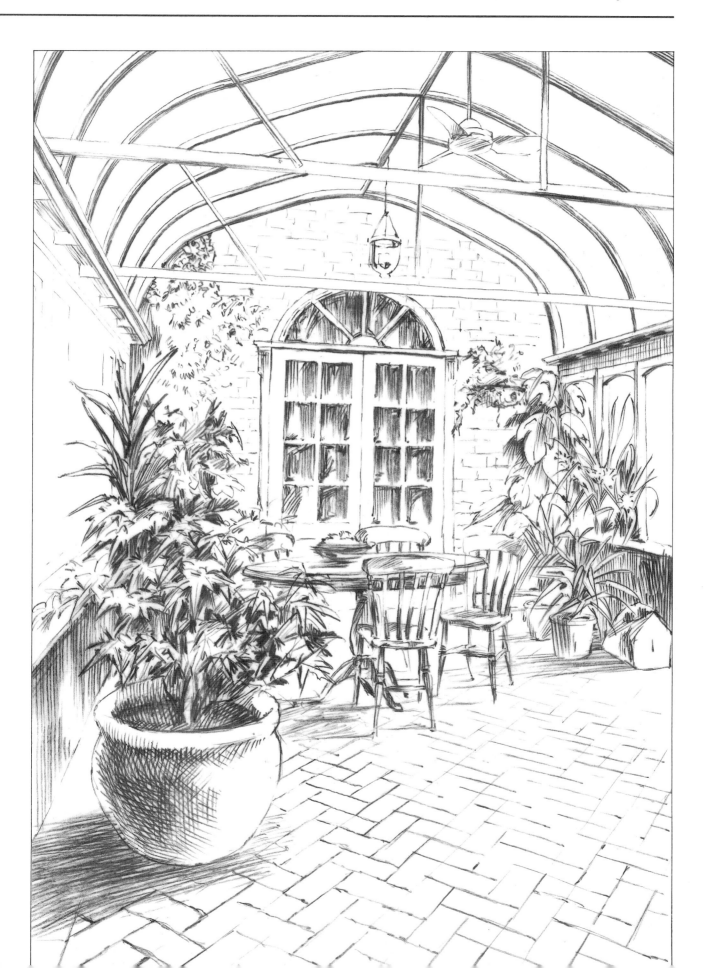

Thick, 4B-pencil strokes
on tracing paper captured
the contrasts of light in
this medieval barn

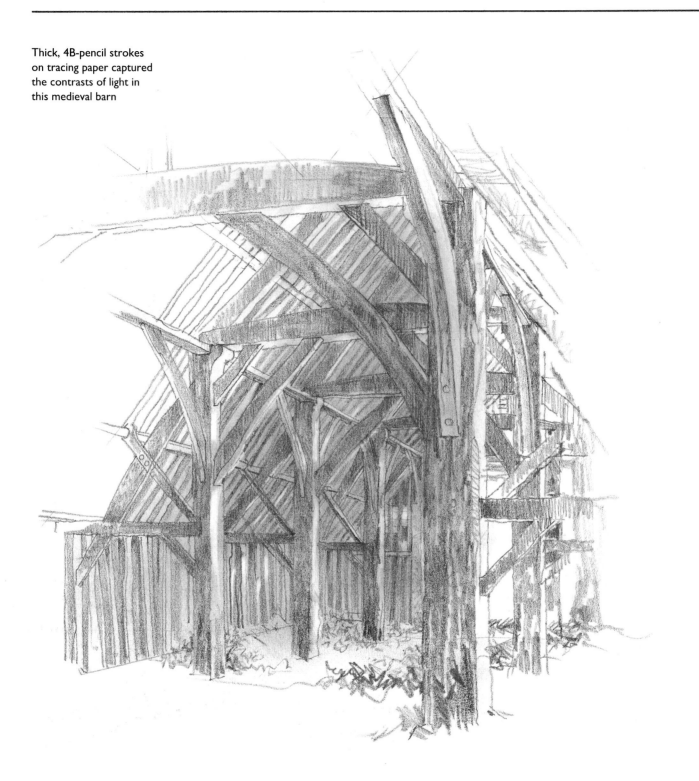

Drawing more complex interiors

More complex structures and the interiors of
churches or town halls will stimulate and
challenge you. Animate your drawing and give
it a sense of scale by adding people (see p. 183).

Good light and a comfortable drawing position
are vital – your sketch may take some time. Find
an unobstructed view out of the way of other
people. Use simple, portable equipment: spilled
inks or paints can lead to disaster.

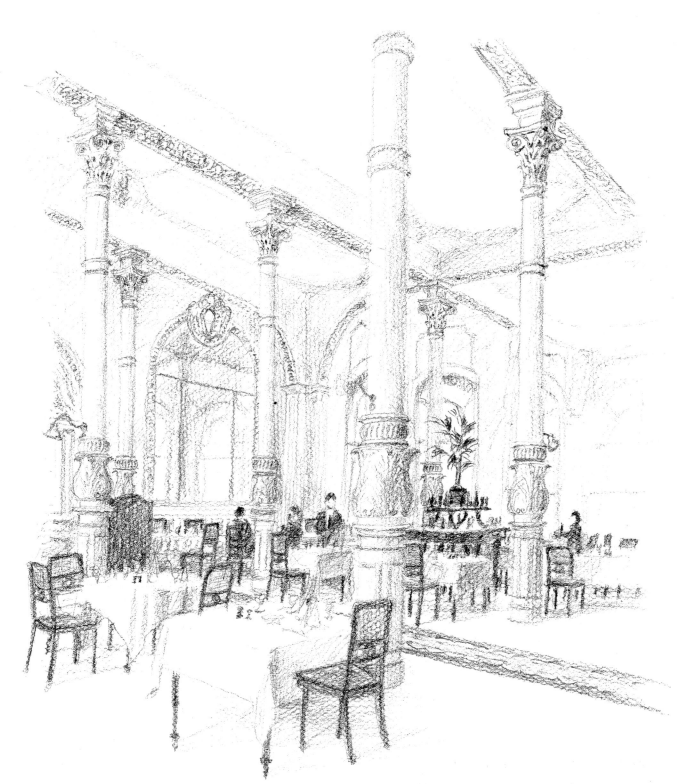

A 2B pencil used on
textured paper conveys
the formality of this
French hotel restaurant

Working Outdoors

Drawing on location

Drawing on location often means working quickly to capture a scene before the light changes or interesting figures move away. Whenever you sketch, you should consider which drawing style best conveys the feel of your subject and how much time you are likely to have for a sketch. Fast, sketchy pencil work may best capture bustling figures in a market, but in a formal study of intricate carving on a cathedral entrance, you can afford the time for a detailed pen and ink study.

Where to sit or stand

Find a spot where you won't attract attention. Concentration is harder outdoors, so try to find a position free of distractions.

Be sure to find a comfortable spot. Combining comfort with the best vantage point can be hard, so try several spots before you settle down.

Tools to take

Take portable equipment that you can easily carry in a shoulder bag. Sketchpads are best, as they provide a hard surface on which to work.

Consider your working conditions. Paints and inks require water and jars, and may not be practical. Start with a range of pencils and pens. Other useful items include clips, tape, tissues and perhaps a sealed container of water for cleaning brushes or creating effects. Look after your tools and don't leave anything behind!

Distance from a subject

The distance between you and your subject is determined as much by your composition as it is by practical concerns, especially if a subject is on private land or in a dangerous spot.

Try to see your entire subject. Even if you draw only part of a building, you'll find you understand it better if you can see all of it.

Position yourself parallel to your subject so that you need only move your eyes – not your entire head – from one side to the other (*above*)

Also, decide whether you want to sit or stand. You could use a lightweight folding chair on level ground. If this is not possible, a comfortable spot on dry ground may provide a good vantage point. If you do a more detailed study, you may prefer to stand and work at an easel

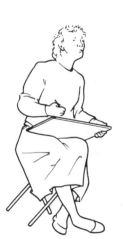

For this church, I used a ball-point pen on smooth paper. Though good for simple sketches, ball-point pen can be messy if shading is overworked

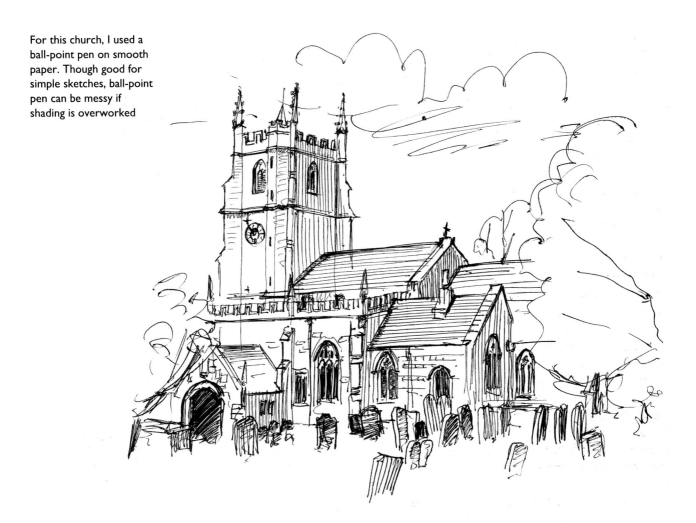

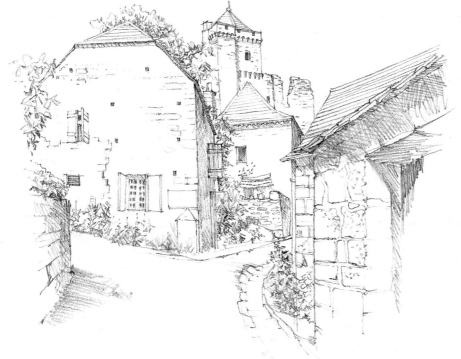

I sketched this French village with a B pencil on cartridge paper. I had no time to make colour notes, so I took some colour snaps to help me with my painting when I got home

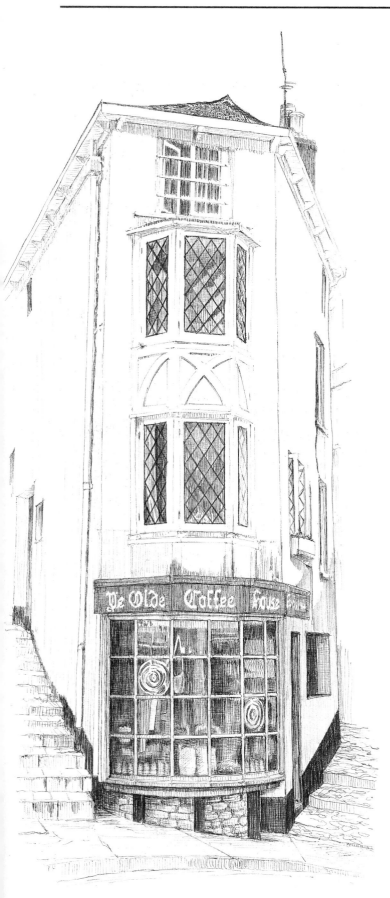

Drawing glass

Drawing the glass in windows can be like trying to draw the invisible. To help you to draw glass, begin by familiarizing yourself with the way windows look under different conditions.

Observe as many types of window as you can; in particular, compare those that are near with those that are far away, and those in sunlight with those in shade. Curtains, shutters, interiors behind windows, and even the frames of the windows affect the appearance of glass.

This drawing of a coffee house (*left*), in ball-point pen on Bristol board, illustrates the various ways in which glass can be represented

You can tell when a window is open or closed – a closed one reflects light, as shown below in 2B pencil on smooth paper

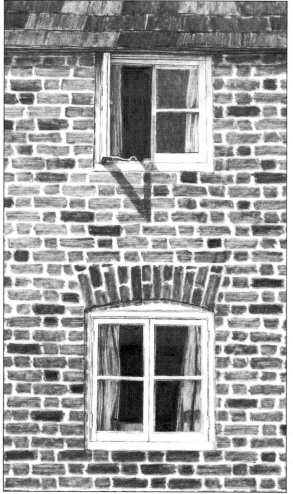

Transparency

Glass is transparent, which means that you often don't see it at all, but you know when a window has glass in it and when it doesn't. Although transparent, it is affected by light, shadows and reflections.

The presence of glass in windows can be suggested by using tones. Vary the tones you use in each window pane, trying not to make them all identical. To avoid monotony in your drawings, try not to draw every pane in detail.

The drawing below, in H pencil on smooth paper, shows a lit interior. Glass seems more transparent here than when the interior is dark (*opposite*)

Reflections

Another quality of glass is the way it reflects the world outside. This can be confusing for both the artist and the viewer, as other buildings, trees and even people can appear reflected in the glass of windows. On a tall building, the windows high up may appear lighter than those nearer the ground because the high windows reflect the sky, which is brighter than the buildings and other objects reflected in the lower windows. It often helps to limit the amount of reflected detail you include.

In strong sunlight, you will find that glass reflects the things around it, as I've shown in the drawing below, using ball-point pen on tracing paper

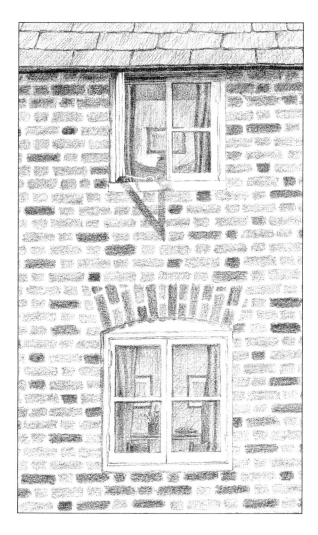

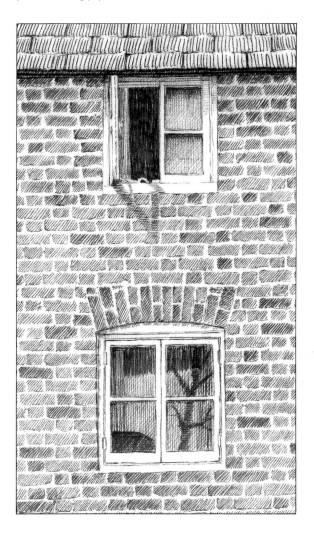

Street Life

You can enliven your drawing by adding street life and street furniture. People, cars, bicycles, lampposts, benches and phone boxes all add excitement and a sense of realism to your scene. Little details add telling atmosphere. A scene in a run-down part of town might include scrawled graffiti, peeling posters and pavement litter.

Street activity and street furniture

Street markets, busy city avenues, even country lanes abound with life and objects unique to that particular environment. The more information you include in your drawing, the more the viewer can sense the location, life and atmosphere of the scene.

In a French street, for example, letter boxes, wastepaper bins, telephone boxes and even the lettering on shops have a distinctive look that will help evoke a French feel to your drawing.

This pen and ink sketch on cartridge paper of Düsseldorf (*below*) lacks great detail, but a German shop sign and an avenue of trees, which is unusual in Britain, tell us that we are in a foreign country

I jotted down examples of street furniture (*above*), people and animals (*opposite*) in a sketchbook. It's an ideal way to collect and store details that can be incorporated in larger drawings or paintings. I often use details I sketched many years ago

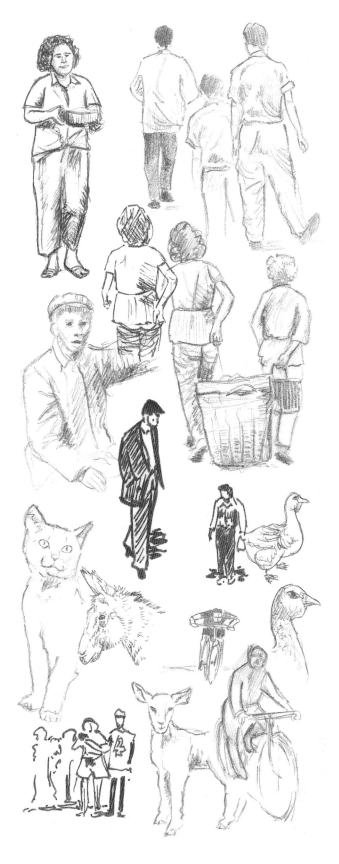

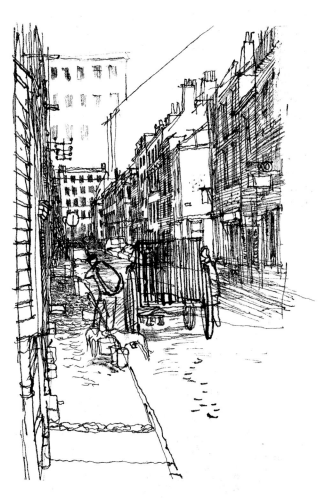

Even if I carry nothing else, I always make sure I have a fountain pen and small sketchbook to capture scenes like this (*above*), of a tradesman delivering from a horse-drawn cart

People and animals

People are vital to animate any scene. The presence of people and animals gives a sense of proportion, size and scale, and adds 'local colour', conveying the feel of the culture or customs, and maybe the uniqueness, of the place you have sketched.

Be careful not to clutter your drawing with too much detail. It helps to draw a few figures and other details first, then draw buildings and landscape around them. You can always add more figures later.

A square like the one on these pages is busy at most times. To convince, you need people in your drawing. But people interact with their surroundings – they window-shop, they wait at red lights, they admire the view from a park bench, they clean windows and they take snaps. Running or walking figures will add purpose and movement to a scene. Remember, too, that people interact with each other – show couples walking hand-in-hand, parents scolding a naughty child, someone giving directions or children playing.

I used pen and ink to draw this popular American tourist town. I chose cartridge paper to work on because I knew it wouldn't buckle when I added lots of ink. I varied my pen pressure to emphasize different aspects. I used heavy strokes for the statue to convey a sense of its solidity. The movement of the people is suggested by lighter, fluid strokes. Ink takes time to dry, so I carefully dabbed the finished statue with tissue paper to prevent smudging

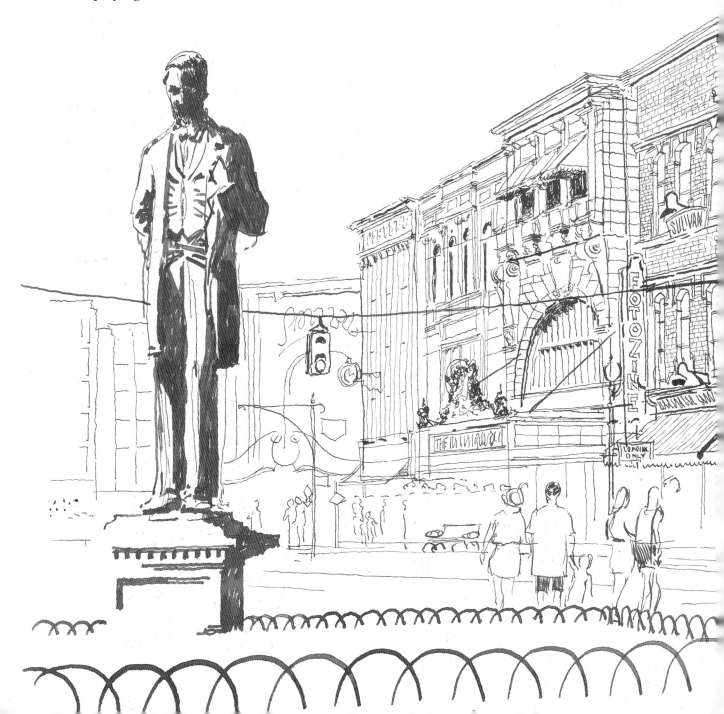

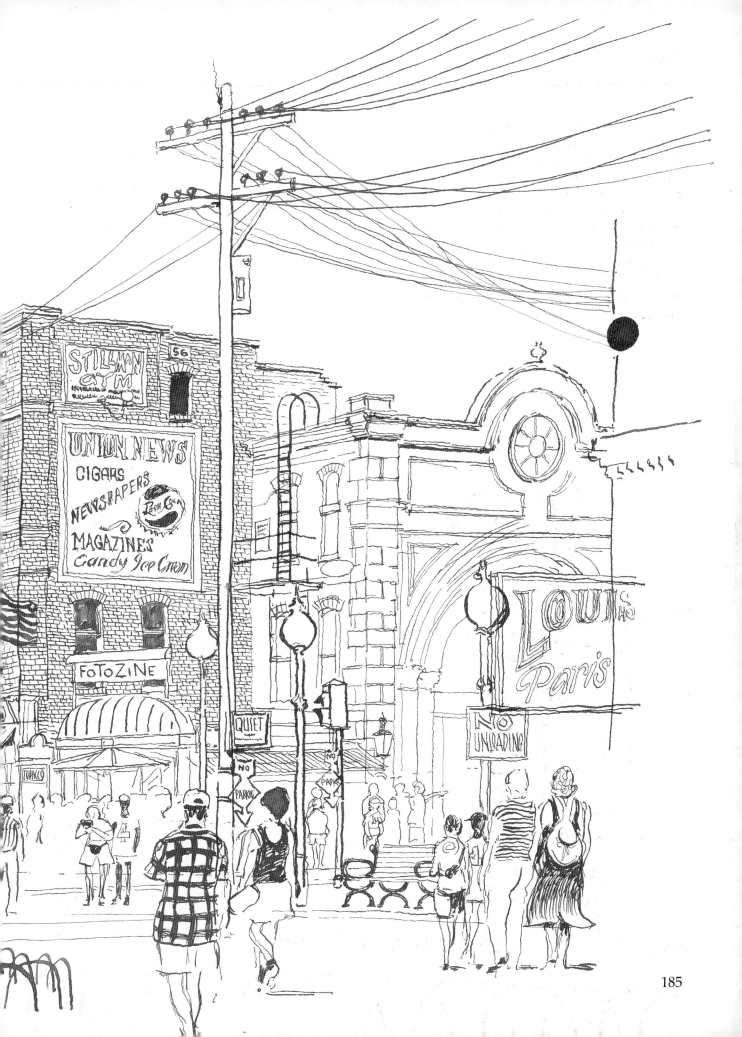

Buildings in Settings

Landscape can give vital clues to a building's locality and place in history. A mountain chalet sketch would mean little if you left out the mountains. A Norman castle drawn without the defensive hill on which it stands would remove it from its historical context and rob your drawing of much of its power.

Seasons and time

Trees can help show the time of year. In spring, buds or immature leaves reveal most of a tree's branches. By summer, mature leaves obscure most of the branches; in autumn, dead leaves litter the ground and branches begin to show again. Bare branches, of course, indicate winter. Shadows are telling clues to the time of day. A low early morning or late afternoon sun casts long shadows, but in the middle of the day an overhead sun casts much shorter shadows.

I drew this French château with felt-tip pen on cartridge paper. The full tree foliage and open flowers suggest that it is summer. The flowers and bricks give visual clues to the wall's height, which in turn helps us to visualize the size of the château

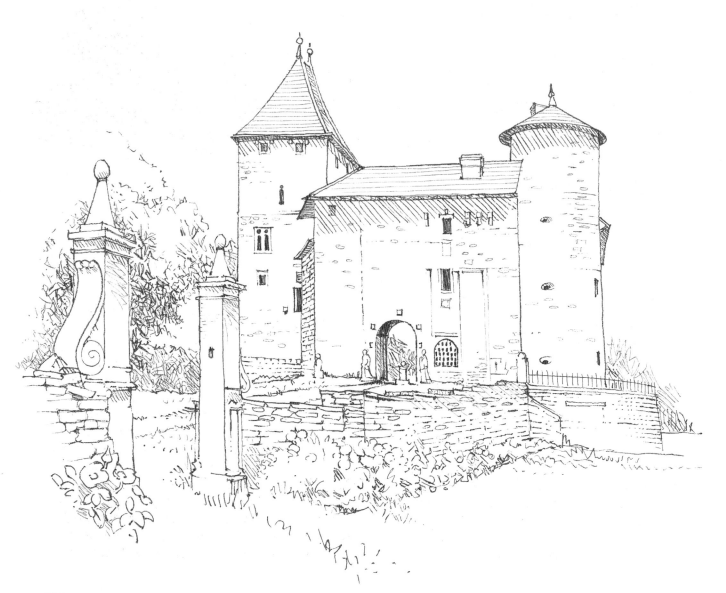

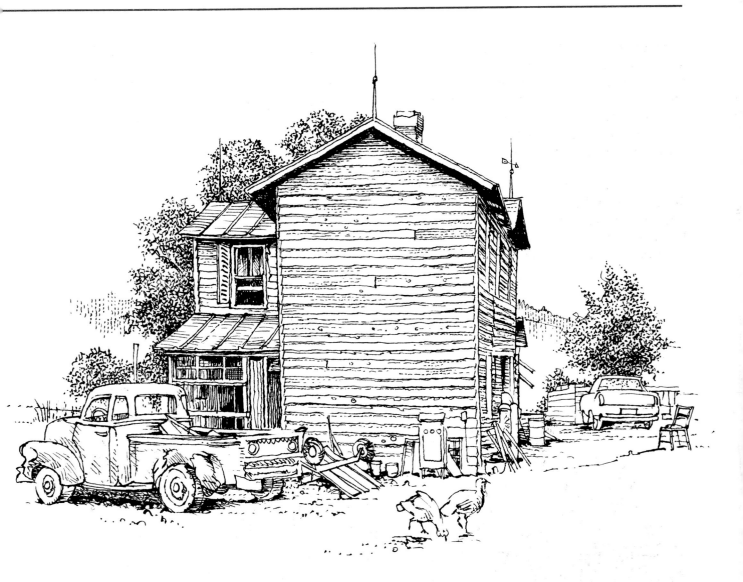

A detailed, high-key drawing of this Mississippi farmstead was made in pen and ink on textured paper. Imagine the building without any of the objects around it. We wouldn't know it was a farm house. We might not even know it was in America without the car and truck parked outside

Size and scale

A building lacks meaning if we don't know its size. Doors and windows on a house show scale because we instinctively relate them to the human figure. But a building like a high-tech factory may provide no easy clues to its size. Add people, cars or any other familiar objects to give scale to these sorts of buildings.

Showing a building's function

There can be little doubt about the role of a church. But function is not always obvious in architecture. For example, if you draw a small country station on a preserved steam railway, you might find the best viewpoint obscures any posters or lettered signs that are clues to its function as a station. If you don't include any surrounding railway detail, it may be difficult to recognize what your drawing represents. But the addition of a steam locomotive with smoke drifting from its chimney would immediately tell us that this is a railway station. A few coaches in a siding, a porter in old-fashioned uniform and some signals would be finishing touches for a drawing full of atmosphere.

This felt-tip pen on cartridge paper sketch of a church perched on a hill shows the sort of old town we would all like to visit. Yet without the buildings, the sketch would simply show an ordinary church to which few people would give a second thought

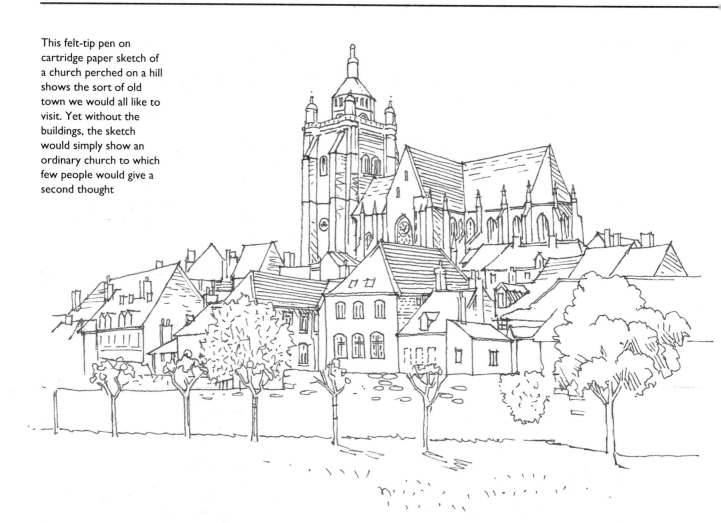

On the previous pages you saw how surroundings and associated detail convey information and lend atmosphere to an individual building. Similar principles apply when you're drawing a townscape, when, by definition, you want to capture some of the flavour of a town and not just a single building set in isolation.

A mining town set in a steep-sided valley may yield interesting Victorian terraced houses. If you concentrate on just a few houses and ignore the rest of the town, you'll lose the sense of row upon row of houses seeming to tumble down the valley sides. The distant parts of your drawing don't need to be drawn in detail – a few simple pencil strokes to show receding roof tops and chimneys can do the trick.

A sense of history

In a medieval town you usually find that public buildings, like the church or corn exchange, are in prominent positions. A cathedral might sit on a high spot in the town, so that it can be seen from a great distance. A guildhall, for instance, was an important meeting place for the dignitaries of the town, so its builders would often place it in an open square with room for people and horses to gather.

It would be an idea to try to see the guildhall and its square as a whole – taking such buildings out of context deprives them of historical meaning and reduces the visual impact their settings bestow. A modern market held in an old square would make an interesting contrast of old and new.

Marketplace activity

People and street clutter convey the atmosphere of a busy town. Nowhere is this more obvious than in a market. For example, many European towns retain their old 19th-century fruit and vegetable markets, which are often jewels of architectural detail. You could concentrate solely on the elaborate wrought-iron pillars supporting spacious curved glass roofs. But the busy chaos of a market – stalls piled high with crates of leeks, lorry drivers unloading bulging onion nets, porters wheeling trollies laden with potato sacks, dealers haggling over apples, and the trampled debris of squashed fruit, wrappers and broken crates – is what makes a market a living part of a town or city.

In summer, this German cathedral square teems with tourists. But I wanted my pen and ink study to show it on a winter afternoon. Bare trees lend a chilly feeling. Empty market stalls and a few solitary figures add an almost melancholy touch. Had I not included benches, trees and cobblestones to suggest a public square, the building could easily have been in the country

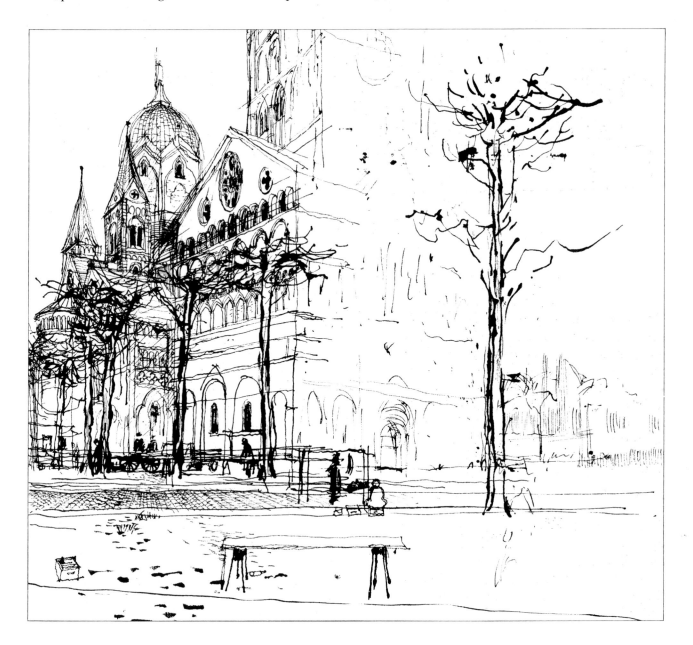

Creating a setting

Using your memories of various places, weather conditions, light effects and atmospheres, you can begin to create your own settings in your drawings. You may have a wonderful drawing of a building on its own that lacks life and atmosphere, to which you can add people and objects to enhance its surroundings.

Look in your sketchbooks for old sketches of artefacts and scenes that may help, or go out and sketch objects you would like to add to your drawing. You can even look in books, magazines or newspapers for helpful images or ask your friends or family to pose briefly for you to catch the stance of a figure you want to introduce to your drawing.

Remember to think about space, viewpoint and perspective when you add people or objects.

People drawn some distance apart from each other, and in perspective, will differ in size. Those in the far distance will be smallest while those in the foreground will be largest. Their feet, in the picture plane, will be on different levels: the further away the subjects are, the higher their feet will be. But their heads will appear to be on one broad level – your eye-level.

Once you have your composition, work out where you want your light source to come from and think about atmosphere: will it be a sunny summer day, or a dreary, wet and windy winter morning?

From the beach house sketches in my sketch-book (*below*) and sketches I made from books and magazines of boats (*right*), I created a beach setting (*opposite*). I changed the size of the boats to give the drawing depth. The final drawing was done in HB pencil on watercolour paper

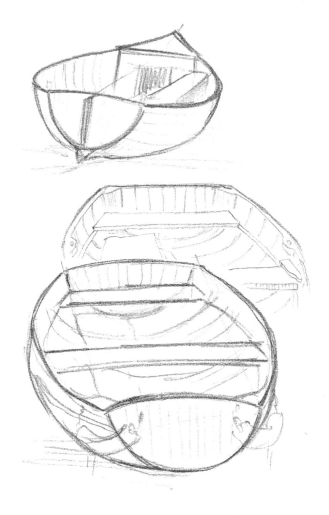

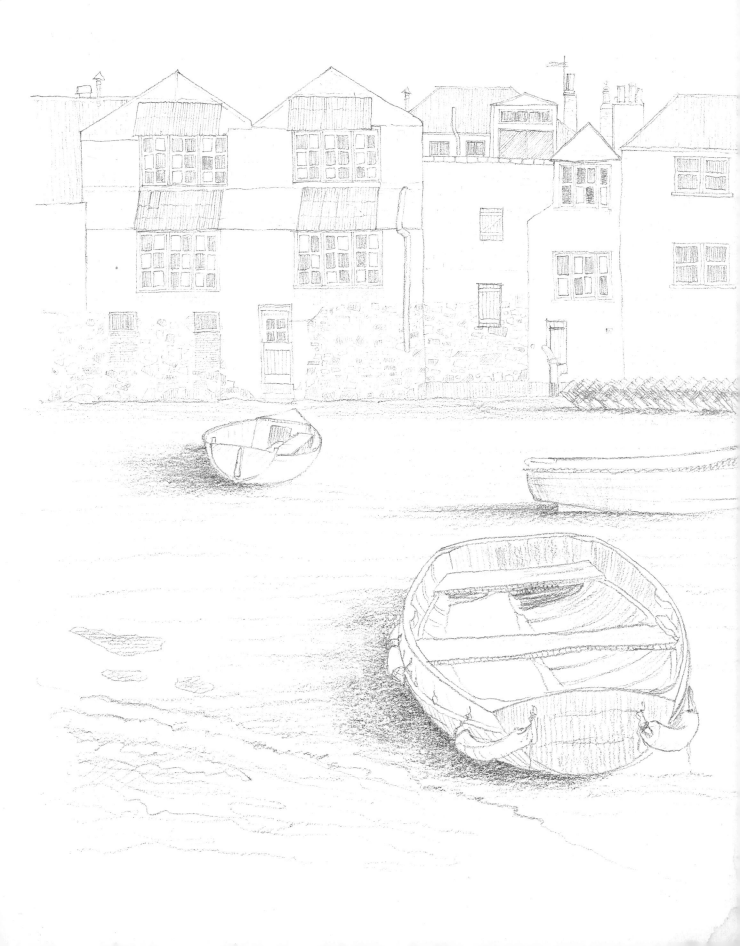

Index